earth

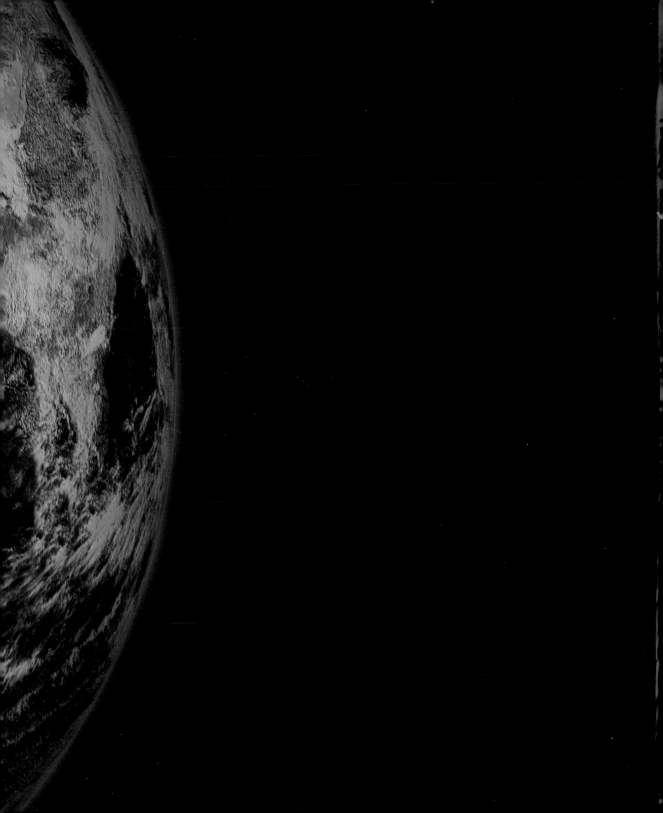

earth

a new perspective

Nicolas Cheetham

Quercus

{contents}

{ The View from Here 6 }

{
earth
mountains, canyons, tectonic
plates, rocks, rifts, deserts,
erosion, earthquakes

14
}

water
oceans, seas, rivers, wetlands,
lakes, reservoirs, glaciers, ice
sheets, icebergs, currents

{ } 58

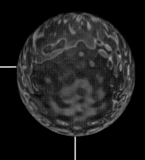

fire
volcanoes, impact craters, wild
fires, man's environmental impact:
cities, agriculture, mines

{ } 146

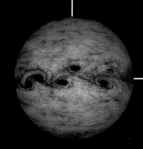

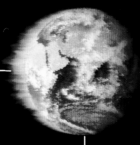

air
atmosphere, clouds, weather,
hurricanes, dunes, sandstorms,
aurorae, ozone hole

{ } 106

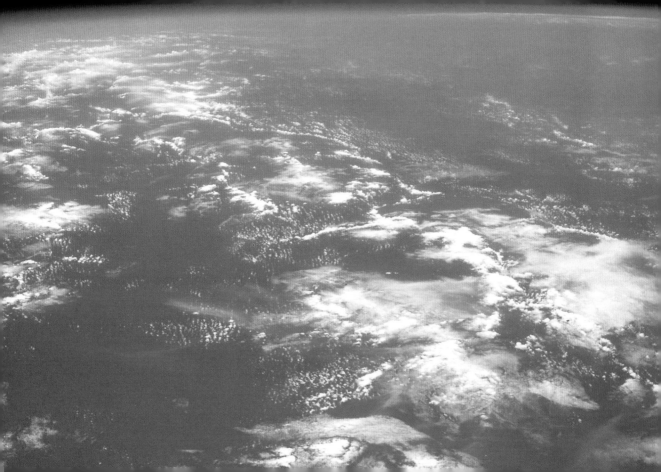

The View from Here

From Earth we have looked deep into the universe, a celestial view that extends for 130 billion trillion kilometres (80 billion trillion miles) in every direction. We have ventured far beyond the narrow archipelago of visible light, and discovered that our cosmic horizons are bound only by the far shores of space and time: we have surveyed alien landscapes, glimpsed smouldering embryonic stars, watched the death throes of stellar hypergiants, uncloaked black holes, witnessed galaxies in mid-collision and charted the afterglow of the Big Bang. But what happens when we look back, when, rather than observing the heavens from Earth, we behold Earth from the heavens?

In the mind's eye our image of Earth is immediate and indelible: a fragile blue orb stippled with cloud and set alone in an endless night sky. This iconic 'blue marble' is perhaps the most memorable image of the twentieth century. One of the great legacies of Project Apollo, it marks the moment, some 45,000 kilometres (28,000 miles) en route to the Moon, that our species first perceived the entirety of its home.

Over three decades later and near-Earth orbit is crowded with flocks of observers – the once unseen planet is in danger of over-exposure. Perched just 360 kilometres (220 miles) above Earth's surface, the International Space Station has established a permanent observation post in space. Circling the globe every 92 minutes, it commands views of our planet that span 3,000 kilometres (2,000 miles) from horizon to horizon. In higher orbits, roosts of satellites – Landsats, Meteosats, Earth Observing Systems and Geostationary Operational Environmental Satellites, to name but a few – bristle with electronic eyes as the same sensors that have unlocked the universe's distant reaches are brought to bear on our home planet.

Just as the heavens blaze across a spectrum of energies far broader than the eye can behold, so does Earth. By venturing beyond the familiar rainbow of visible light we reveal the secret hues of the blue planet. Gamma ray and X-ray emissions crown the outer atmosphere and poles as cosmic radiation is absorbed, the sky shines with the ultraviolet glow of rare gases, green continents shimmer with the infrared reflections of vegetation, while the naked geology just below is exposed by longer wavelength thermal radiation.

To record this hidden world, a battery of esoteric instruments from spectro-radiometers to synthetic aperture radars, sweep across the planet every day, probing land, sea and air and beaming their findings back. Orbiting 705 kilometres (438 miles) above Earth, Landsat 7 scans the entire globe every 16 days, dividing its landmasses into 57,784 scenes, each 183 kilometres (115 miles) wide by 170 kilometres (106 miles) long. Its principal instrument, the ETM+ (Enhanced Thematic Mapper Plus) measures the planet's emissions at visible and near infrared wavelengths, capturing approximately 3.8 gigabits of data for each scene – the rough equivalent of nearly 15 sets of encyclopedias at 29 volumes per set. Meanwhile, NASA's Terra satellite, home to a veritable alphabet of acronymic spectro-radiometers – MOPITT, ASTER, MODIS, MISR, CERES – beams a terabyte (a million megabytes) of data back to Earth every day – enough information to fill 220,000 such encyclopedic sets.

Back on *terra firma*, this feast of raw digital data is digested and refined by computer software to extract and highlight the precise information required before being recast in pictorial form. Possessed of an abstract – almost alien – beauty, the resulting images are the landscapes of the information age, where each pixel conceals a measurement, each swathe of colour reveals a once invisible set of electromagnetic wavelengths.

Left: The best view of all? 360 kilometres (220 miles) above Earth's surface you command a view that spans 3,000 kilometres (2,000 miles) from horizon to horizon.

Uniting aesthetics with utility, the satellite's all-seeing eye allows us to follow a thread of gold as it weaves its way through a mountain range; we can uncover cities swallowed by shifting sands or dense jungle; we can gaze into the eye of the hurricane or the maw of the volcano; we can watch forests disappear and ice sheets melt. So sensitive are our instruments that we can read the undulations of the ocean floor in surface waves, and watch a continent sink under the extra weight of water it carries during the rainy season. But more than this, our satellite soundings have revealed a dynamic planet that lives and breathes around us, but one whose heartbeat, paradoxically, we could not fully sense for our very proximity. As Socrates said nearly 2,500 years ago, 'man must rise above the Earth – to the top of the clouds and beyond – for only thus will he fully understand the world in which he lives'.

The view from above these clouds is the subject of this book: in pursuit of new planetary perspectives we shall girdle the world in 192 pages, flitting between continents and hemispheres as easily as our satellites sail the electromagnetic waves of the spectrum. Just as our inquiry has been launched with one Greek philosopher's injunction to rise above the clouds, so shall it proceed under the aegis of another. From space, earth, water and air are the obvious constituents of our planet, in undeniable harmony with three of the four elements proposed by Empedocles of Agrigentum over two millennia ago. We shall group our chapters under these primeval elements, if only to discover what modern science has added to our understanding of these ancient fundamentals. Only Empedocles' last element, fire, appears to leave no trace on the tranquil blue orb that floats before us. But this is an illusion. Earth was born from fire, and her Hadean depths harbour it still. Thus our last chapter takes its heading from our muse's final element and charts the fires of Earth: recording not only its volcanoes and impact craters, but also mankind's influence that has transformed the planet as surely as any inferno. Keep an eye open for Empedocles too, for we shall meet him again on the slopes of Mount Etna.

Earth

Our survey begins with a cloudless view of Earth summed from four months of clear-skied observations by NASA's Moderate Resolution Imaging Spectro-radiometer (MODIS). This Earth is instantly familiar, its continents and seas the stage upon which all human history has been performed – yet this configuration of rock and water represents a fleeting geological moment, having existed for no more than 4 million years, a mere 0.01 percent of the planet's lifetime.

But look closer at this surface and a deeper past emerges. Earth's 4.57-billion-year history can be reconstructed from the shreds and patches of rock that adorn its crust, for here, layer by sedimentary layer, Nature has written her own chronology.

Chipping away at mountain seams, geologists laboured for centuries to break the petroglyphic cipher that encoded the history of the world, but with little success. A clang with greywackes, gabbros and gneisses, geology was long on description but short on insight: we could read the letters of our planetary history, but we couldn't understand the words.

Only in the last four decades have we made sense of all that twisted rock. The key to the code was plate tectonics, a concept some have hailed as geology's Grand Unified Theory. Beautifully elegant, plate tectonics can explain the occurrence and formation of the entire catalogue of geological phenomena, from mountain ranges to deep ocean trenches. It has revolutionized the science just as Copernicus' heliocentric universe transformed astronomy – indeed, there is a passing resonance between the two paradigm shifts: in both cases the Earth moves.

Stripped to its bare essentials, plate tectonics suggests that Earth's thin crust (or lithosphere) floats on the mantle and is broken into 15 or more pieces (plates). Each plate is free to move and has three possible modes of interaction with its neighbours: convergent (two plates push against one another); divergent (two plates move away from each other); and transform (two plates slide past one another). From these simple relationships all of geology is spawned: convergent plates buckle sheets of rock into mountain folds, ignite volcanoes and dig deep ocean trenches; divergent plates create mid-ocean ridges and, ultimately, new oceans; and transform plates produce earthquakes. The power source for all this activity is believed to leak from an 8-kilometre (5-mile) ball of uranium at the centre of the planet. A stream of nuclear fission drives a cascade of convection cells that lick against the brittle lithosphere and fuel the inch-by-inch migration of the continents.

The tectonic revolution has brought the lithosphere to life – a planet that was once quite literally set in stone can now be seen from a new perspective. And there is no better place to appreciate the view than from orbit: serried ranks of mountains mass at the frontline of tectonic battlefields; dislocated massifs stranded on opposite ocean shores stand as monuments to Pangaea's or Gondwana's long-lost supercontinental bulk; Precambrian granites –

Right: 370 kilometres (230 miles) above the Caribbean, the furious bulk of Hurricane Ivan is framed against the solar panels of the International Space Station.

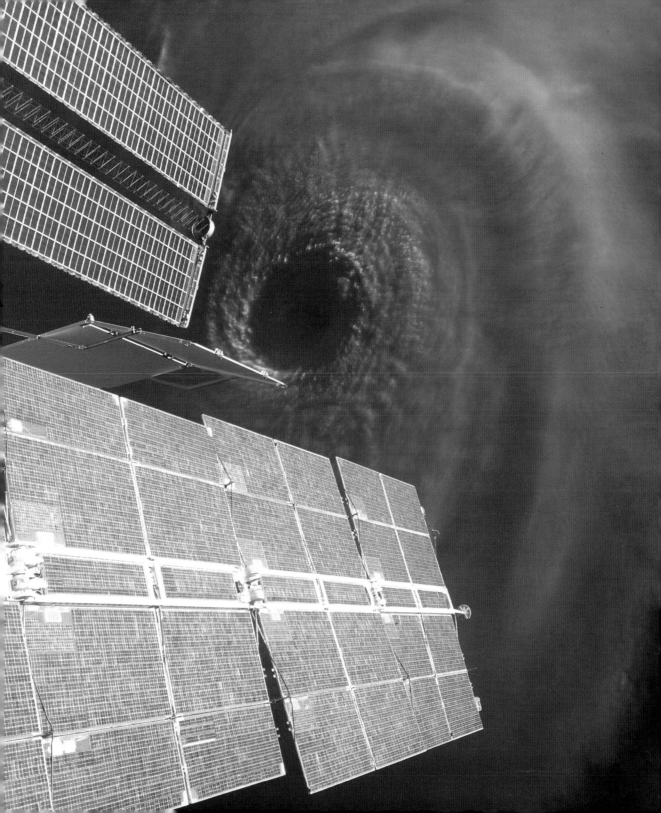

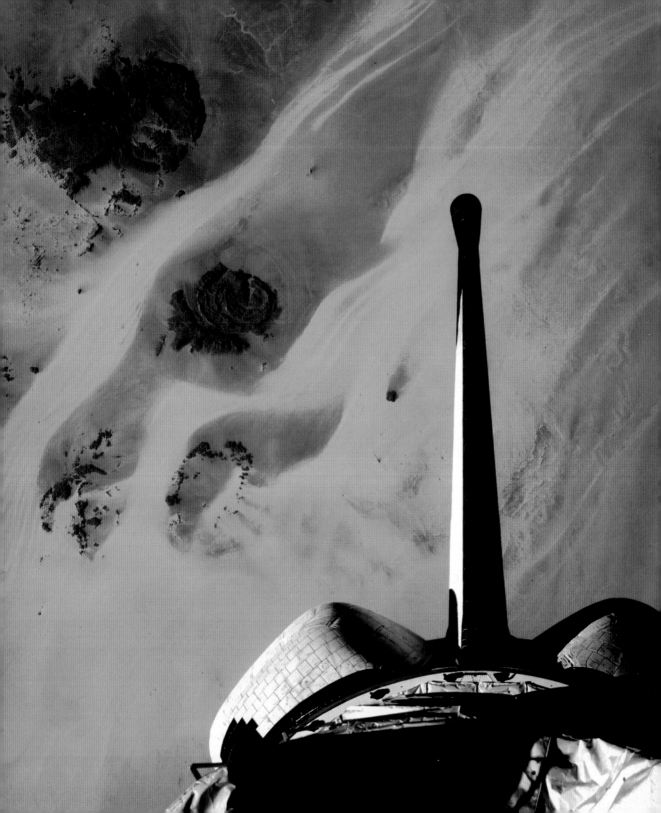

the scarred veterans of a billion years of erosion and the tectonic mill – huddle at the centre of continents; the fossilized igneous umbilicals of long-extinct volcanoes rear above desert sands. Such vibrant geological fauna is unique to Earth; the singular consequence of the only tectonic engine still operating in the solar system.

As well as reading our planet's past, with tectonics we can prophesy its future: Africa will close the Mediterranean, constructing a chain of mountain peaks from its sediments that will stretch from Cadiz to Karachi; Antarctica will inch towards a reunion with Australia, while Australia flees into the arms of South East Asia; the Atlantic will widen at the expense of the Pacific before the focus of seafloor production switches oceans and it begins to close again. 250 million years from now the tectonic carousel will reunite all the continents in some far future echo of ancient Pangaea.

But tectonic artistry is only one part of the equation that defines Earth's landscapes; to complete the sum we must move on.

Water

Arthur C. Clarke once pointed out how inappropriate it was to name our planet Earth, when quite clearly it should have been called Ocean.

Earth's hydrosphere is one of the wonders of the solar system: 1.36 billion cubic kilometres of water (326 million cubic miles) weighing over a million trillion tons cover more than 70 percent of our planet's surface. Strip Earth of its topography, and an uninterrupted ocean would submerge the planet under 2,500 metres (8,200 feet) of water. No other world (as far as we know) has even a single drop of liquid water above ground. Even if other planets conceal vast subterranean reservoirs, they are unlikely to rival Earth's reserves, for recent experiments suggest that beneath its crust, our planet holds five to ten times as much water as resides above it.

Water's very ubiquity blinds us to its astonishing properties. Firstly, it is the only substance on Earth that can happily co-exist in all three physical states of matter – solid, liquid and gas. Secondly, in apparent contravention of the laws of physics and rules of chemistry, its solid form is less dense than its liquid. Such a combination of vanishingly rare characteristics has been instrumental in the origin, evolution and continued existence of life on Earth. Without water there is no doubt our planet would be uninhabitable: Neptune's methane skies may well rain diamonds, but as far as life is concerned, Earth's precipitation of dihydrogen oxide is an infinitely more precious commodity.

Water is an enduring feature of the planet. First appearing 3.8 billion years ago, its exact origin is contested: conventional wisdom condenses it solely from volcanic out-gassings; more recent speculation delivers some of it to Earth as frozen chunks of cometary ice. Water's vessels – oceans, seas, rivers and lakes – are not nearly so ancient; they come and go at the bidding of plate tectonics.

However, rivers are some of the Earth's most ancient geographic features. At least 400 million years old, the Finke River in central Australia is reputed to be the world's oldest. It seems strange that something as ephemeral as a river – as Heraclitus (yet another Greek philosopher) observed, you cannot cross the same river twice – should predate most of the planet's mountain ranges. Rivers endure because once established, they are largely immune to further tectonic interference: they simply grind their way through any obstacle placed in their path. The Colorado River has chewed its way through a mile of rock and nearly 2 billion years of geological history, while the Brahmaputra has gnawed through the entire Himalaya.

By comparison, Earth's oceans are entirely at the mercy of the planet's tectonic engines. There is no ocean floor older than 200 million years – its rocks are locked in a cycle that sees their creation at mid-ocean ridges evenly matched by their destruction in the trenches that ultimately fringe them. Smaller standing bodies of water, such as inland seas and lakes, are not only sensitive to the lithosphere's convulsions, they are also subject to climactic variations. So constrained, their lifespan is extremely limited: the most venerable of their ilk is Russia's Lake Baikal at a mere 25 million years old.

As we embark upon our circumnavigation of the hydrosphere, we need not ponder the source of the Nile or the course of the Niger as European geographers did for over two millennia – from our orbital perspective we can view them in their entirety as they unwind from highland to ocean. We can follow the Amazon from Andean head-waters to Atlantic mouth, marvelling at the 184,000 cubic metres (6.5 million cubic feet) of water it discharges into the ocean every second – a flow that will continue until the Andes themselves are brought low. We can watch the waters of the Aral Sea recede, stranding skeletal fleets of fishing boats up to 60 kilometres (40 miles) from an ever-receding coast. We can track an oceanic river of heat as it unfurls from the tropics and curls round Europe, delivering the warmth of a million power stations to northern shores.

Left: The space shuttle floats over the positively Martian landscape of the Libyan Sahara. Protruding from the desert are Jebel Uweinat (top) and Jebel Arkenu, the fossilized roots of two long-eroded volcanoes.

Any pursuit of the hydrosphere's denizens leads to the planet's loftiest peaks and its Poles. Here, we encounter water in its most fearsome phase: ice. As recently as 18,000 years ago ice embraced one-third of the planet, but today's world is warming, its ice sheets thawing, and its glaciers beating a hasty retreat to their high mountain lairs. But such climactic fluctuations have beset the planet for the last 40 million years on a regular 40,000-year cycle. What goes around comes around: the ice will return.

To continue our journey, we must now take to the air.

Air

The Earth is on its third atmosphere. Its original atmosphere was constructed from helium and hydrogen, lightweight elemental leftovers from its accretion, and was quickly boiled off into space by the heat of a still-molten world. As the planet cooled, it bedecked itself with a new atmospheric mantle of carbon dioxide, water vapour and nitrogen, gathered from the gaseous exhaust of its volcanoes (and perhaps the occasional passing comet). Up to this point oxygen was conspicuous only by its absence; the 1,000 trillion tons of it in today's atmosphere are the legacy of 3.3 billion years of biological pollution. Earth's first inhabitants were phototrophs, converting carbon dioxide, water and sunlight into glucose and oxygen, keeping the glucose for themselves, but dumping the oxygen into the environment like the bacterial scum that they were. As a result of this ecological vandalism, significant quantities of an incredibly toxic, rather flammable chemical accumulated in the atmosphere, where it remains to this day. Such a concentration of waste posed an insurmountable problem for many of the original polluters. Those unable to reap what they had sown suffered, succumbing to the first of the planet's periodic waves of mass extinction. We should consider this tale and look to the ozone hole.

The atmosphere forms a protective carapace around Earth. It insulates the planet from the cold rigours of the vacuum and shields it from incoming radiation, not only scattering blue light to lend Earth its distinctive hue, but also absorbing high-energy particles before they can wreak havoc on the biosphere below.

There are intimate connections between air and water, and scientists tend to treat them as a single system. The hydrosphere's fingers reach beyond glacier-clad peaks and into the atmosphere. Actually, only the very tips of the hydrosphere's claws pierce the atmosphere, as clouds and water vapour make up only 0.001 percent of its total mass – but what claws they are. To our eyes, the atmosphere is a largely invisible kingdom, its secret workings betrayed only by the condensation of clouds. But venture into the infrared, and even the laciest wisp of cloud reveals a seething cascade of convection currents, stirred as colossal quantities of solar energy are traded between water and its surroundings as it switches from liquid to vapour and back again.

Such energy exchanges are the lifeblood of all atmospheric phenomena, from the sweetest zephyr to the most potent tempest. At the more violent end of the meteorological spectrum, the energies unleashed are prodigious: thunderclouds can suck half a million tons of water vapour up to 15 kilometres (9 miles) into the air, releasing enough energy to power a city of 100,000 for a month. Hurricanes, typhoons and cyclones are little more than vast heat engines, stalking tropical seas and extracting up to 30 megatons of energy per hour from their warm waters. As El Niño blossoms, it can release enough energy into the atmosphere to temporarily slow the planet's rotation.

But even with such power at its disposal, the atmosphere, like the hydrosphere, is not immune to the attentions of plate tectonics. With a well-aimed thrust a mountain range is capable of disrupting its prevailing circulation or forcing it to shed its watery cargo; the slow congregation of landmasses about a pole can reflect enough sunlight back into space to cool the atmosphere and trigger an ice age. But Earth's spheres are harmoniously linked, and the higher plate tectonics force the lithosphere, the more feverishly erosion – the action of water, ice and air – works to bring it low again.

From orbit we dash through this chaotic realm, cataloging clouds, watching thunderstorms spark hurricanes, exploring turbulent vortices spinning from mountain peaks and tracking the rolling progress of wind-sculpted sand seas as they crawl across the continents.

Fire

Fire is the final function in our planetary equation. It is an integral part of the planet, personifying the flux – the movement of rock, air and water – that so characterizes Earth.

The lithosphere, hydrosphere and atmosphere are but a thin skin over the rocky bulk of Earth's mantle and its dense metallic core. At the planet's heart, temperatures exceed 4,700 °C (8,500 °F) – as hot as the surface of the Sun – and the pressure is 3 million times that of the atmosphere at the surface. Such Hadean depths are the real

Right: Russia's MIR space station and the Moon above a swollen line of heavy thunderstorms. After 15 years in space, MIR was deliberately de-orbited in 2001, breaking up over the Pacific as it plunged back to Earth.

stuff of the planet and the ultimate wellspring of the tectonic forces that shape the world above.

This underworld is forever inaccessible to us, but we have a window on it: the volcano. Our orbital survey traces the tectonic margins of the world where the deep clash of plates ignites volcanic rashes on the surface. Such igneous intrusions are a reminder of the turbulent youth of our planet. We also look at asteroid impacts, taking us even further back into the planet's history, to a time before its birth even, when it was still accreting from the debris left over from the formation of the Sun. Meteorite bombardment and vulcanism built the world, and still have the power to change it.

Such are the terrestrial and extraterrestrial forces that have written and re-written history, but as of recent millennia the Earth has spawned another power that may ultimately rival them. Born in Africa's Great Rift Valley, nurtured on the banks of the Nile, Euphrates and Indus, a distant descendant of the bacteria that first terraformed the planet over 3 billion years ago, this force is man.

The final orbits of our journey look at humanity's spread across the globe: our farms, mines and cities. We close as we started, with a satellite map stitched together from months of observation. Before us lies a planet engulfed by global night. In the dark, natural geography has been supplanted by a galaxy of city lights. Earth shimmers as they swarm across the globe, following coasts, rivers, railroads and highways: the Egyptian Nile phosphoresces; the Trans-Siberian Railway spins a web of conurbation. Economic and political secrets are betrayed: oil refineries burn on Alaska's arctic shore; North Korea stands ominously dark. Only Nature's greatest monuments dam the flood: the Himalaya stand untouched; the deserts of Africa, Arabia and Antarctica remain *terra incognita* for the city.

Elsewhere, urbanization shadows our march across the planet. In some areas, cities are coalescing, losing their individual borders as they consume the lands that once separated them. Just as volcanic eruptions and asteroid impacts have described past transitions between epochs of Earth's history, perhaps the rise of the megalopolis will define the next.

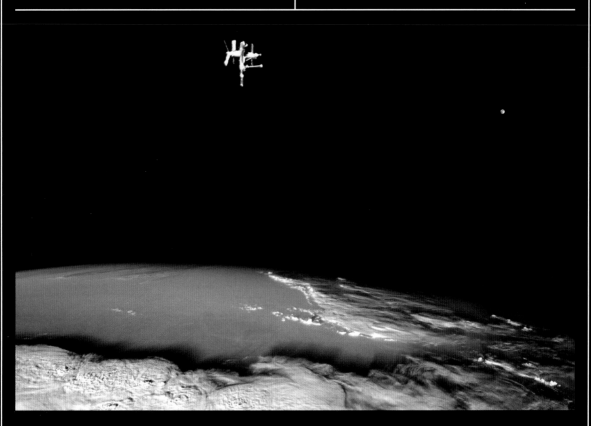

I

earth

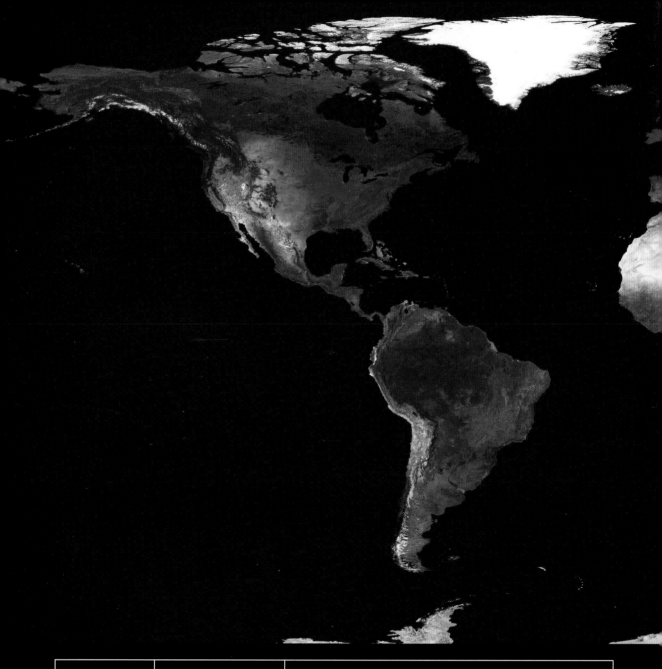

Earth

Earth's surface is a thing of shreds and patches, a 4-billion-year-old geological palimpsest inscribed by a deep tectonic hand, erased by the subtle teeth of erosion, and over-written again and again. Mere flotsam on the magmatic seas that churn within the planet, the crust is in constant flux: oceans wax and wane, continents marry and separate, mountains erupt and erode.

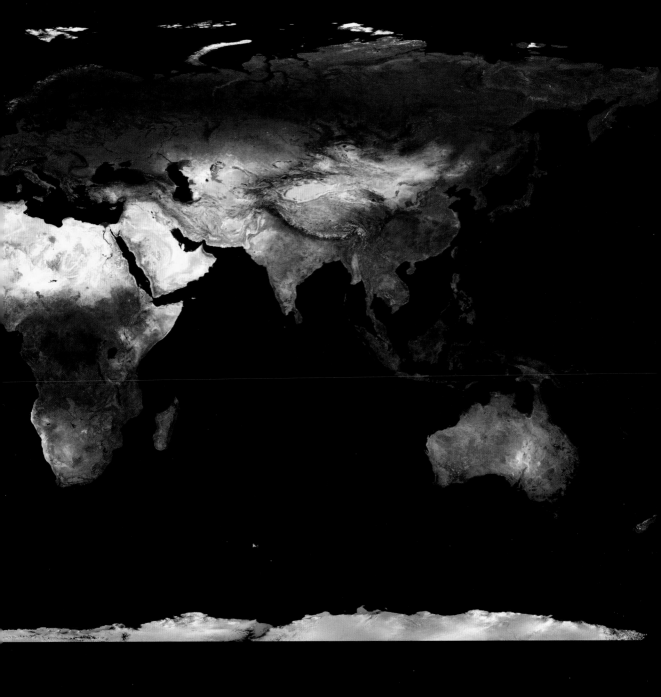

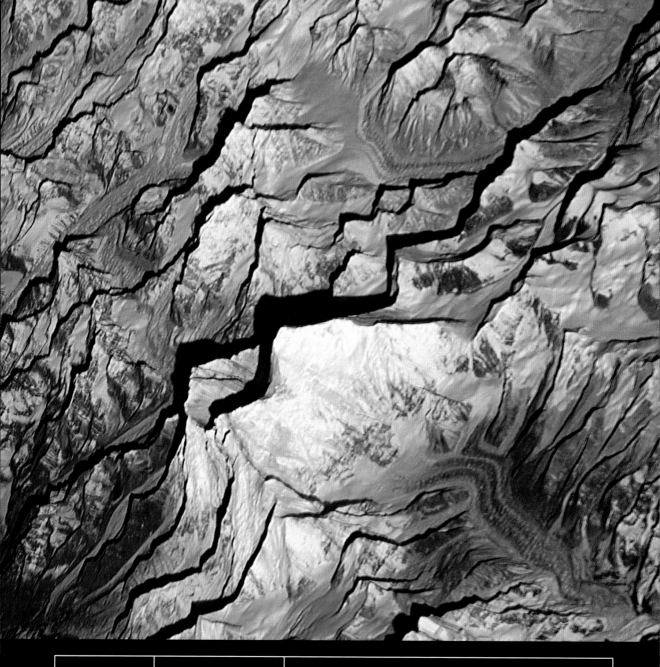

*Mount
Everest*

Nepal / Tibet

Bathed in dawn's early light, Mount Everest stands 8,850 metres (29,035 feet) above sea level, the very peak of Earth's thin lithosphere. But beneath sea level, the deepest ocean abyss would swallow Everest whole – and still have room for a medium-sized Alp on top. And one day, the mountain's eroded remains will indeed feed such deeps, for such is the tectonic fate of the Earth's crusts.

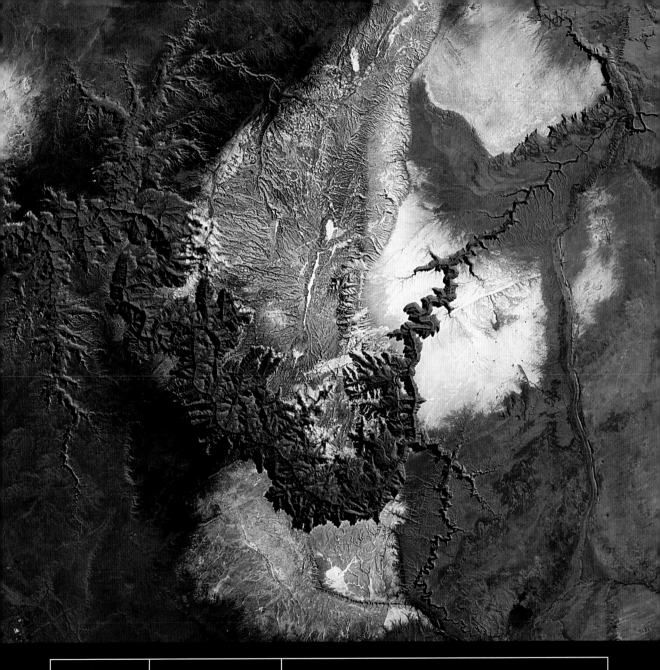

Grand Canyon

Arizona, USA

Cutting a mile (1.6 kilometres) into the surrounding landscape, the Grand Canyon unearths nearly two billion years of Earth's geological history. Excavated over the course of two million years by the Colorado River, the canyon descends through the sedimentary remains of shallow seas, swamps and deserts, charting their advance and retreat over proto-North America.

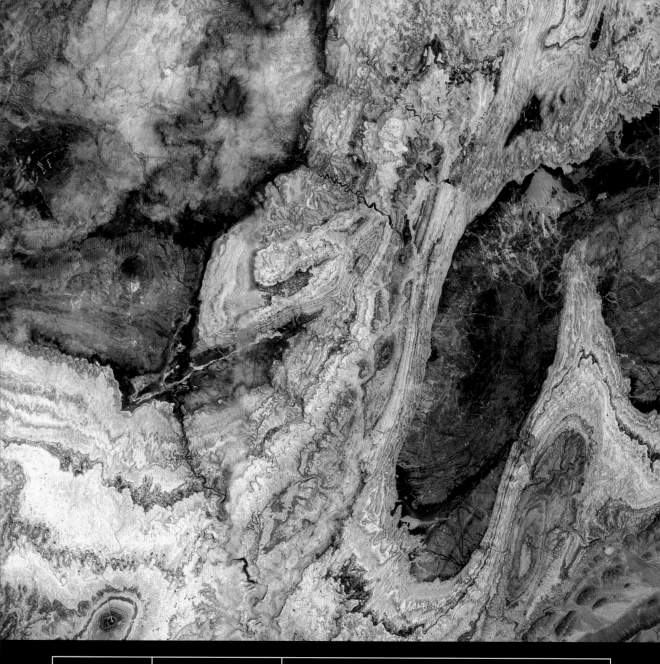

Anti-Atlas

Mountains
Morocco

Earth's story is engraved on every mountain fold: the Anti-Atlas tell of a clash of continents and the demise of the Tethys Ocean. Caught in a tectonic vice between Africa and Eurasia, ancient ocean floors twisted and heaved, building mountain peaks from abyssal sediments. In this infrared image, yellow, orange and green denote limestone, sandstone and gypsum; blue marks underlying granitic rocks.

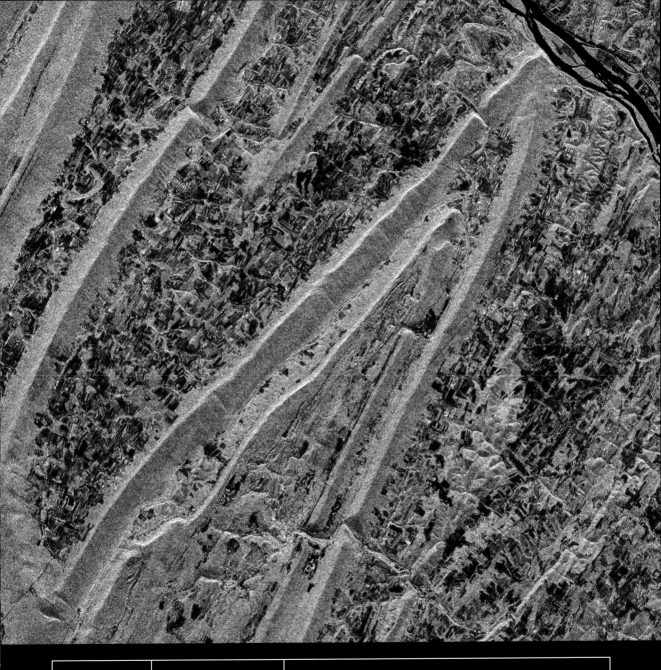

Appalachians

Mountains
Pennsylvania, USA

The Appalachians' sinuous ridges bear the weathered memory of a mountain range that once rivalled the Himalayas in stature. Originally roused from shallow equatorial seas 450 million years ago, the Appalachians were sculpted by a succession of tectonic collisions, finally reaching their apotheosis 250 million years ago when they formed the backbone to Pangaea's supercontinental bulk.

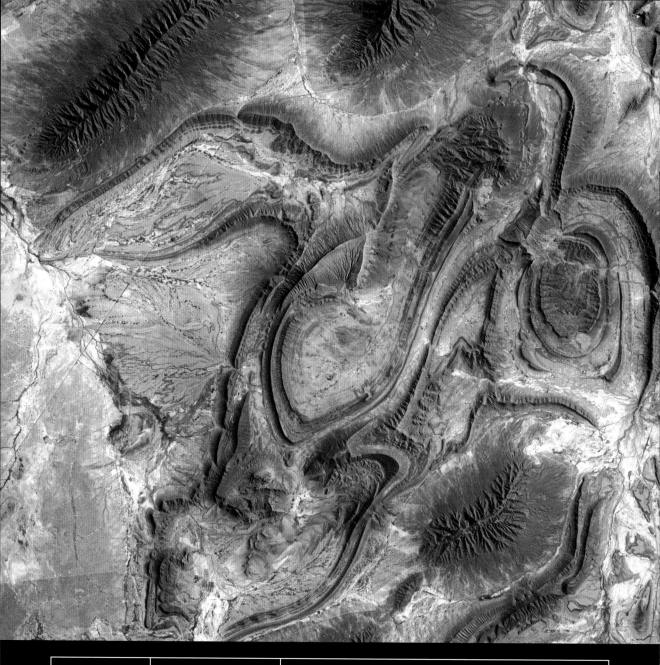

Sierra Madre

Mountains
Mexico

These rorschach petroglyphs are the tectonic masterwork of a 30-million-year mountain-building spree that buckled and rebuckled the Americas from Alaska to Mexico, creating, in the process, the Rocky Mountains. Now 40 million years old, weathering has only sharpened the Sierra Madre's ridges, abrading softer strata to leave more resilient layers standing proud.

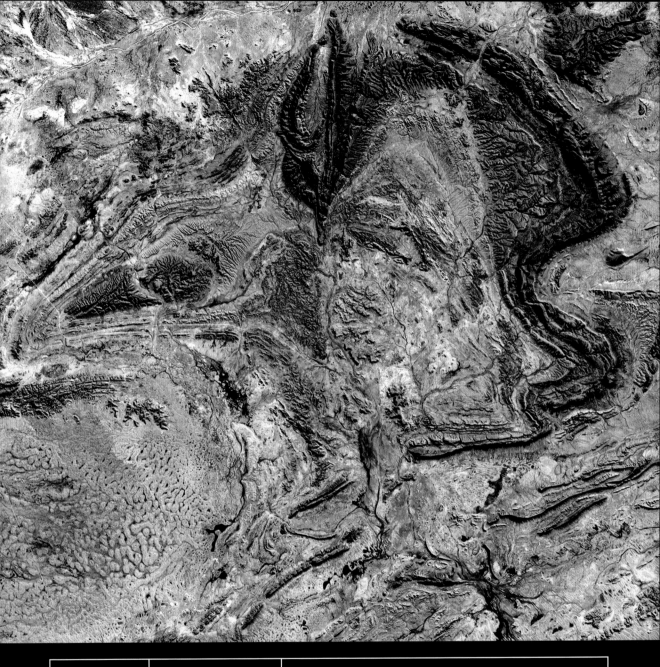

MacDonnell Ranges

Mountains
Northern Territory, Australia

Standing at the heart of the continent, the MacDonnell Ranges bring some relief to the flatlands of the Australian outback. Spanning 640 kilometres (400 miles), their contorted sandstone spines are a ghostly echo of a Gondwanan massif. Ground into oblivion hundreds of millions of years ago, a more recent wave of tectonic uplift has resurrected these tired mountains for our epoch.

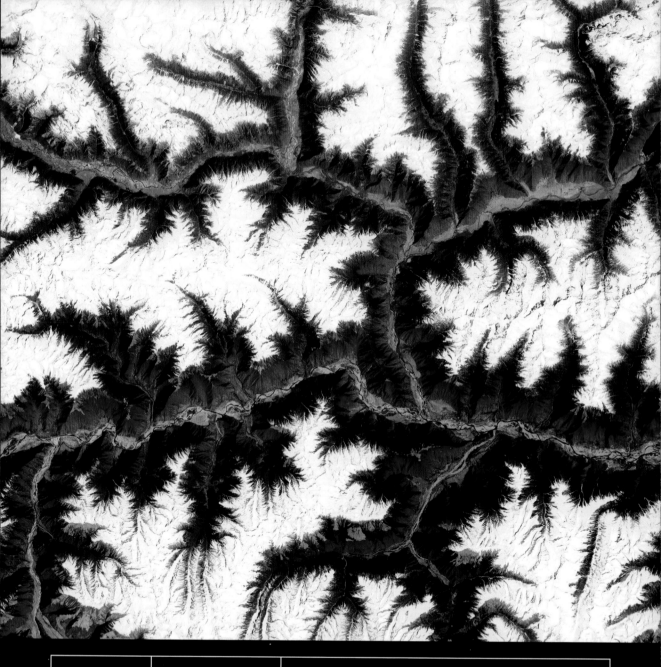

Himalaya

Mountains

Tibet

Just beyond the visual spectrum, the red glow of vegetation conjures dragon spines from eastern Himalayan valleys. The whole 3,000-kilometre (2,000-mile) massif was forged by India's collision with Eurasia, an impact that began 100 million years ago and continues today: every year the Himalaya climb 5 millimetres (0.2 inches) higher and push 27 millimetres (1 inch) further into Asia.

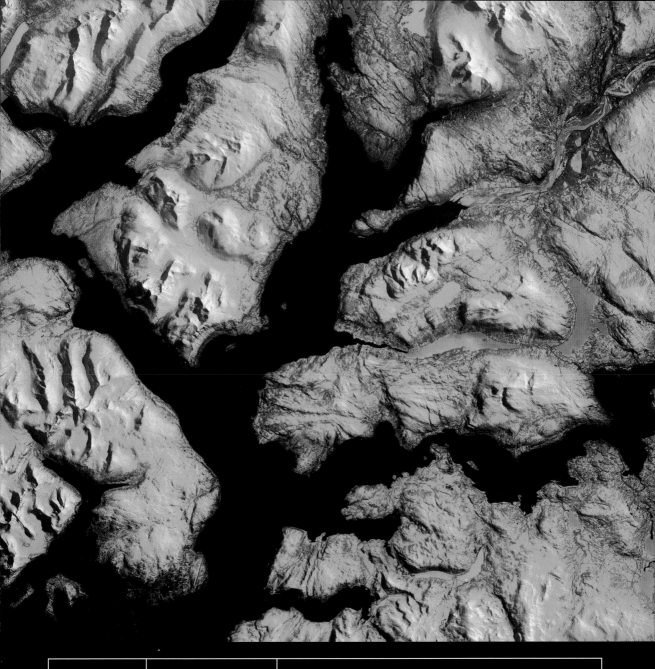

Fjords

Norway

Norway's precipitous coastline is a dislocated remnant of ancient Pangaea's backbone, gnawed by the advance of ice-age glaciers and drowned by their retreat. Wrenched from its birthplace by the burgeoning Atlantic Ocean 180 million years ago and winched eastward no faster than your fingernails grow, this European coast was once a ridge of the distant Appalachian mountains.

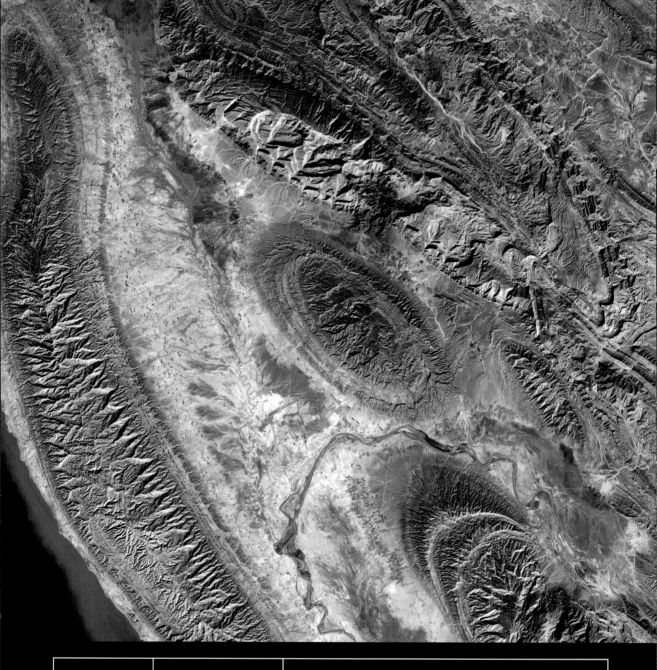

Zagros

Mountains

Iran

Calved from Africa 35 million years ago, Arabia has thrust under the Eurasian plate, erecting the crenellated Zagros Mountains. As fast as Earth's vigorous geological metabolism can push up new rocks and fold new massifs, erosion keeps pace, providing endless grist for the tectonic mill: today's mountain is tomorrow's sea bed, and today's sea bed is tomorrow's mountain.

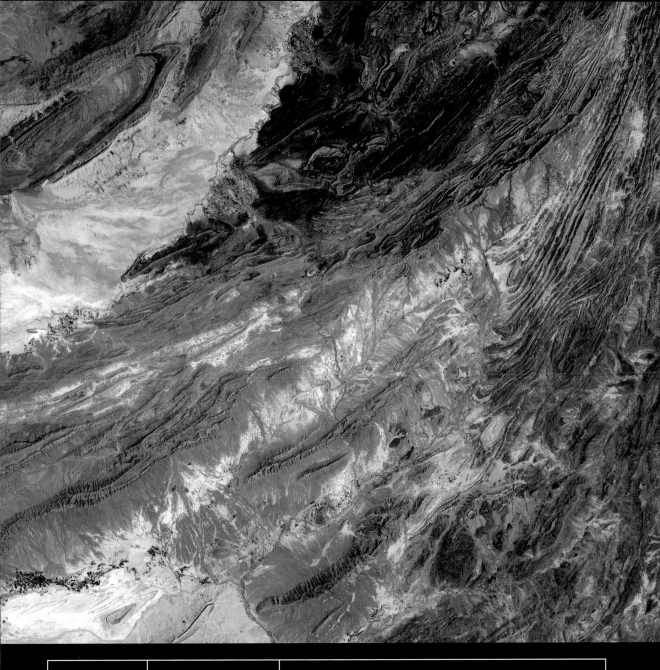

Sulaiman

Mountains
Pakistan

The Sulaiman range joins the serried ranks of Asian mountains marshalled by India's tectonic offensive. But to what subterranean beat do the plates themselves march? Stoked to 4,700 °C (8,500 °F) by nuclear fires, Earth's core pours energy into the mantle, driving churning convection cells that, as they lick against the brittle lithosphere, fuel the continents' migration.

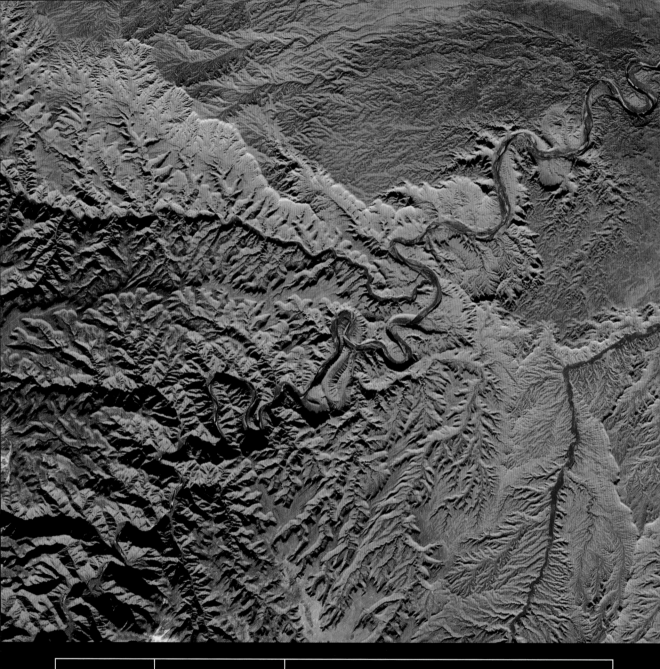

*Desolation
Canyon*

Utah, USA

The Green River has not so much rubbed against Utah to create Desolation Canyon, as Utah has rubbed against the Green River. The river has fought a rearguard action against tectonic uplift, working feverishly to slice through the rising landscape faster than the underworld can lift it aloft. And it has been quite successful: Desolation Canyon rivals the Grand Canyon for depth.

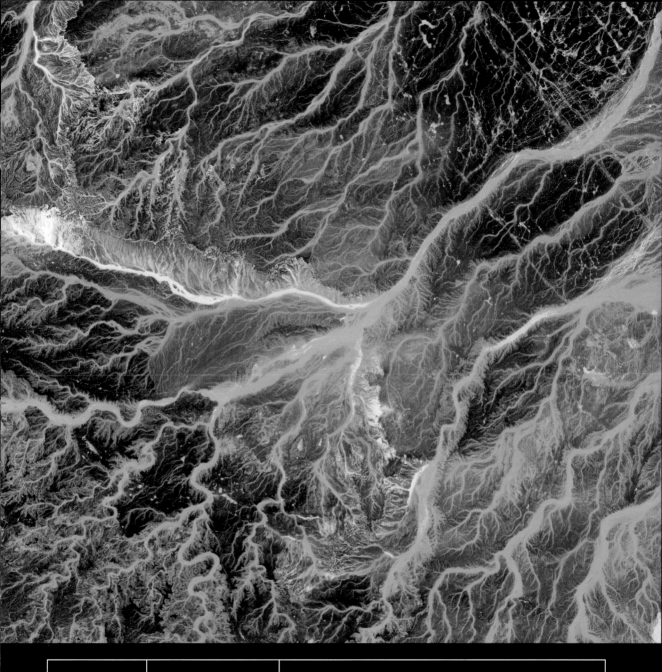

Desert Wadis

Jordan

The arid slopes of southeastern Jordan are scarred with a meandering filigree of waterless gullies, or wadis. Rainfall in the Arabian Desert is ephemeral at best, and certainly not substantial enough to have woven this elaborate skein. The drainage pattern is in fact a fossil; a relic of the rains that fell at the end of the last ice age.

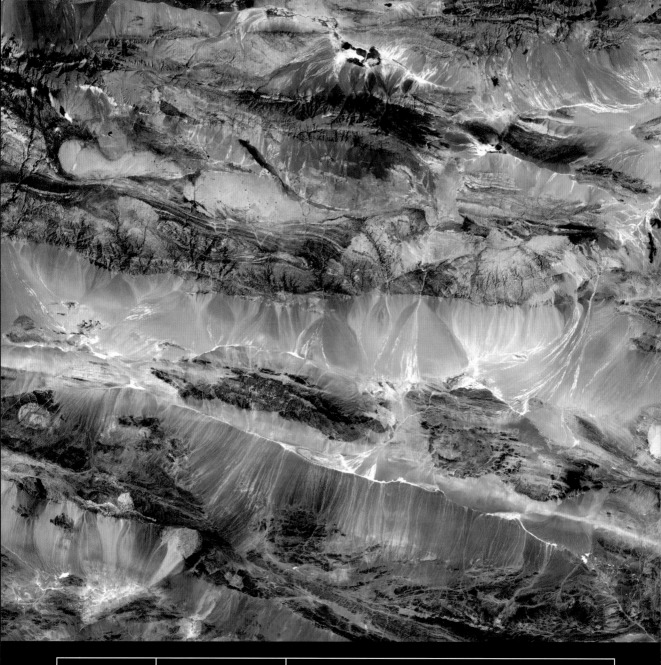

Gobi Altai

Mountains
Mongolia

An echo of the tectonic collision that spawned the Himalayas and thrust Tibet heavenward, these corrugated ridges mark the boundary between China's Gobi Desert and Mongolia's rolling steppe. Close inspection of these hills reveals the day-to-day details of life in the Cretaceous: their bare sandstone slopes conceal a flourishing, if fossilized, dinosaur population.

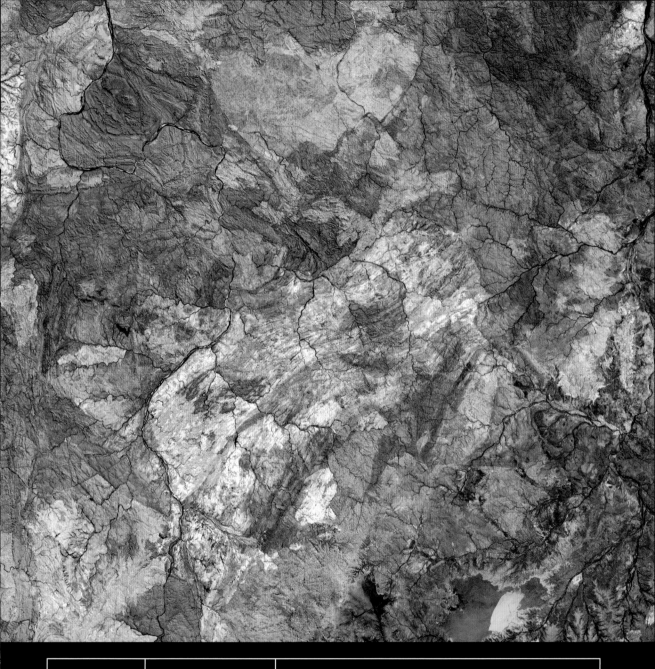

Great Sandy Desert

Western Australia

The southwestern periphery of Australia's Great Sandy Desert is, ironically, almost entirely devoid of sand. The lack of dunes exposes a tapestry of ancient rocks, Precambrian survivors from ancestral Gondwana. Protected from tectonic insult by Australia's long isolation, these rugged Methuselahs lie low, levelled by 200 million years of erosion.

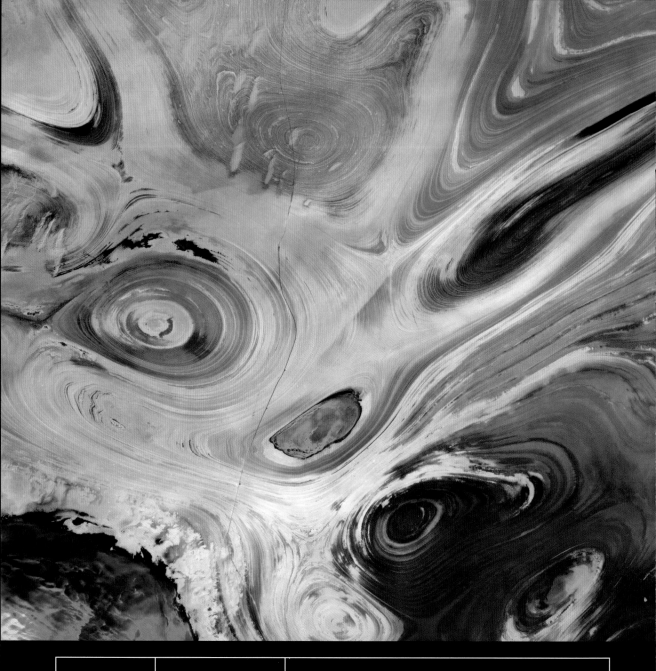

Dasht-e Kavir

Desert
Iran

Behind a mountainous barricade – the Zagros to the west and the Elburz to the north – lies the Dasht-e Kavir's treacherous embrace. 600 swirling kilometres (400 miles) of salt quicksands await the unwary. For centuries caravans plying the Silk Route crossed its fringes at their peril, following a trail marked only by the salt-pickled carcasses of their predecessors' camels.

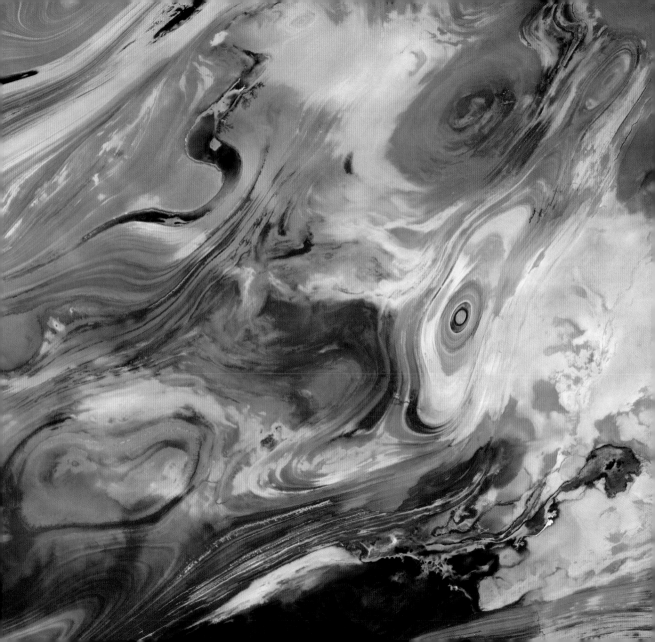

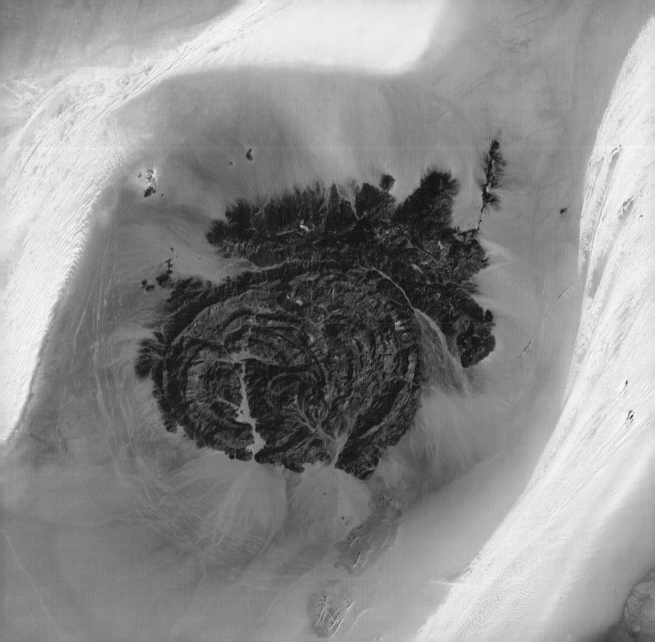

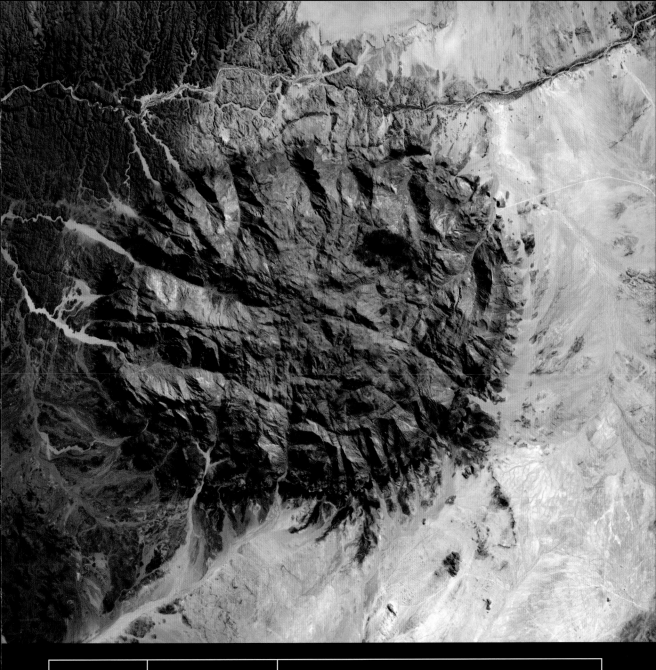

Brandberg
Massif

Granitic intrusion
Namibia

The rupture of Gondwana and the birth of the Atlantic Ocean unleashed a column of magma that punched deep into the Earth's crust. 120 million years of erosion have exhumed its remains – a granite fist that now rears 2,573 metres (8,441 feet) above the Namib desert. A dark ring of rocks forced upward during the mountain's arrival encircles the intruder's 90-kilometre (56-mile) girth.

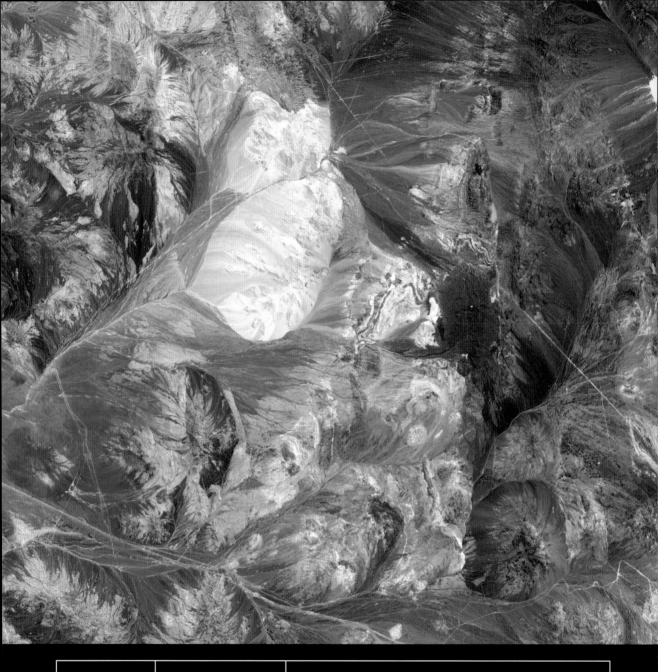

Atacama

Desert
Chile

Overshadowed by the Andes' thirsty peaks, the Atacama Desert is starved of water. Rain only falls here a few times a century – if it falls at all: some parts have no record of ever having been watered. Lifeless gorges choked with mineral-streaked sediments reveal the Atacama's only attraction: not only is there gold in them thar hills, there's also copper, silver and platinum.

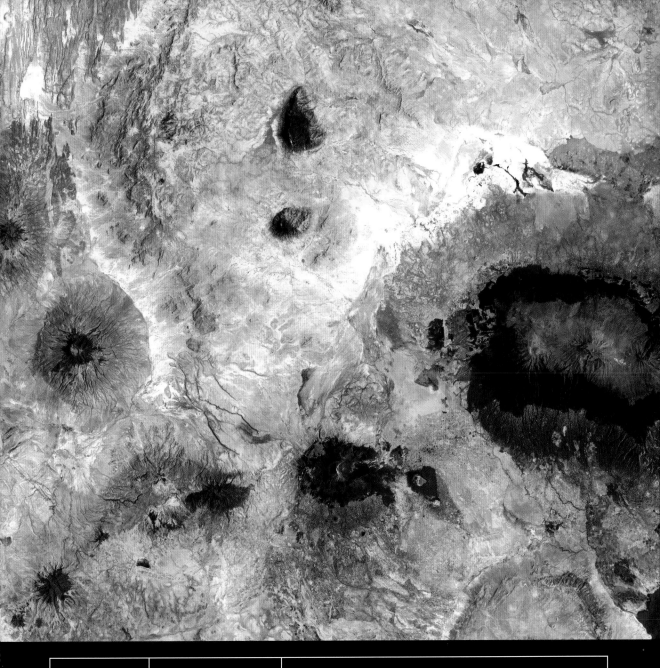

Kilimanjaro

Volcano & rift valley
Tanzania

Kilimanjaro (above right) and its cousins are the surface vents of a mantle plume – a superheated column of magma rising from deep inside the planet. For the last 10 million years, it has been melting through the African plate, weakening the crust and cracking the continent open from Mozambique to Ethiopia. If this tectonic blowtorch keeps burning, Africa will ultimately shed its eastern horn.

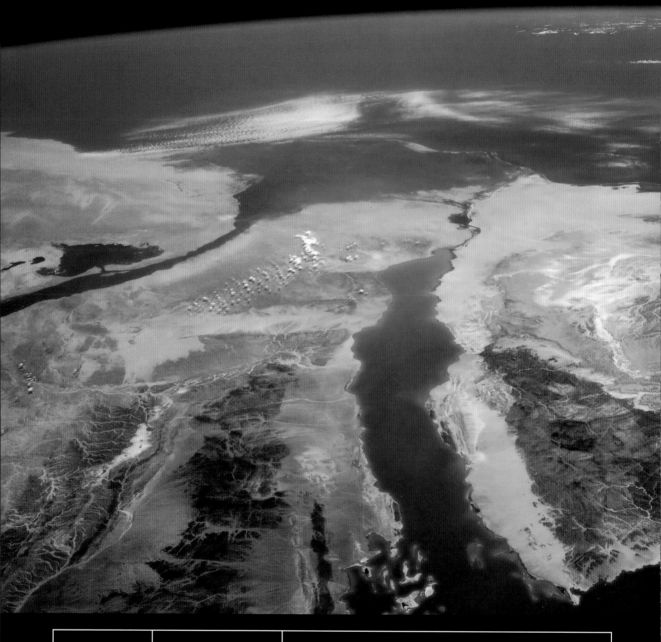

Great Rift Valley

Middle East

From space, 35 million years of tectonic laceration can be visually sutured, reuniting a dark swathe of rock spread across Egypt, the Sinai peninsula and Arabia. Ploughing a furrow through the Gulf of Aqaba (right) and up towards the Dead Sea is the northern arm of Africa's Great Rift Valley. Cleaving 6,400 kilometres (4,000 miles) of the Earth's crust, the rift runs from Mozambique to Syria.

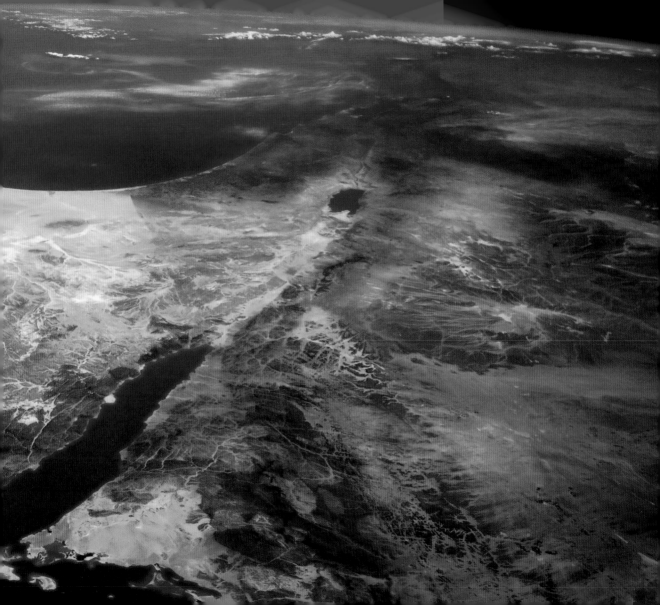

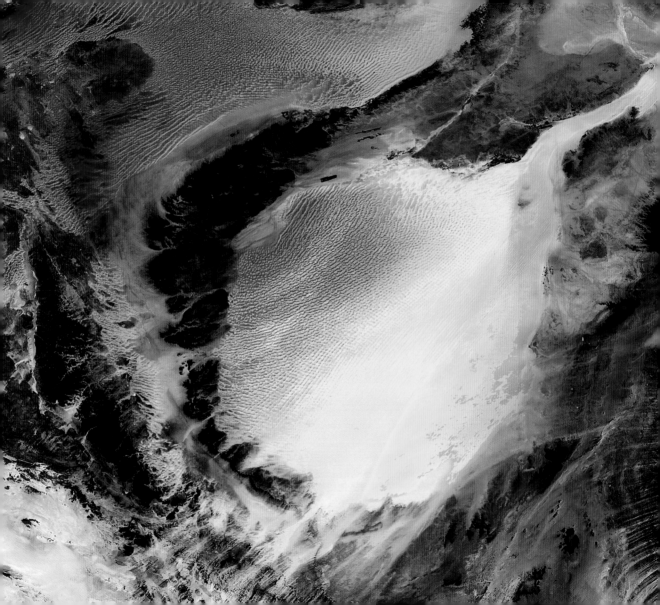

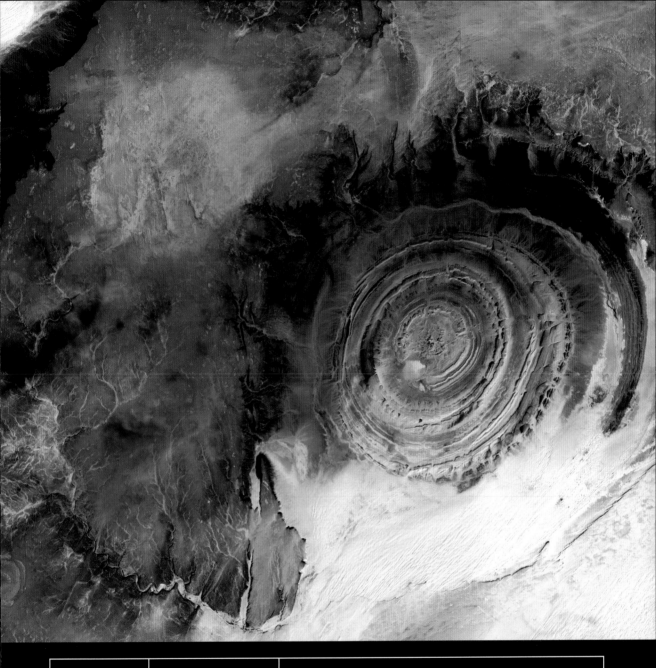

Guelb Richat

Erosion feature
Mauritania

Neither impact crater, time-worn volcanic stub, nor monstrous fossilized mollusc, Guelb Richat's nested ridges have been sculpted by the slow caress of erosion. Exposed to wind and sand, concentric bands of hardened metamorphic rock resist abrasion while their softer brethren succumb, creating a 500-kilometre (300-mile) ripple of stone on the edge of the Mauritanian Sahara.

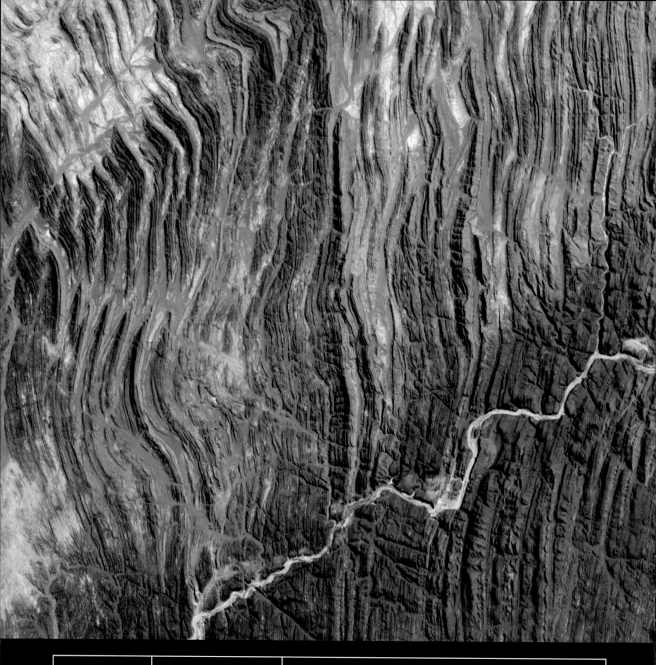

Ugab River

Sedimentary rocks

Namibia

Earth's geological history is a many-leaved volume, written by erosion, layer by sedimentary layer, in silt and sand on the ocean floor. Here, tectonic convulsions have seized thinly bedded sheets of limestone, sandstone and siltstone, heaved them on edge and thrust them back to the surface, where the Ugab River bores into them and the whole cycle begins again.

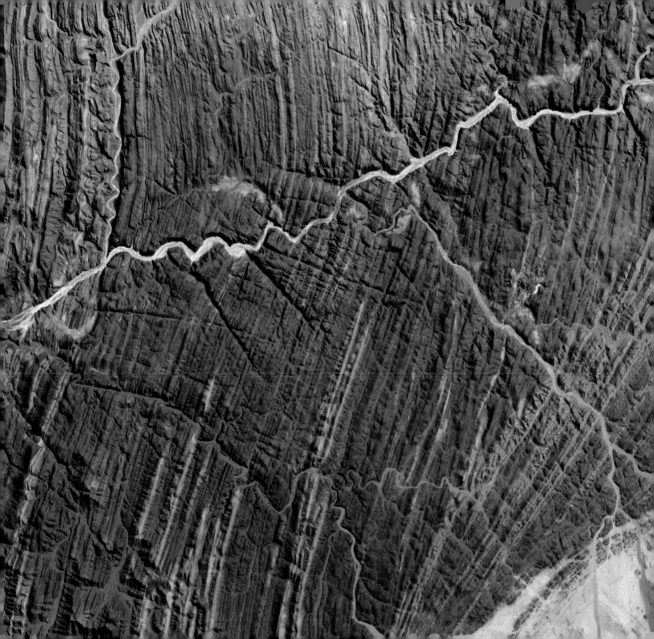

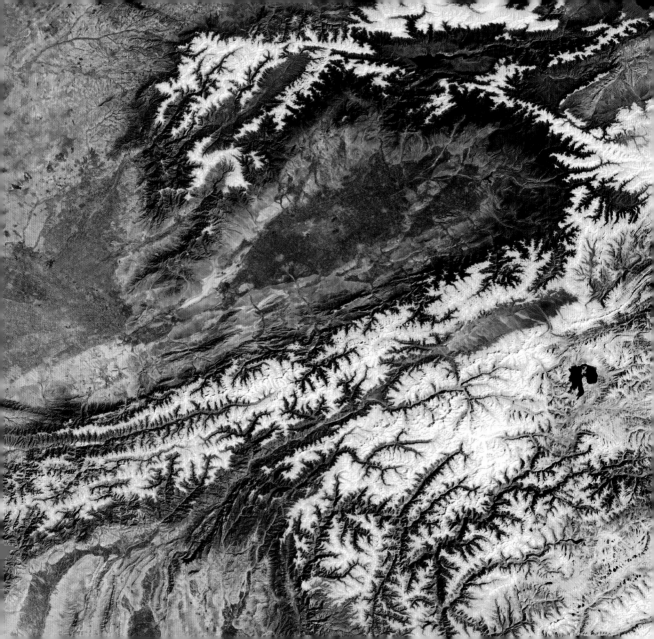

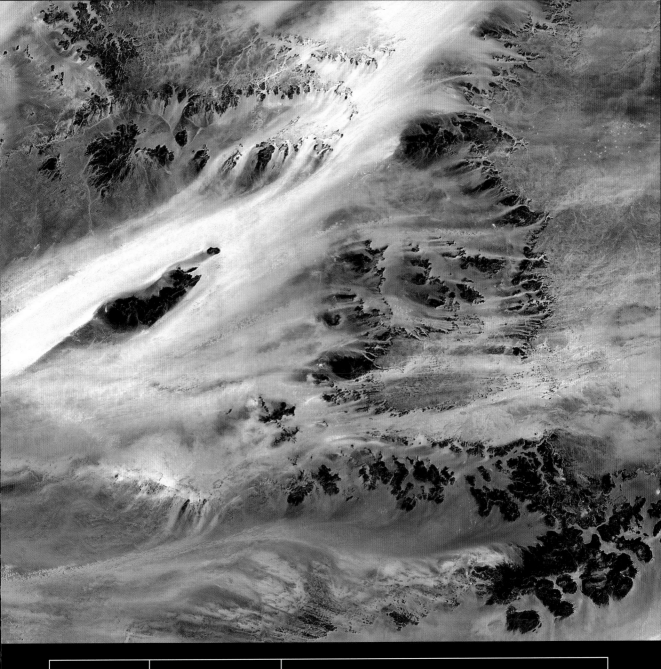

Terkezi Oasis

Chad

On the border between Libya and Chad, a river of sand pours over a reef of Saharan rocks. The desert landscape appears timeless, but it deceives: its sands only recently replaced grasslands that supported antelope, giraffe and elephant as well as man, cattle and sheep. Today, it is inhabited only by their petroglyphic shadows – a 5,000-year-old memory of a lost world inscribed by a forgotten culture.

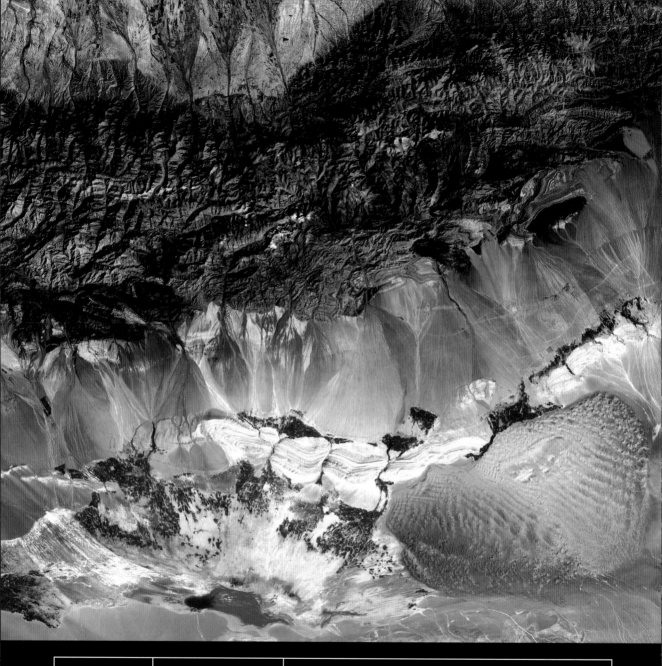

Turpan Depression

China

At the foot of the Tian Shan mountains, India's relentless tectonic assault on Eurasia has fractured the Earth's crust. 13,000 square kilometres (5,000 square miles) of rock have carved a rift valley as they subside between two parallel faults. Sinking to 154 metres (505 feet) below sea level, the Turpan Depression's depths are surpassed only by the Dead Sea.

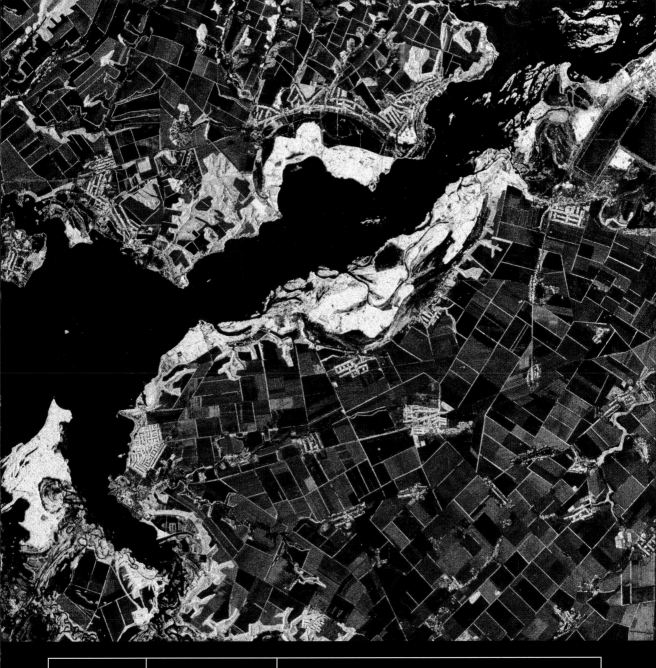

Ukrainian Fields

Ukraine

Radar reflections paint the Ukraine's bare soil with an amethyst glow – it is early spring so wheat has yet to sprout from the tilled fields surrounding the Dnieper River. Mixed from weathered rock and decomposing organic matter, the thin layer of dirt beneath our feet is a vital interface between geosphere, atmosphere and biosphere – from earth we come and to earth we shall return.

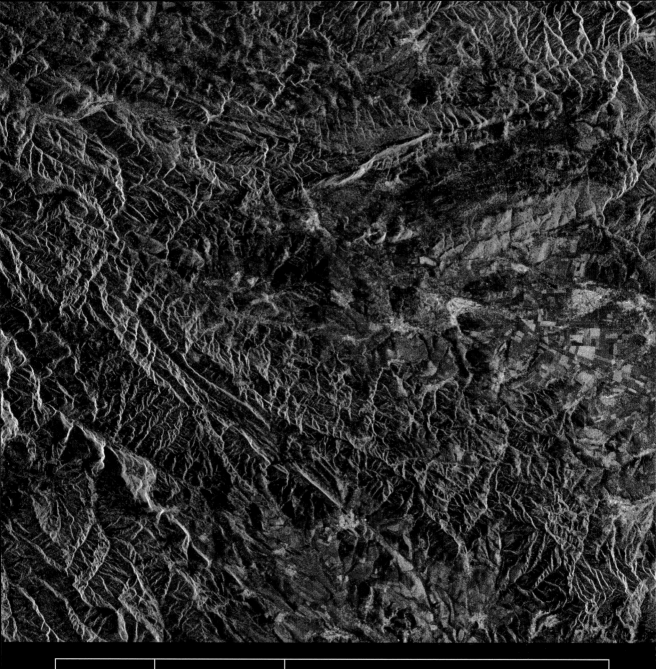

Sofia

City
Bulgaria

Venturing beyond the visible spectrum's familiar rainbow, the pulse and echo of microwave energy uncloaks an altogether more fantastic Earth, a world dominated by its naked geology – lined with saw-toothed mountain peaks and dazzling geometric patterns. Viewed in a more conventional light, this alien vista clears, revealing Sofia, capital of Bulgaria, set amid fields and Balkan hills.

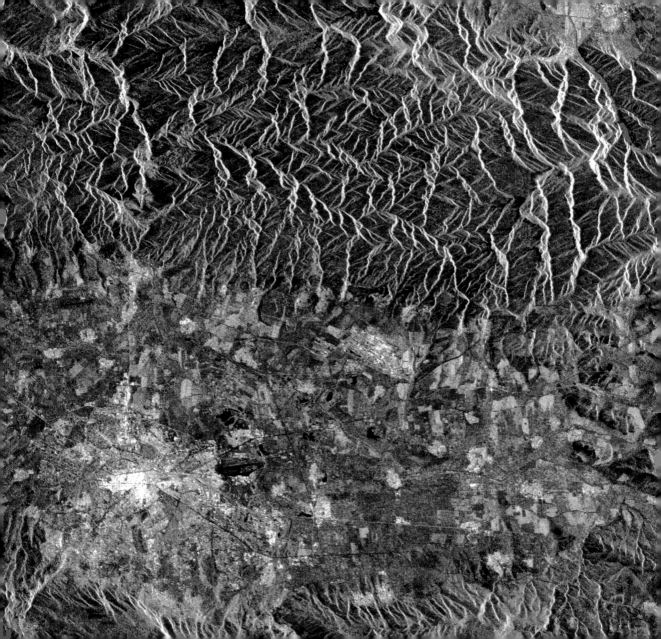

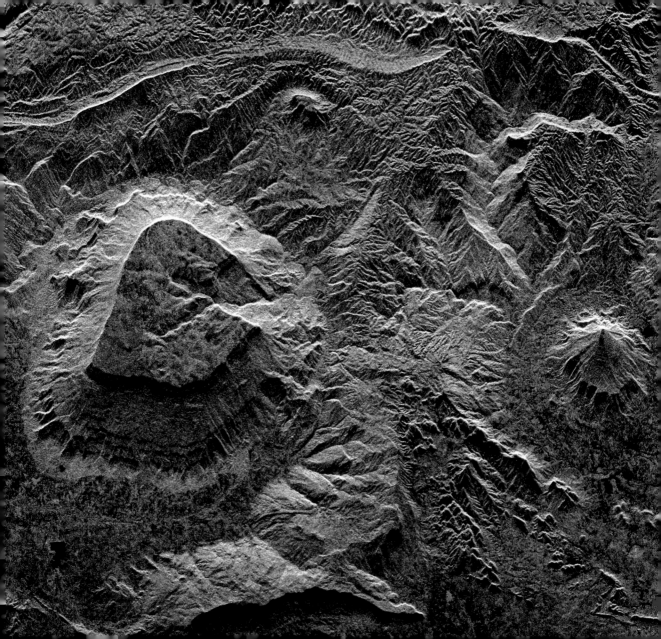

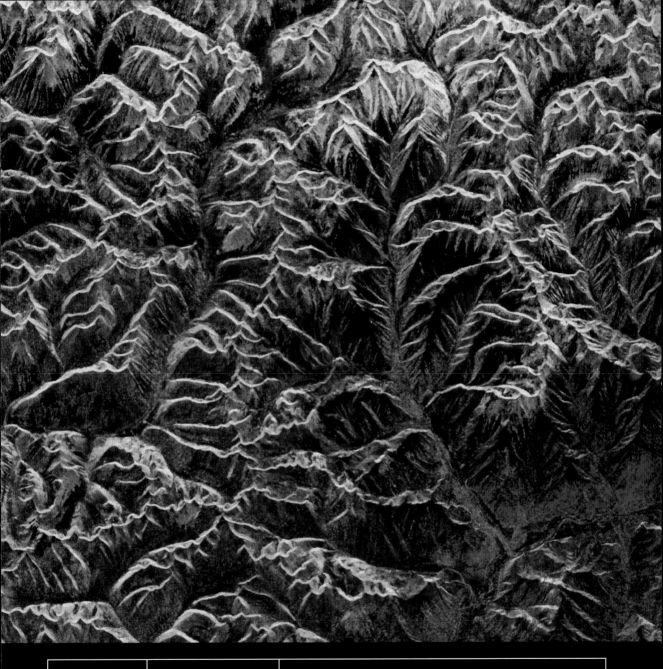

Himalaya

Mountains
Tibet

Tuned to probe the geological anatomy of the southeastern Himalaya, orbital radar reveals worn shreds of bluish sedimentary rock hanging from the orange bones of more resilient granite ridges. These wounds have been inflicted by erosion: since the range first formed, over 12 million cubic kilometres (3 million cubic miles) of rock have been scrubbed from its peaks.

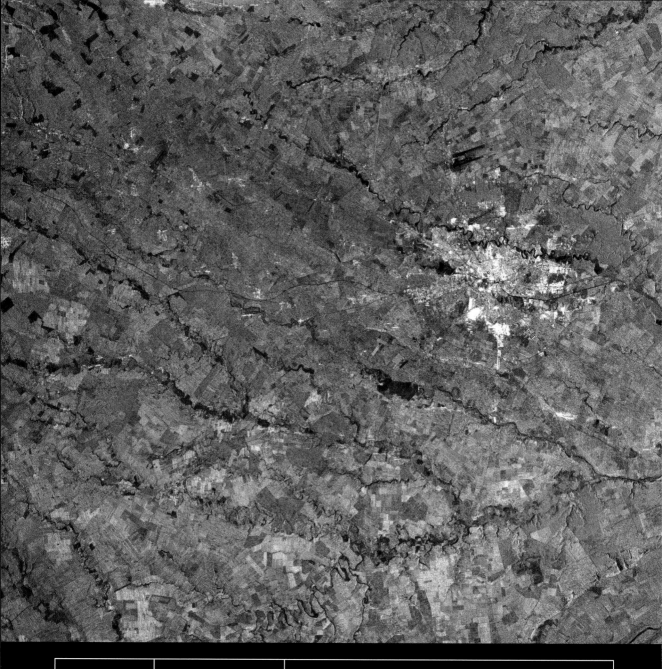

Bucharest

City
Romania

Set amid a pastoral mosaic of fields, Bucharest shines brightly as the hard edges of it streets and buildings act as mirrors, bouncing incoming radar waves straight back at their source. Such microwave portraits of the planet are exquisitely sensitive to environmental change, whether it be tectonic uplift, flooding, drought, urban sprawl or agricultural land use.

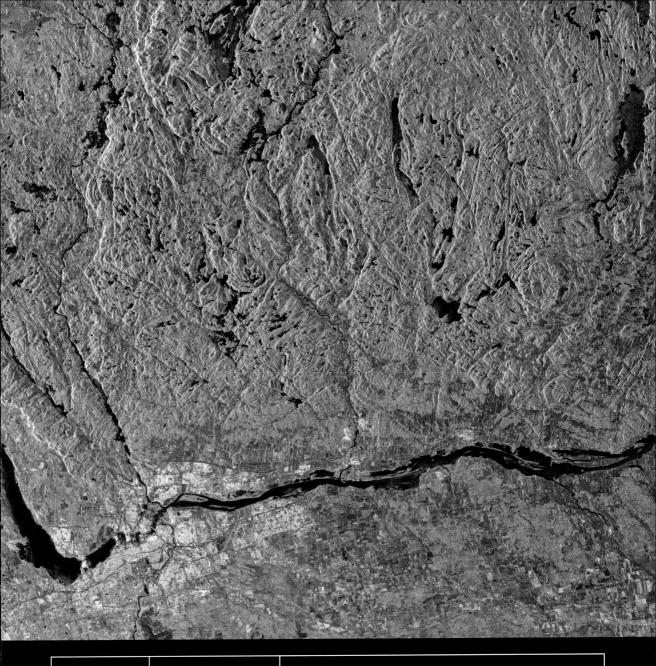

Laurentian Shield

Canada

Radar waves gild the ancient rock of the Laurentian Shield with silver and gold as they scatter off the streets and fields of Ottawa and Ontario. The Shield's low hills were once locked deep underground, the roots of a Precambrian Himalaya. Flensed by countless aeons of water, wind and ice, they have risen up as the massif above them eroded, bearing more gold and silver than meets the eye.

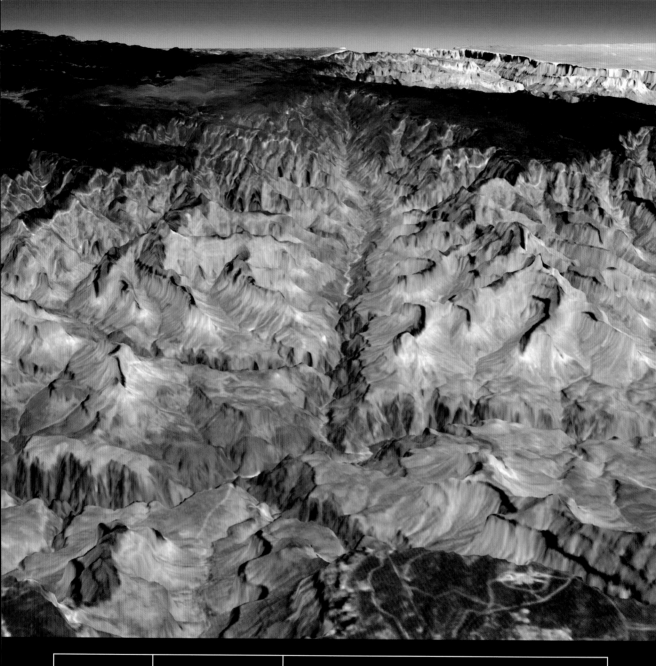

Grand Canyon

Arizona, USA

Skeletal radar soundings were fleshed out with visible and near infra-red data to reconstruct this virtual panorama. The Grand Canyon has inspired artists from Thomas Moran to David Hockney, and although this digital representation may not rival their interpretations, such a marriage of data builds a useful 3-D facsimile of the original that takes the map one step closer to being the territory.

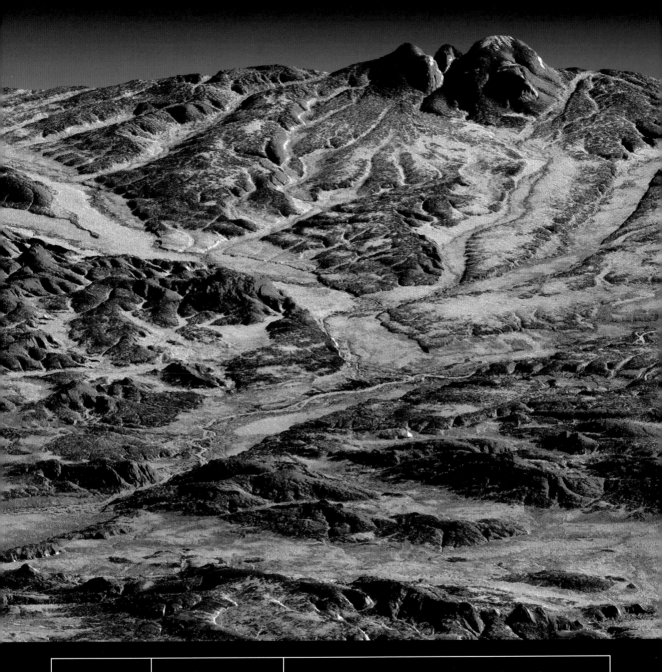

Tigil River

Kamchatka, Russia

Tracking the descent of the Tigil River and its tributaries from Kamchtka's volcanic highlands, this synthetic landscape was built from radar elevation data and painted with a Landsat overlay. Bursting from the northeastern arc of the Pacific 'ring of fire', Kamchatka's flanks are built from lavas brewed by the final plunge of oceanic plate into the depths of the Earth.

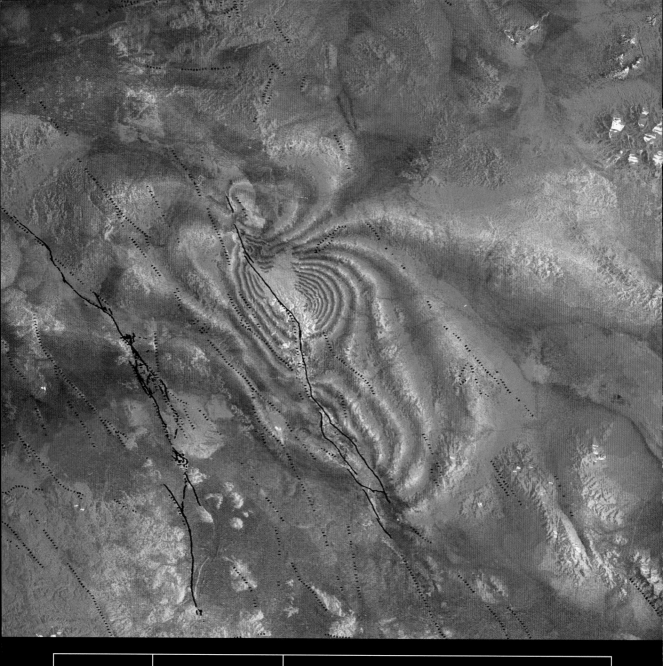

Hector Mine

Earthquake
California, USA

16 October 1999, 2:46:47am: an earthquake ruptures a 41-kilometre seam along the Mojave Desert, delivering in ten tremulous seconds the energy equivalent to a 50-megaton nuclear blast. Its aftermath was mapped by superimposing two radar scans – one pre-strike, the other post – and measuring the difference: each band of colour records 10 centimetres (4 inches) of displacement.

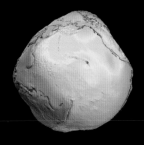
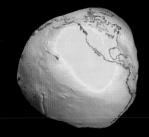
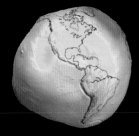
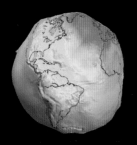
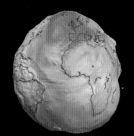
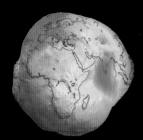

Gravity Map

These crumpled spheres chart the fluctuations of Earth's gravitational field: the lower the elevation, the weaker the pull of gravity. Most of the anomalies can be traced to the seasonal ebb and flow of water around the globe; some mirror surface geography (look for mountain ranges and the Mid-Atlantic Ridge); others are more mysterious, hinting at deep tectonic structures.

II

water

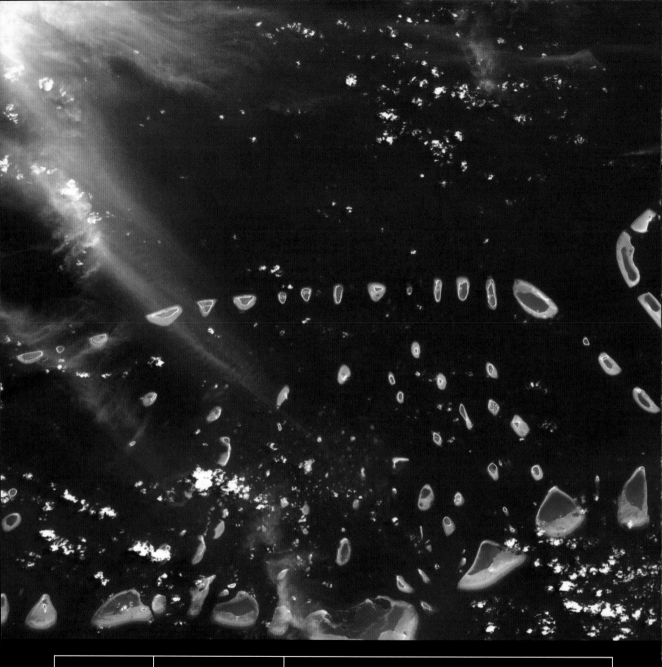

Malosmadulu
Atolls

Maldives, Indian Ocean

We live on a waterworld. Strip the 'Earth' of topography, and an uninterrupted ocean would submerge the planet under 2,500 metres (8,200 feet) of water. With nothing to perch upon, even coral atolls like these wouldn't break the surface of such a sea. And there's more: up to 2,900 kilometres (1,800 miles) beneath the ocean floor, five times as much water saturates the planet's mantle.

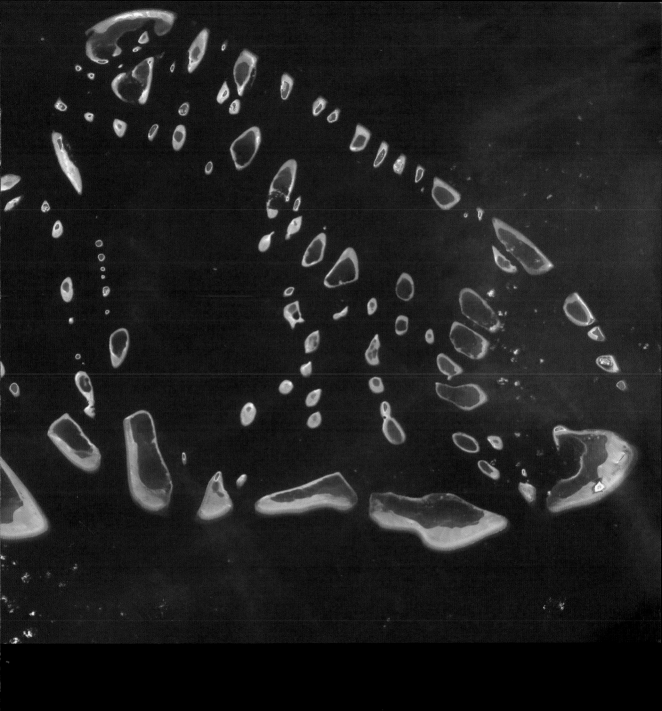

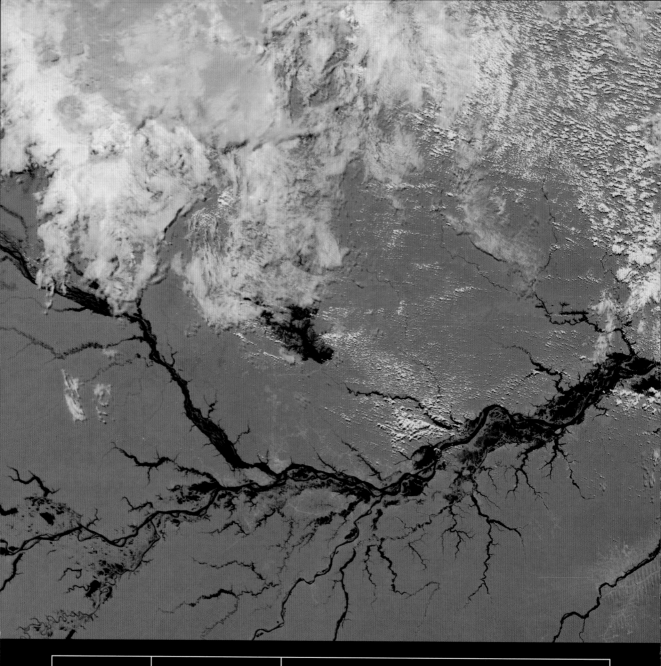

Amazon

River
Brazil

This enhanced image tracks the lower third of the Amazon's 6,430-kilometre (3,990-mile) course. At its 300-kilometre (200-mile) wide mouth, the river discharges one-fifth of the total volume of fresh water entering our planet's oceans. Suspended in this vast efflux, a bloom of sediment reminds us that the ultimate fate of the Andes is to lie as mud on the bottom of the Atlantic.

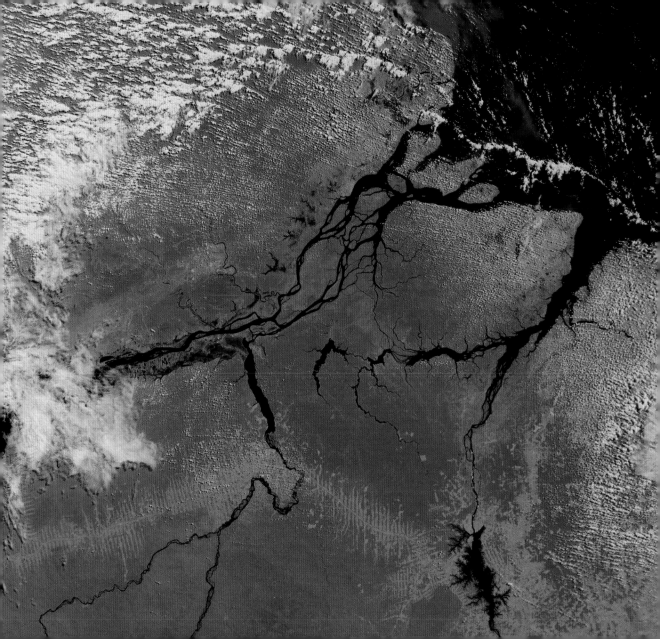

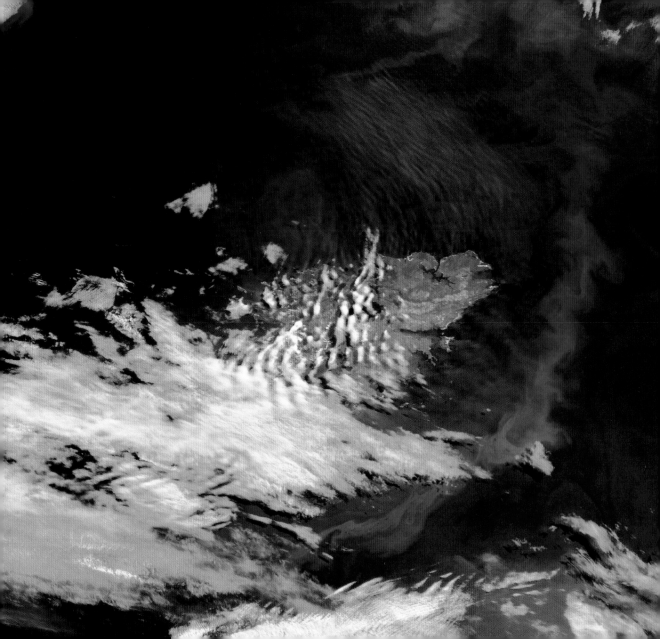

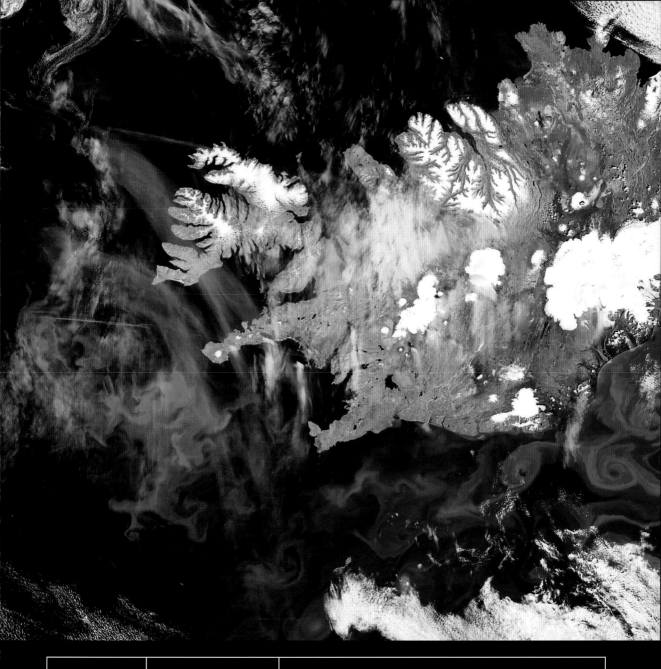

Phytoplankton Bloom

Iceland, North Atlantic Ocean

As the Gulf Stream flows past Iceland it cools and plunges to the ocean floor, igniting whirling blooms of phytoplankton as it displaces nutrient-rich water from the deeps. Hugging the abyssal plain, the stream then turns south, embarking on a thousand-year circumnavigation of the planet. It finally resurfaces in the northeast Pacific and returns to the South Atlantic as a warm surface current.

Florida
Everglades

Wetlands, Florida, USA

In the wet season Lake Okeechobee overflows, creating the Everglades, an annual shallow, slow-moving flood up to 100 kilometres (60 miles) wide and over 160 kilometres (100 miles) long. Caught between better-drained uplands and the deep blue sea, such wetlands form unique transitional zones between the two, supporting diverse ecosystems of specially adapted plants and animals.

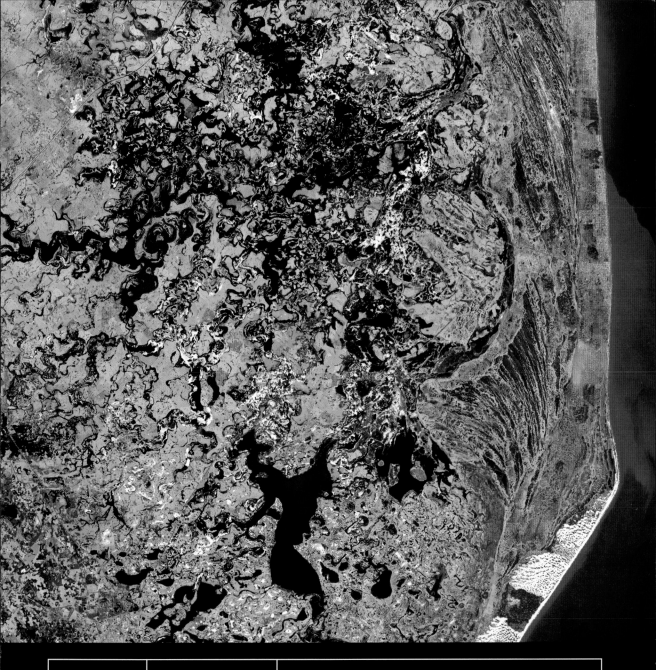

Bahía de Samborombón

Wetlands, Argentina

300 kilometres (200 miles) southeast of Buenos Aires, Cabo San Antonio juts out into the Atlantic Ocean along the Argentinean coast. Behind its beaches, a mosaic of creeks, saltmarshes, sand dunes, lagoons, streams and grassland provide one of the last remnants of the wet pampas vegetation that once grew throughout central-eastern Argentina.

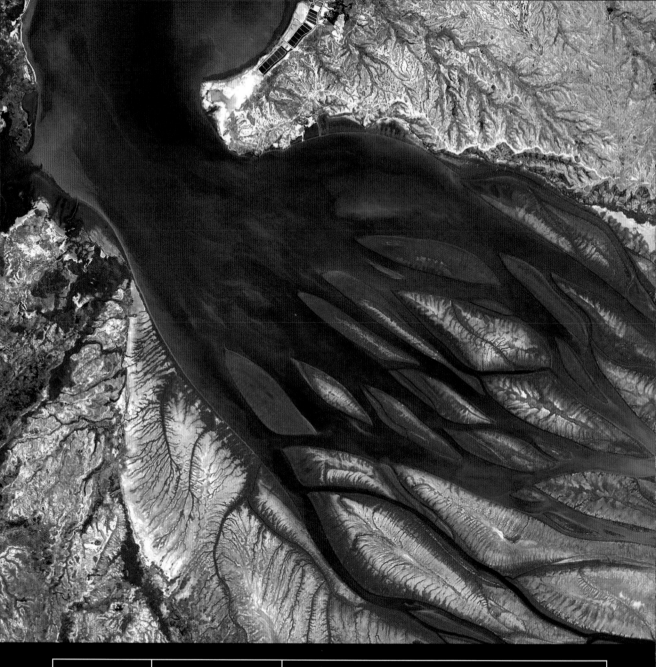

Betsiboka

River delta
Madagascar

Rivers are the most errosive agents on Earth, washing some 20 billion tons of land into the oceans every year. Given enough time, they can level mountains and flatten continents. Deforestation and monsoon rains sharpen the Betsiboka's teeth as it gnaws at Madagascar, and where the island's soil bleeds into the sea new spits and shoals briefly wax and wane.

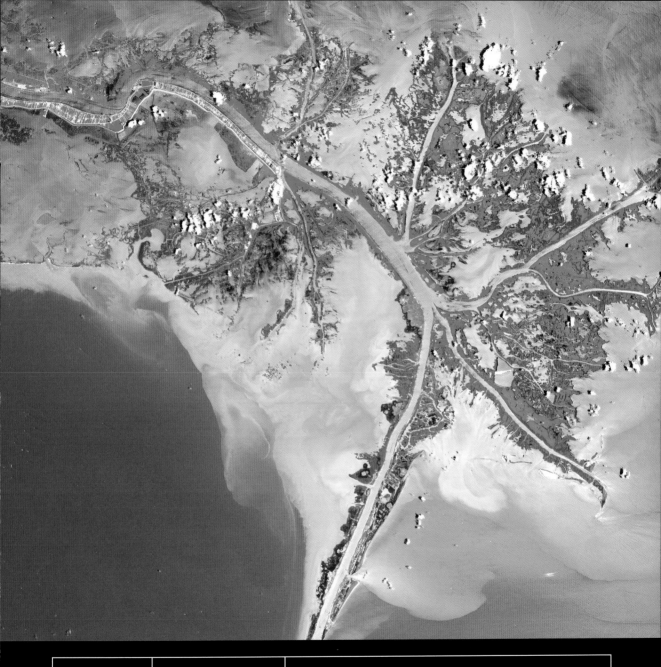

Mississippi

River delta
Louisiana, USA

The Mississippi leaves its source, Lake Itasca in Minnesota, as a crystal-clear stream. 3,780 kilometres (2,350 miles) later, its waters arrive at the Gulf of Mexico, carrying half a million tons of sediment every day. Here, the river's turbid waters deposit their cargo, slowly extending North America ever southwards with a web of marshes and mudflats, intercut only by shipping channels.

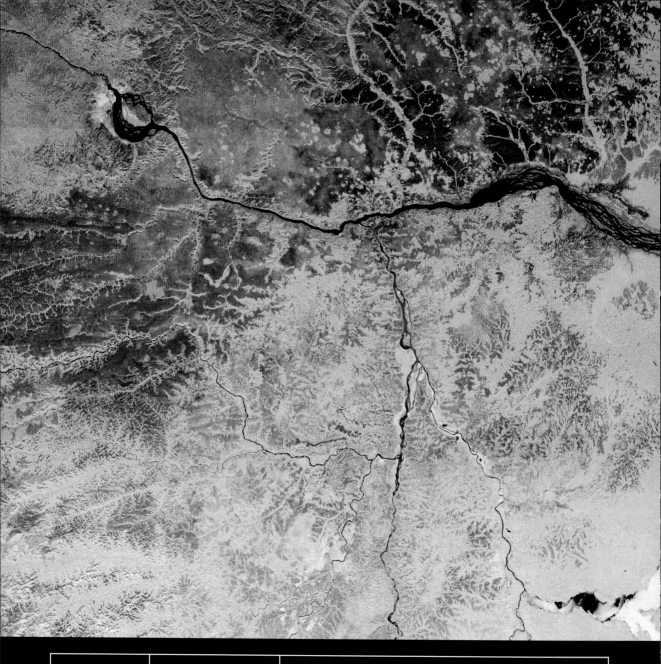

Congo

River
Democratic Rep. of Congo

Second only to the Amazon in the volume of water it carries, the Congo cuts a dark swathe through the verdant heart of Africa. Flowing 4,670 kilometres (2,900 miles) from the highlands of the Great African Rift, the river is surrounded by a quarter of the planet's rainforests and nurtures an exotic reservoir of life, including the dinosaur hunter's best bet, the legendary Mokele-Mbembe.

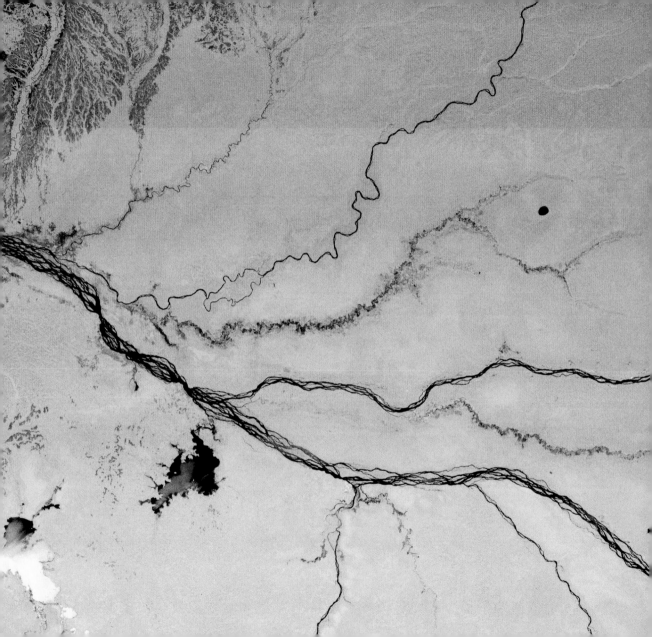

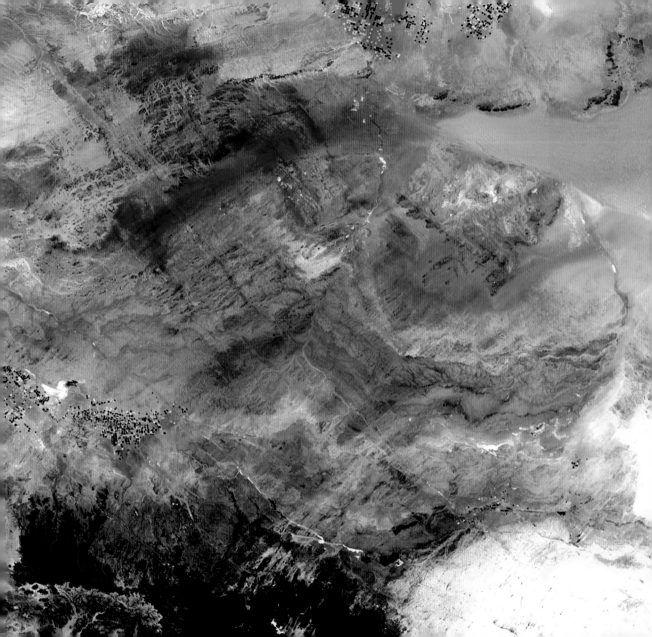

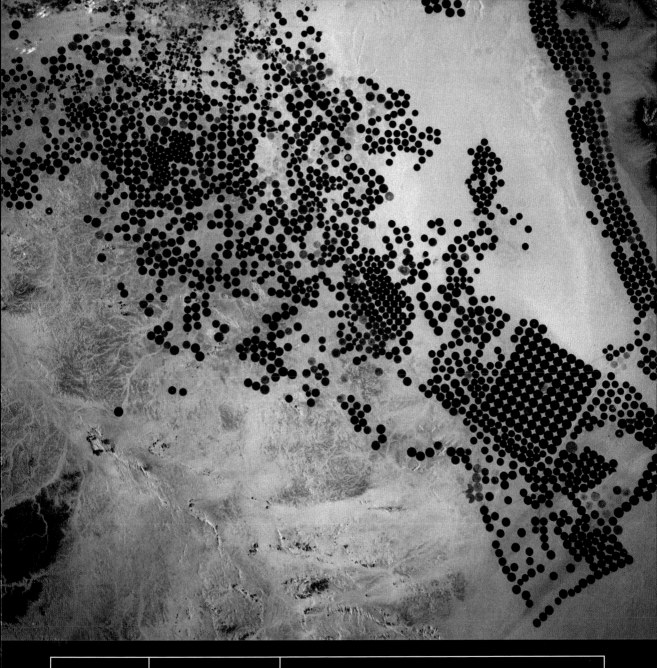

Jabal
Tuwayq

Saudi Arabia

A geometric flourish of oases blossom on the Jabal Tuwayq escarpment as it rises from the arid Najd Plateau. Each bloom provides 200 acres of farmland, irrigated by water pumped from up to 1,200 metres (4,000 feet) underground. Since the 1980s these central-pivot crop circles have marched across Arabia, infiltrating deep groundwaters to triple the area under cultivation.

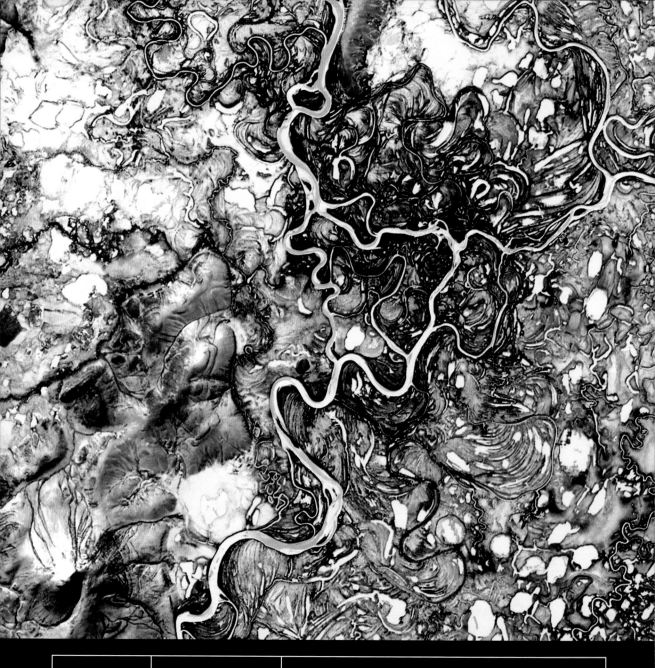

Siberian Permafrost

Russia

The far northeast of Siberia sleeps beneath a near-endless winter, frost penetrating its soils for hundreds of metres. Summer's return will fleetingly wake the land, a superficial thaw allowing its rivers to flow again. Over millennia this rhythmic thaw and frost has carved a shattered landscape etched with splintered rivers and pockmarked with small lakes and pools.

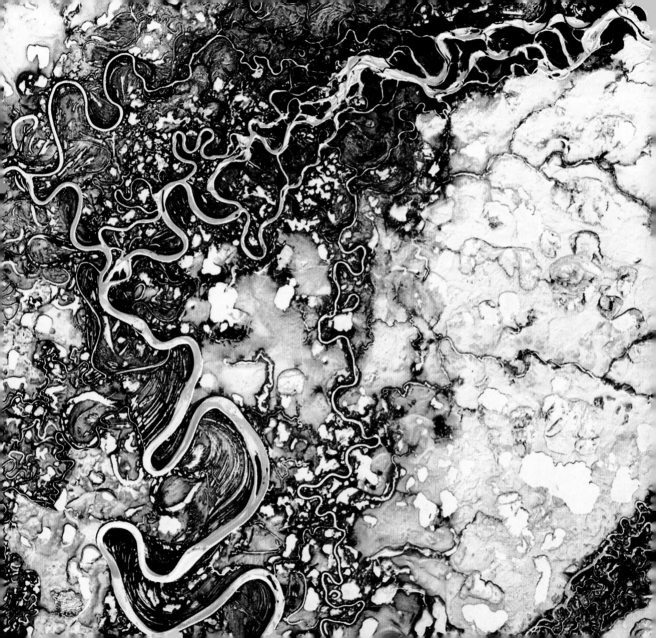

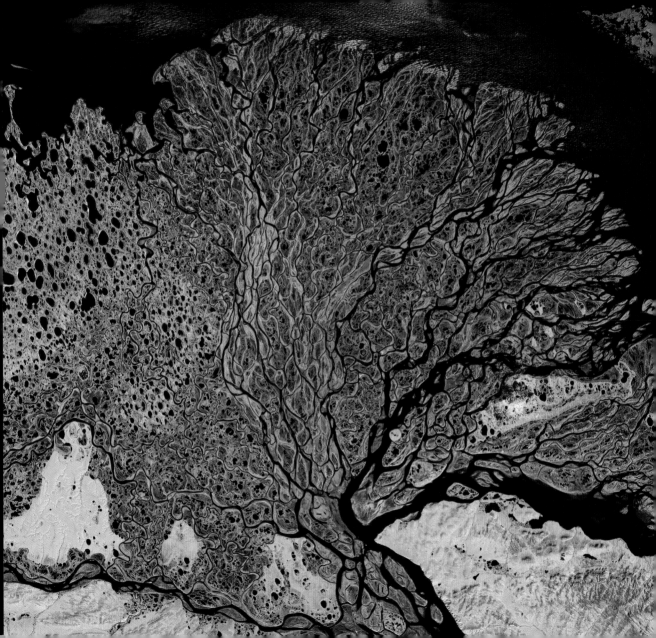

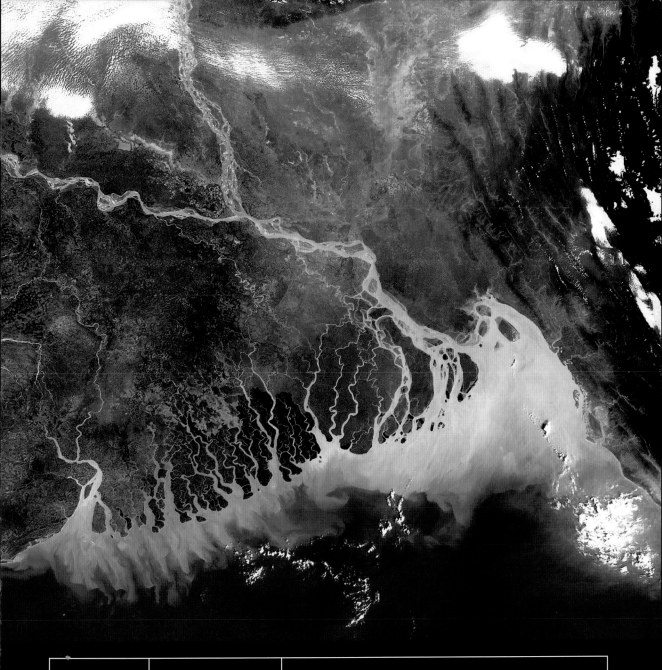

Ganges

River delta
Bangladesh / India

From the Ganges' labyrinth of mouths, two billion tons of Himalayan spoil swirl into the Bay of Bengal every year. Flowing over a bed built from 10 kilometres (6 miles) of accumlated sediment, the sacred river's milky waters feed the Sundabans – a knot of wild mangrove forest dark against the paler green of cultivated fields – and nurse one in twelve of the planet's human population.

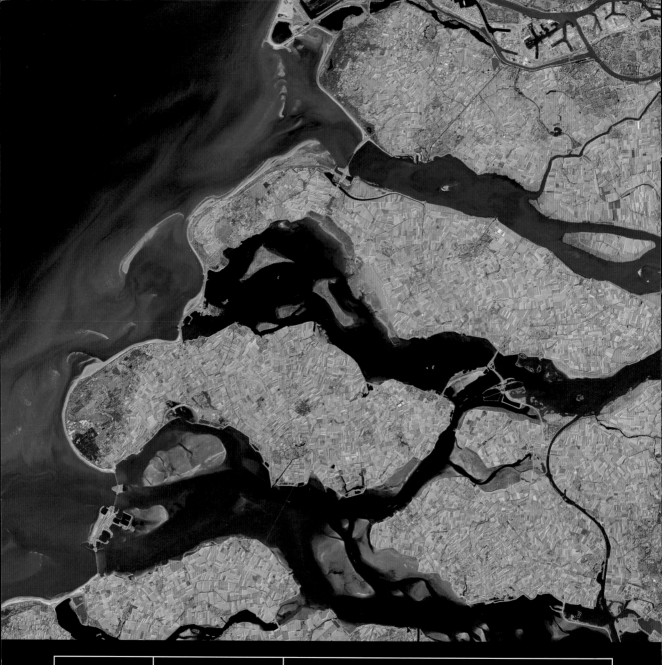

Zeeland

River delta
Netherlands

On the southwest coast of the Netherlands, the Rhine, Meuse and Schelde deltas converge, their silt-laden waters a blessing to the Zeeland archipelago's farmers. The distinctive fingers of this fertile but fickle boundary between land and sea were born of a single storm in 1134 and almost destroyed by another in 1953. For now, they stand firm, stoutly fortified by dikes, dams and locks.

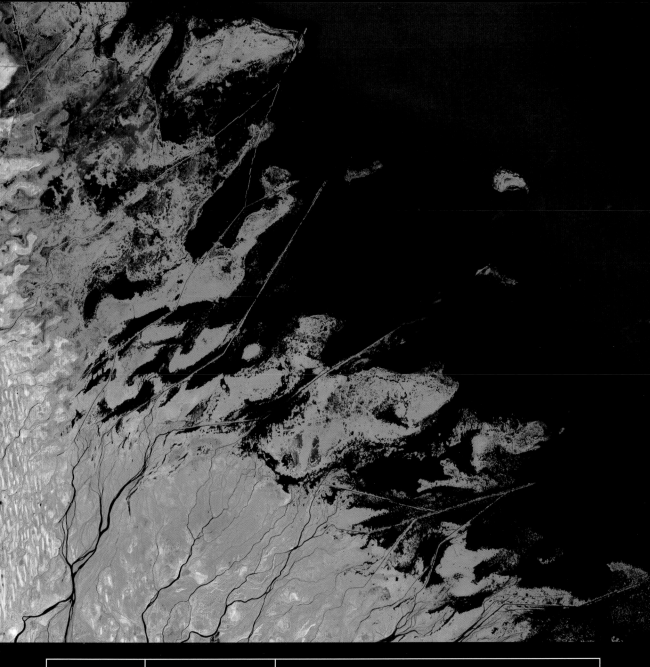

Volga

River delta
Russia

Russia's 'Mother Volga' dissolves into a swarm of over 500 streams before she flows into the Caspian Sea's brackish waters. The green lines leading into this maze mark navigable waterways dredged by the river's lauded boatmen. Unlike its vanishing neighbour, the Aral Sea, the Caspian has risen 2.5 metres (8 feet) over the last 30 years, pushing the Volga delta 100 kilometres (60 miles) inland.

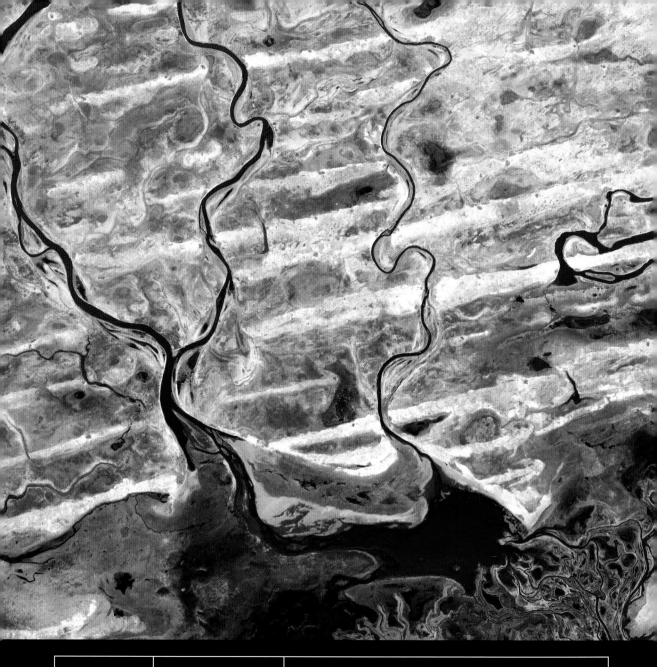

Niger

Inland river delta
Mali

Rising from the Guinea Highlands, the Niger is only 240 kilometres (150 miles) east of the Atlantic. Yet it flows inland, probing the Sahara before it reverses its course and finally reaches the ocean some 4,180 kilometres (2,613 miles) later. In the desert it empties on to the dry bed of an ancient landlocked sea, weaving an extensive inland delta of braided waterways, lagoons and marshes.

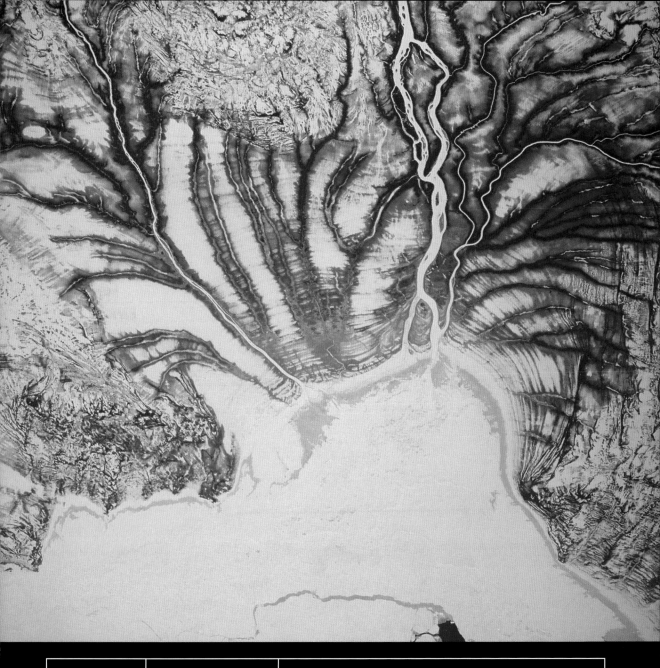

Hannah Bay

Hudson Bay, Canada

Nearly 3 kilometres (2 miles) of ice buried Hudson Bay at the height of the last ice age, weighing heavily on the underlying contintental crust. As the glaciers retreated the crust slowly rebounded, creating the concentric fossil shorelines accentuated by winter snows here. At about a centimetre a year, the uplift is ongoing, and will continue for another 10,000 years.

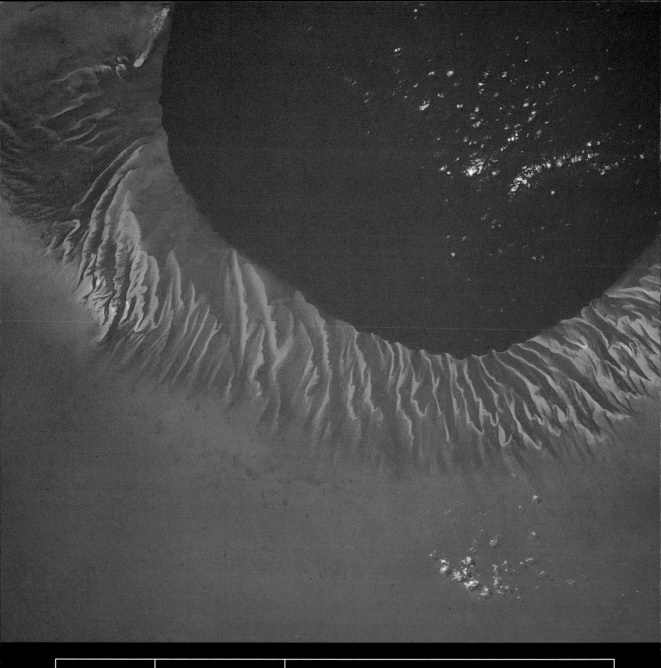

Tongue of the Ocean

Submarine canyon
Bahamas

The Tongue of the Ocean cuts a dark path through the Bahamas' turquoise waters, as shallow seas plummet into the abyss. At the Tongue's tip, a vertical cliff-face plunges over a mile (1.7 kilometres) into the gullet of the Great Bahama Canyon. From here, the canyon runs for 225 kilometres (140 miles), descending to a depth of over 4 kilometres (2.5 miles).

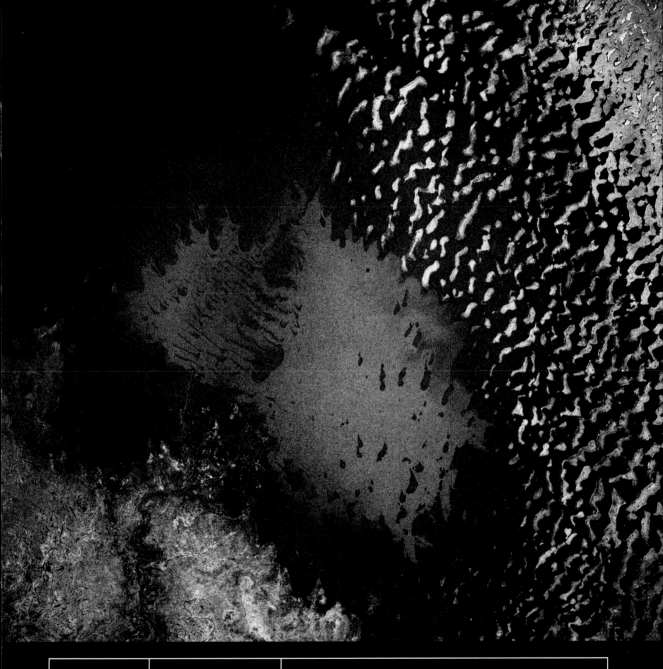

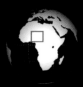

Lake Chad

Chad / Niger /
Nigeria / Cameroon

Shimmering on the southern edge of the Sahara, Lake Chad is the dwindling ghost of an inland sea. As recently as 6,000 years ago its shores spanned over 1,000 kilometres (620 miles); now mere tens of kilometres separate them. As the lake heads towards extinction, drifting sand dunes encroach its margins, wading through shallow waters and smothering wetlands beneath them.

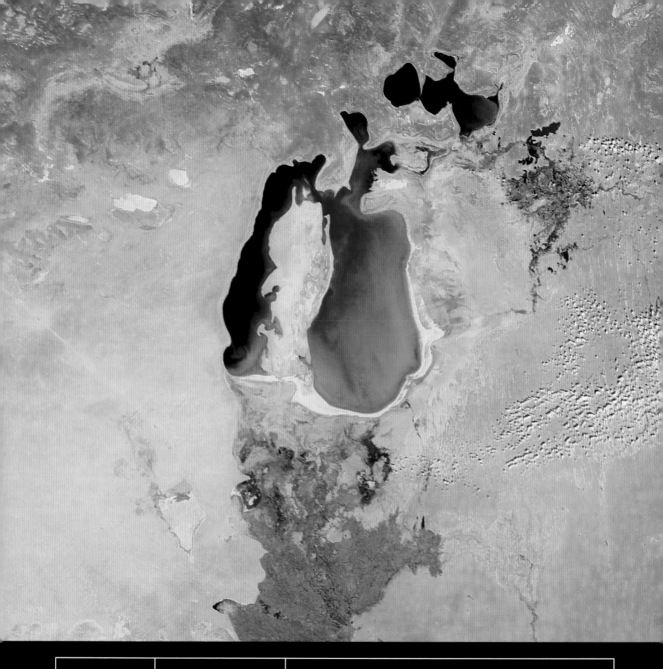

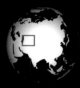

Aral Sea

Kazakhstan / Uzbekistan

What was once an oasis amid central Asia's arid steppes, and the world's fourth largest inland body of water, is now mostly salt desert scoured by winds laden with toxic dust. Sacrificed to irrigate vast fields of cotton, more than 60 percent of the Aral Sea has disappeared over the last four decades, stranding skeletal fleets of fishing boats up to 60 kilometres (40 miles) from an ever-receding coast.

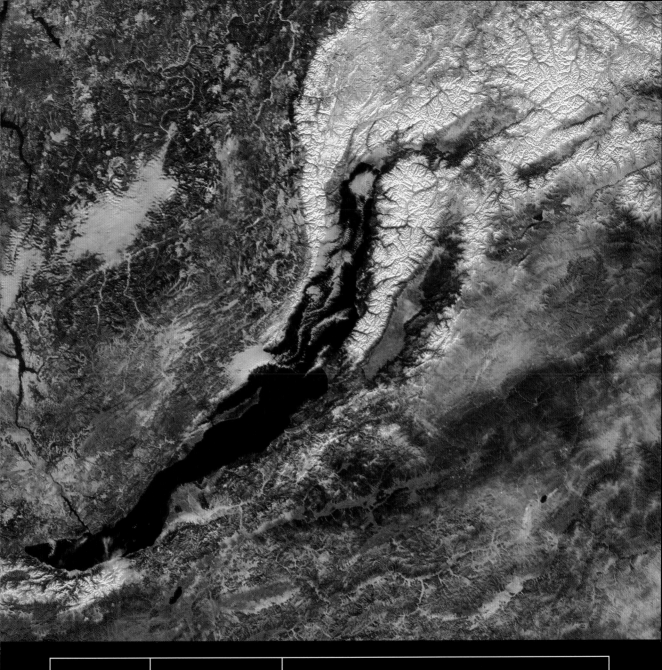

Lake Baikal

Siberia, Russia

Beneath Lake Baikal's autumnal ice cover, beneath 1,732 metres (5,716 feet) of water, beneath 7 kilometres (4.5 miles) of sediment, lies one of Earth's deepest continental rifts. Driven by upwellings of magma, this schism in the planet's crust is widening by 2.5 centimetres every year; Lake Baikal is transforming itself – literally inch by inch – into an ocean.

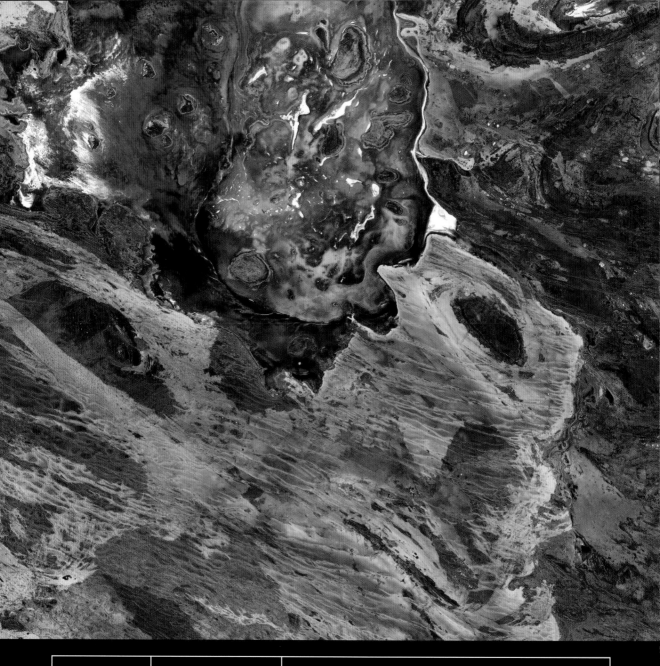

Lake
Disappointment

Western Australia

Surrounded by the dunes of the Great Sandy Desert, Lake Disappointment is one of Australia's many salt lakes. An explorer supposedly named it in 1897 after following a network of creeks he believed would lead to a large lake; they did, but the lake's extremely saline water was undrinkable. Salt lakes form when the rate of water evaporation exceeds the rate of its precipitation.

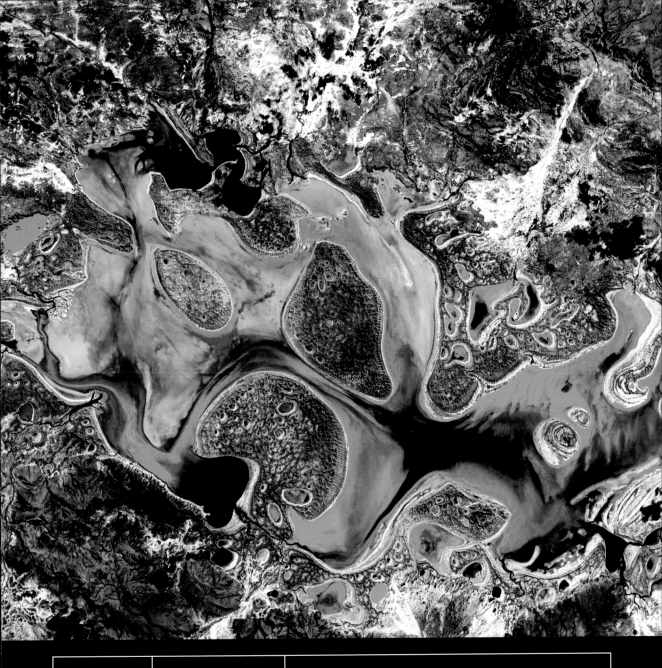

*Lake
Carnegie*

Western Australia

Red blooms of salt-tolerant vegetation take advantage of the uncharacteristic apperance of water in the ephemeral Lake Carnegie. Australia's interior is so flat that many of its rivers drain into inland lakes, rather than the ocean. With barely enough rainfall to keep the rivers flowing, many of these lakes are evanescent, only holding water after exceptionally heavy rains.

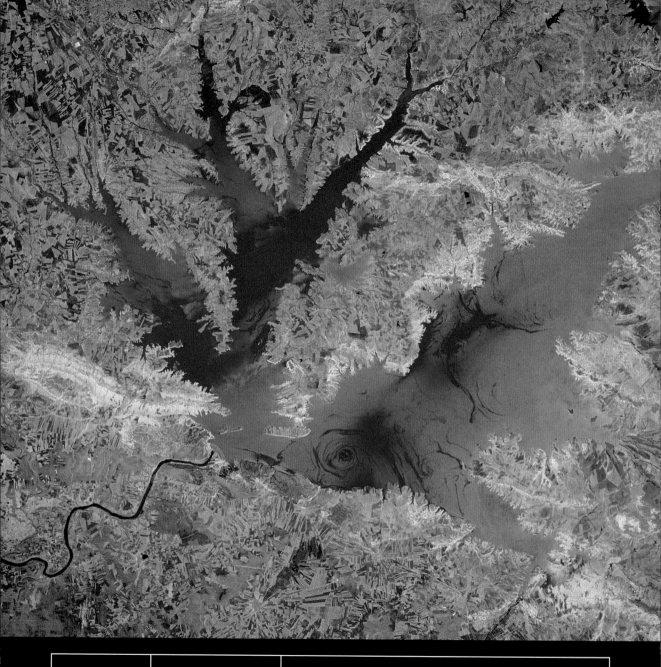

*Atatürk
Reservoir*

Turkey

Six thousand years ago, the waters of the Euphrates nurtured some of
the first flowerings of civilization on the fertile plains of Mesopotamia.
Now, the river's liquid assets are hoarded further upstream, behind
the Atatürk dam, flooding an area 816 kilometres (315 miles) square
and greatly restricting its downstream flow. The river can even be
periodically 'turned off' to refill the reservoir.

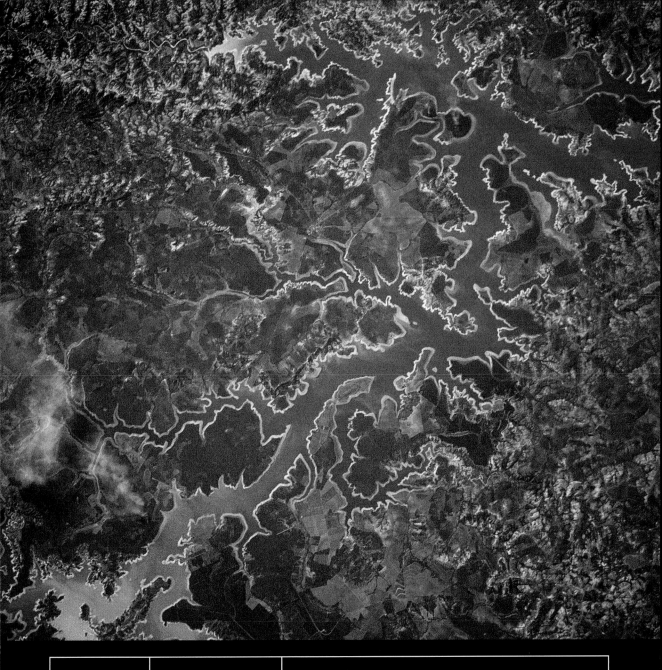

Três Marias
Reservoir

Brazil

Gilded by its drought-exposed shores, the Três Marias Reservoir traces a fractal outline across 100 kilometres (62 miles) of the Brazilian Highlands. A horde of tributary streams drain into the reservoir from the surrounding hills, while the larger São Francisco river (bottom left channel) paints a golden sheen of sediment across its otherwise turquoise waters.

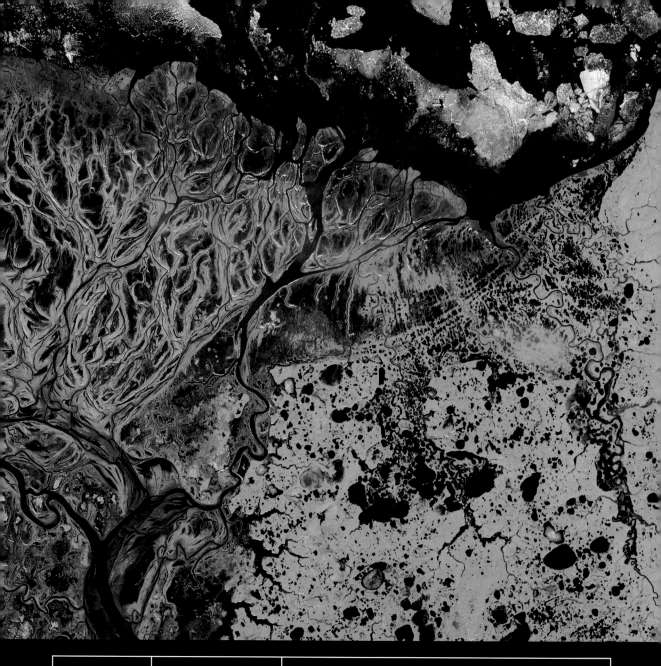

Yukon

River delta
Alaska, USA

The confluence of the Yukon and Kuskokwim rivers has created one of the largest river deltas in the world. Its frigid waters pour over the sunken plains of Berengia, the sediment it carries masking the footsteps of America's first settlers who took advantage of lower sea levels 13,000 years ago to make the crossing from Siberia to the New World.

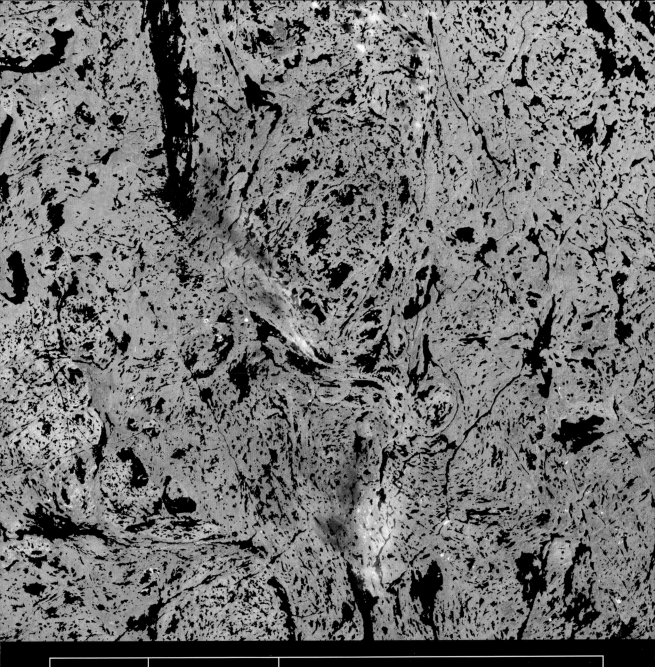

Yellowknife
Wetlands

Northwest Territories, Canada

Yellowknife's rocks bear the scars of the last ice age, a legion of lakes and rivers now occupying the wounds scoured by its glaciers. Yet these ancient rocks have weathered much more. Four billion years of erosion have rendered a once mountainous and volcanic landscape toothless, supplanting Precambrian heights with the placid swell of low-lying wetlands.

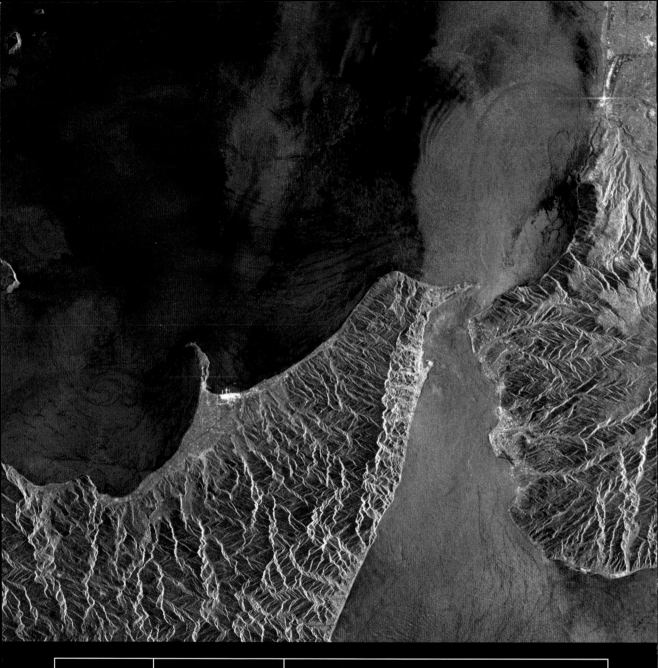

Strait of
Messina

Mediterranean Sea

Radar backscatter unveils the currents and vortices that swirl through the Strait of Messina, keeping an eye on the current location of Charybdis, the sea-swallowing, whirlpool-forming daughter of Poseidon. But even orbital radar can't reveal the whereabouts of the original rock to Charybdis' hard place: the sailor-devouring, twelve-legged, dog-headed, fish-tailed monster Scylla.

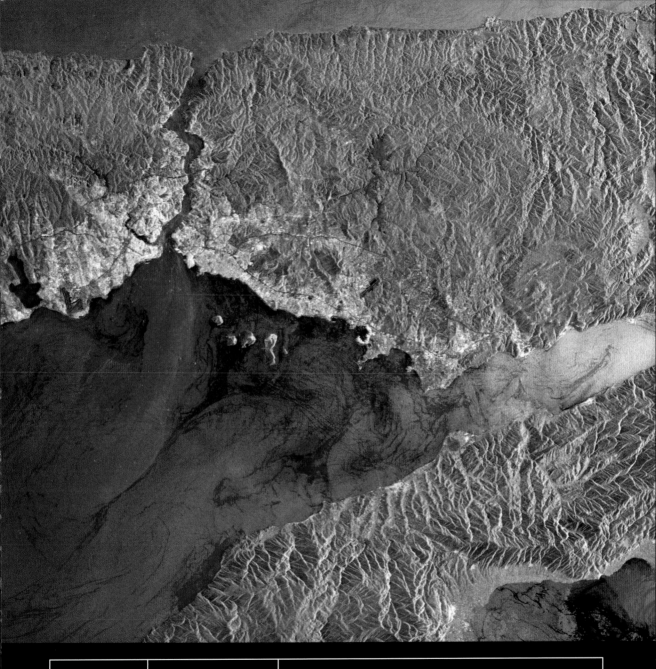

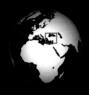

Bosporus Strait

Mediterranean / Black Sea

Around 5,600 BC the rising waters of the Mediterranean burst through the narrow Bosporus gorge, pouring 42 cubic kilometres (10 cubic miles) of water a day into the Black Sea, which was then a freshwater lake. Submerged ruins indicate the lake's shoreline was inhabited and raise the possibility that the memory of this catastrophic deluge survives today, preserved in the story of Noah's flood.

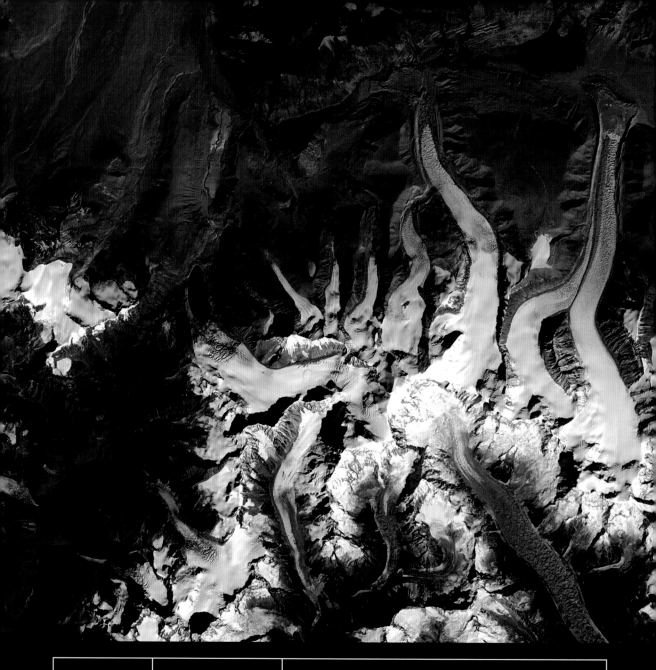

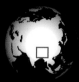

Himalaya

Glaciers
Bhutan

Eighteen thousand years ago, at the height of the last ice age, glaciers embraced one-third of the planet. Today, they are restricted to less than 10 percent of its surface, and their kingdom continues to shrink. Over the last few decades glacial retreat has accelerated: here in the Bhutan Himalaya, meltwater lakes mark their withdrawal to higher altitudes.

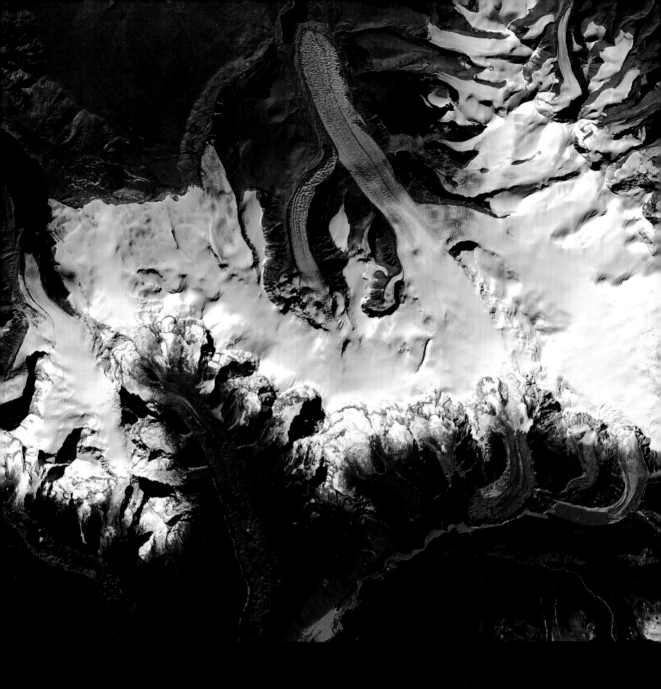

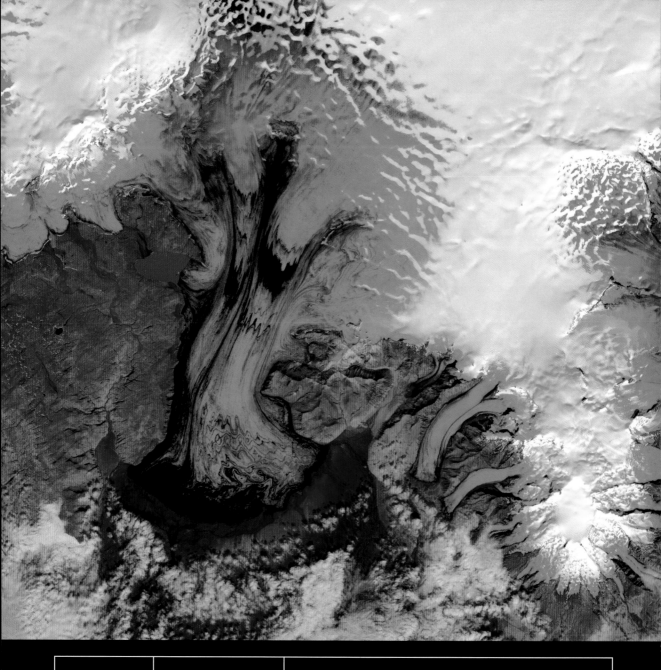

Vatnajökull
Ice Cap

Iceland

To spawn a glacier you need only a single snowflake to survive a summer. If, over subsequent millennia, you can persuade other similarly hardy snowflakes to join it, eventually you will have a glacier – a river of compacted ice heavy enough to flow under its own weight. Given enough raw material glaciers can form Ice-Caps, drowning even mountains, as Vatnajökull here has done.

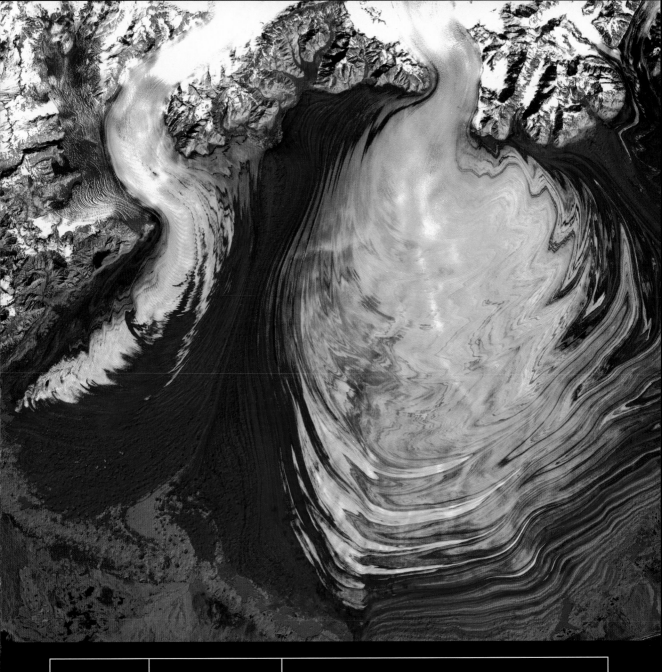

Malaspina Glacier

Alaska, USA

Oozing from its mountain lair, the Malaspina Glacier engulfs nearly 3,000 square kilometres (1,160 square miles) of Alaskan lowlands. This infrared image reveals the viscous anatomy of the beast: surrounded by the red glow of a lifeless cordon of scoured and broken rock, light-blue ice ripples with darker veins of debris ripped from the mountainside.

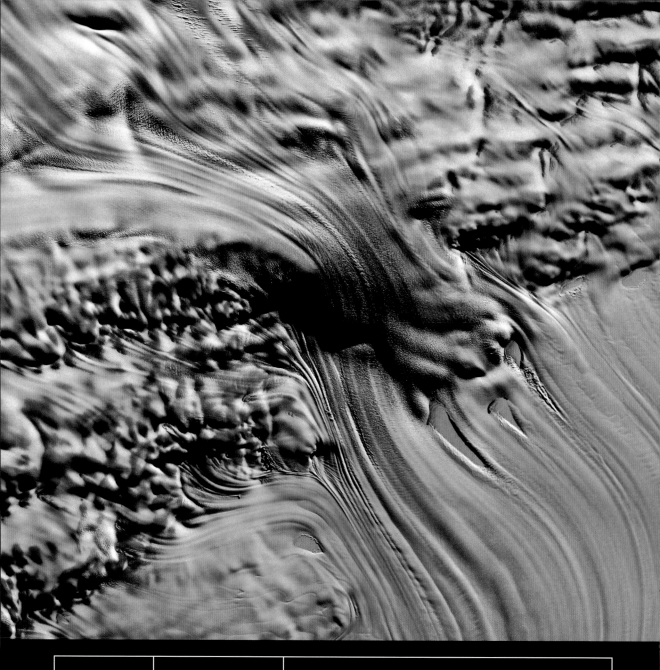

Lambert Glacier

Antarctica

Covering 1,000,000 square kilometres (386,000 square miles), the Lambert Glacier is Earth's largest, delivering 33 billion tons of ice from the East Antarctic Ice Sheet to the Southern Ocean every year. Up to 4.5 kilometres (2.8 miles) of ice containing over 70 percent of the planet's fresh water engulfs Antarctica, weighing so much it depresses the Earth's crust by 900 metres (3,000 feet).

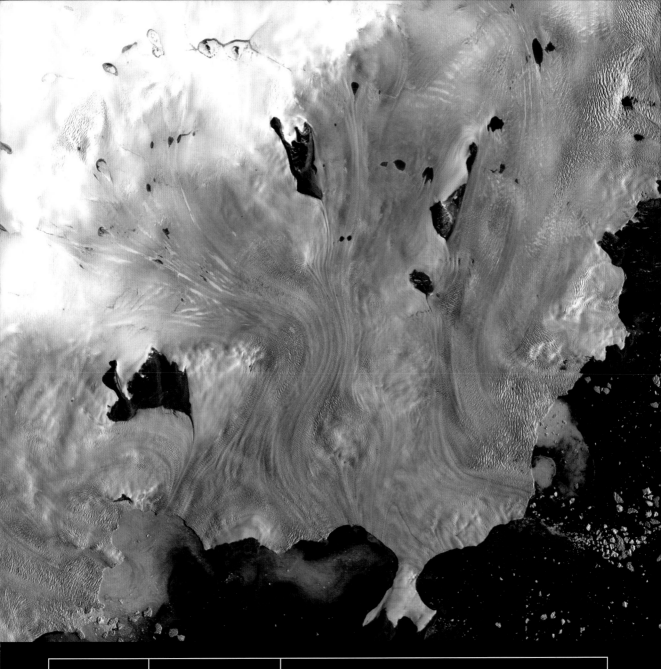

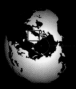

Greenland Ice Sheet

Despite its name, Greenland is smothered by up to 3 kilometres (2 miles) of ice. Corralled by coastal mountains, this 2,000-trillion-ton ice sheet is almost entirely confined to the island's interior. Where the ice breaches this rocky dam it surges into the sea, producing tens of millions of tons of icebergs every day, such as these glaciers discharging into Baffin Bay.

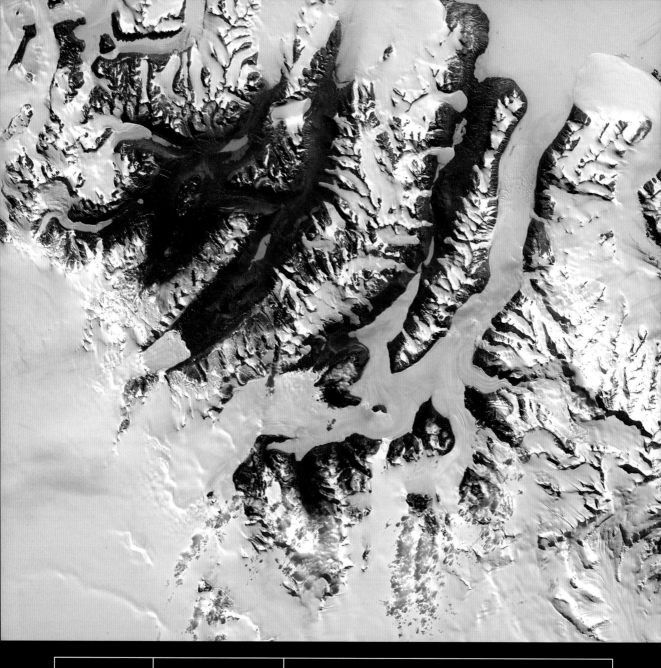

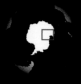

McMurdo Dry Valleys

Antarctica

The bare rock of the Dry Valleys offers a brief oasis amid the thousands of metres of ice that otherwise suffocate Antarctica. The valleys are not entirely dry, however. They host ice-capped lakes, a lake so salty it does not ripple in the wind, and the Antarctic's own Amazon, the Onyx River. Flowing every summer for a mighty 19 kilometres (12 miles), the Onyx is the continent's greatest watercourse.

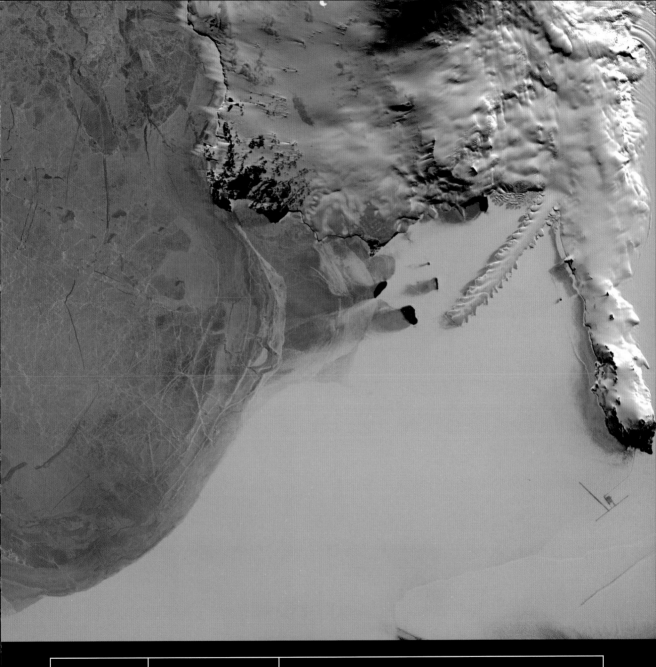

Erebus
Ice Tongue

Antarctica

From its fiery summit the glacier-clad Mount Erebus has plunged a saw-toothed ice tongue into the chill waters of the Southern Ocean. Protruding 12 kilometres (8 miles) into the McMurdo Sound the tongue is growing 160 metres (528 feet) every year. Even when the sea ice thaws in the summer, the ice tongue remains, floating on the water.

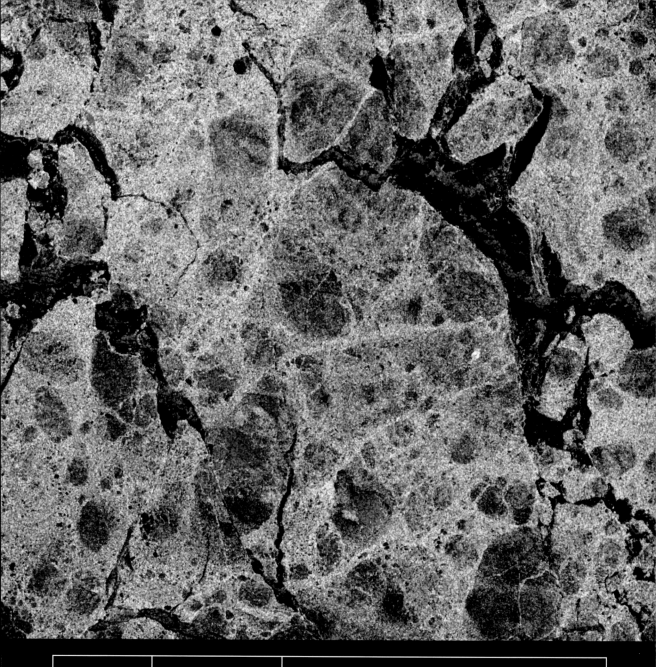

Weddell Sea

Pack ice
Antarctic Ocean

The treacherous Weddell Sea is almost entirely icebound. When illuminated by radar, its otherwise featureless surface reveals a chaotic maze of new and old ice floes, ranging from centimetres (blue and grey) to metres (red) thick. In 1915 the Weddell Sea's icy grip famously ensnared Shackleton's *Endurance*, ultimately crushing the vessel after a ten-month imprisonment.

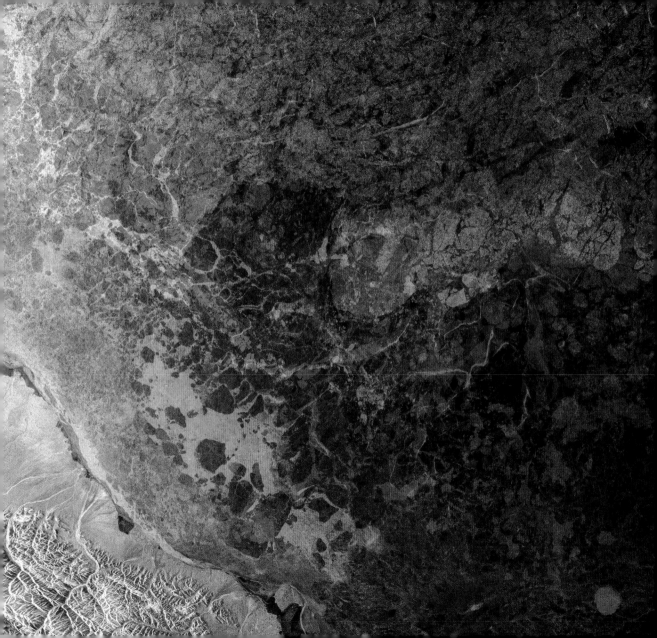

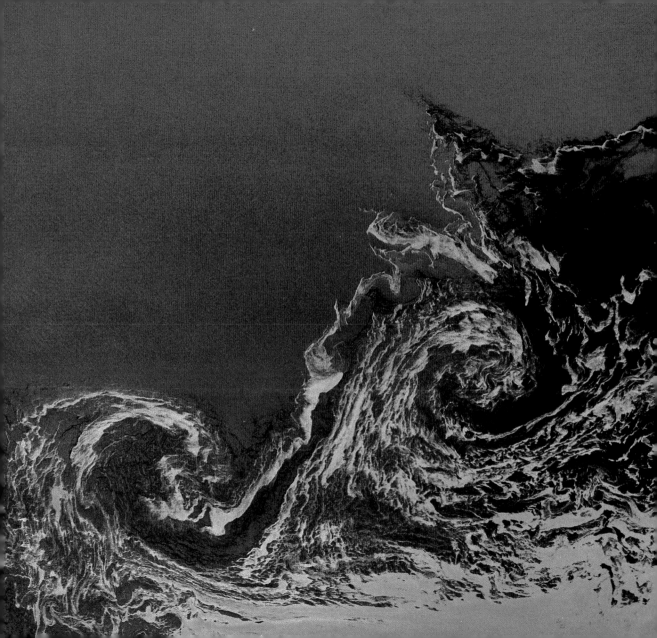

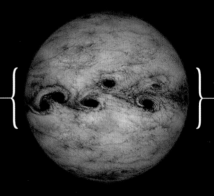

air

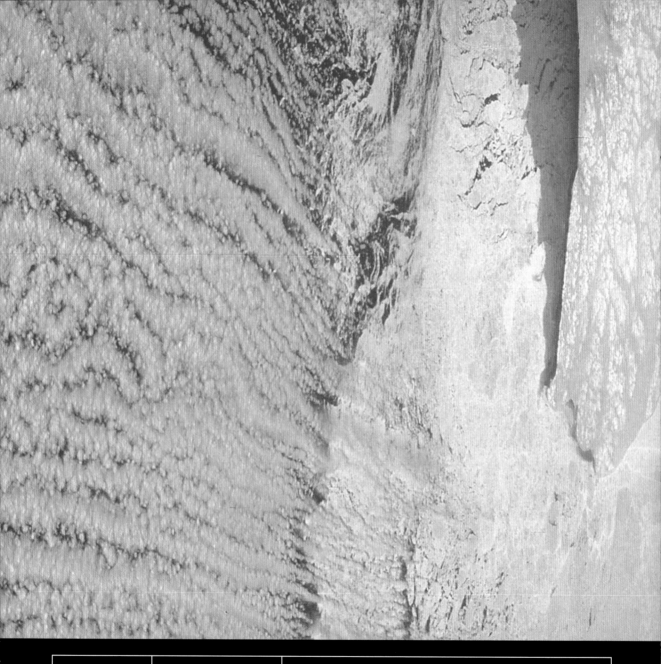

Cloud Streets

Bering Sea

A 190-kilometre (118-mile) carapace of nitrogen, oxygen, argon and water vapour shields Earth from the rigours of open space. Without an insulating atmosphere, the planet would be a frozen iceball with an average temperature of -50 °C (-58 °F), sterilized by a constant bombardment of radiation. Earth's gaseous shell also lends the planet its distinctive hue by scattering blue light.

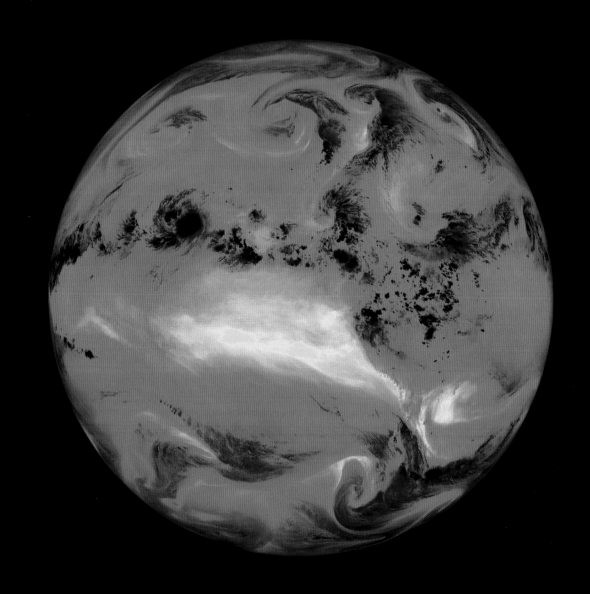

Water Vapour

Pacific Ocean

Earth's atmosphere literally boils with energy. Even the wispiest cobweb or the laciest filigree of cloud masks a seething cascade of convection currents as sun-warmed pockets of water vapour rise, cool, condense and fall. On a global scale, infrared vision reveals these same fluxes girdling the planet, distributing heat from equator to pole, stirring jet stream winds and driving ocean currents.

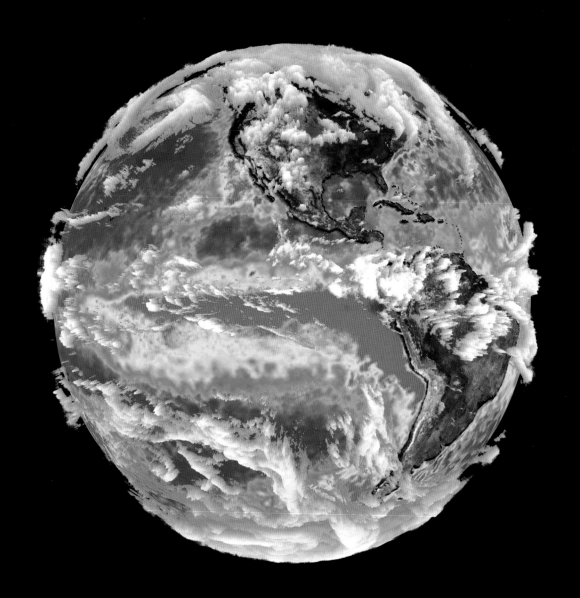

El Niño

Pacific Ocean

Every two to seven years El Niño blooms, a watery explosion of 10 million megatons of pent-up heat rolling across the Pacific. The oceans of air above us are intimately connected to the oceans of water surrounding us, and such a prodigious energy release stirs the entire atmosphere, accelerating it to the extent that it temporarily slows the whole planet's rotation by up to one millisecond a day.

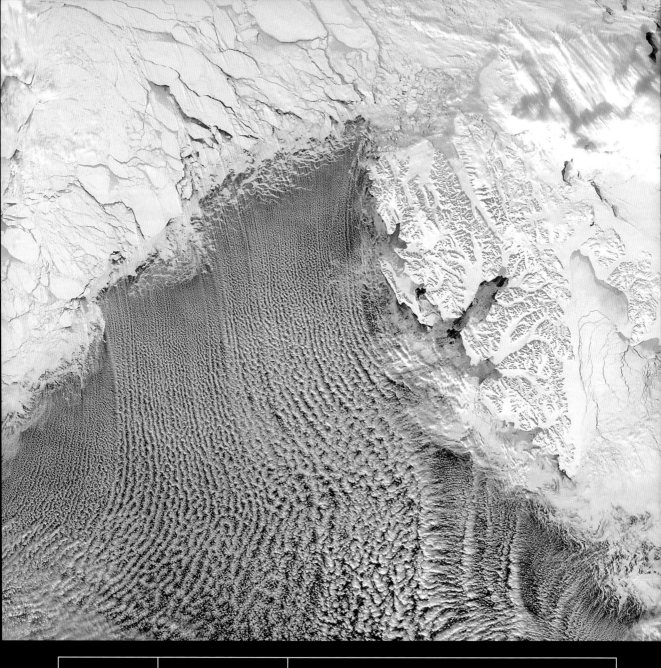

Cloud Streets

Baffin Bay

A cold, katabatic wind spills from the icy snouts of Greenland's glaciers, mustering regiments of cumulus clouds from Baffin Bay's warmer waters and marshalling them into parallel ranks. Thin at first, these ghostly lines swell as the ice-capped island's frigid breath pulls more heat and moisture from the ocean.

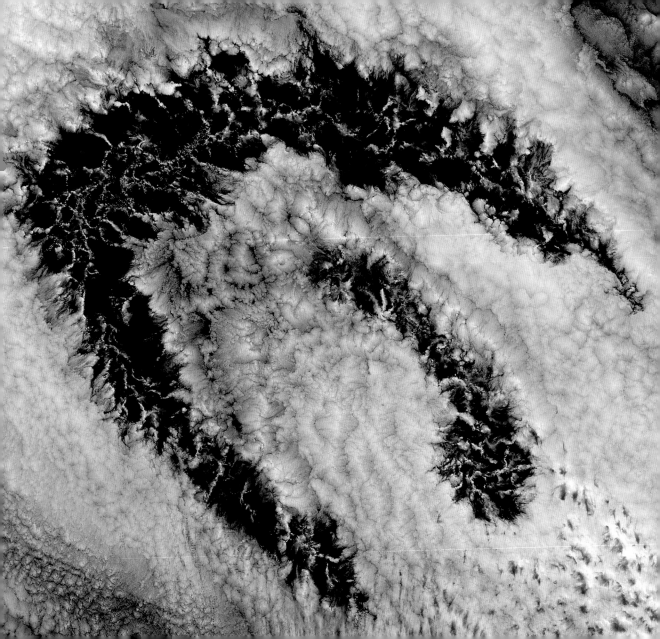

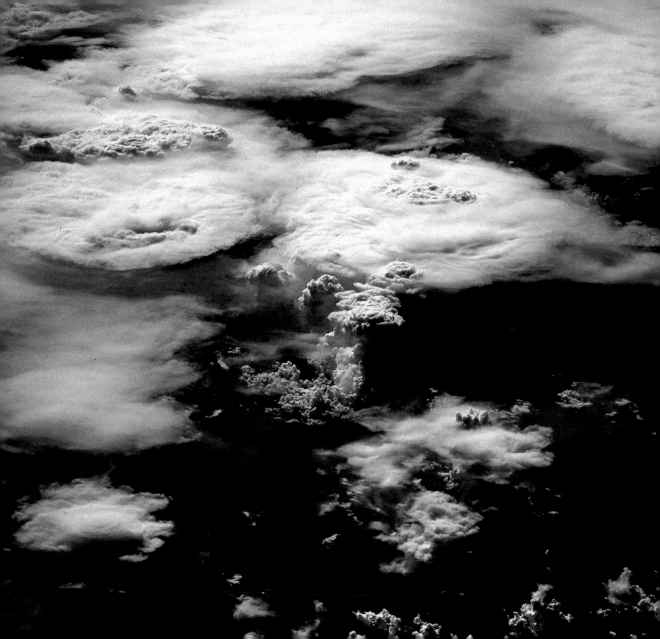

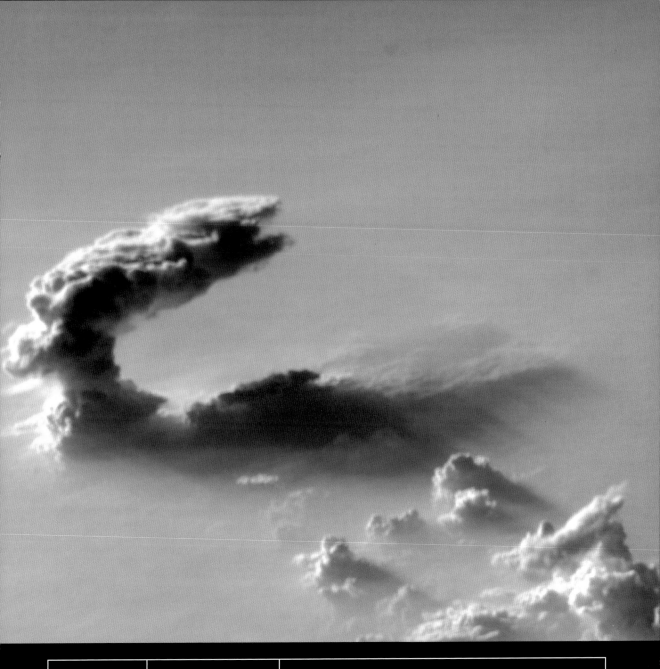

Cloudscape

Cumulonimbus cloud
Democratic Rep. of Congo

A nebulous apparition rears above a pall of smoke and haze over the Congo Basin. Warm and humid, the equator provides ideal conditions for spawning such beasts and the thunderstorms they spark. In a typical thunderstorm, some half a million tons of water vapour are sucked high into the atmosphere, releasing enough energy to power a city of 100,000 for a month.

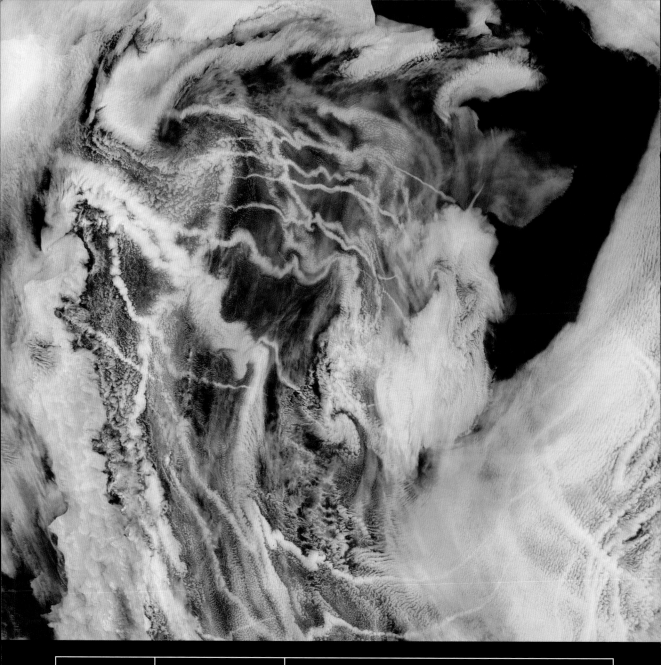

Ship Tracks

North Pacific Ocean

No longer is Nature the only cloud artist on the planet. Over calm waters, long-lived trails of stratus clouds burgeon in the lingering smokestack exhaust of shipping. At its heart, cloud formation is a dirty business relying on minuscule airborne particles to form a seed about which water vapour can condense. Usually such particles are natural, but man-made pollution works just as well.

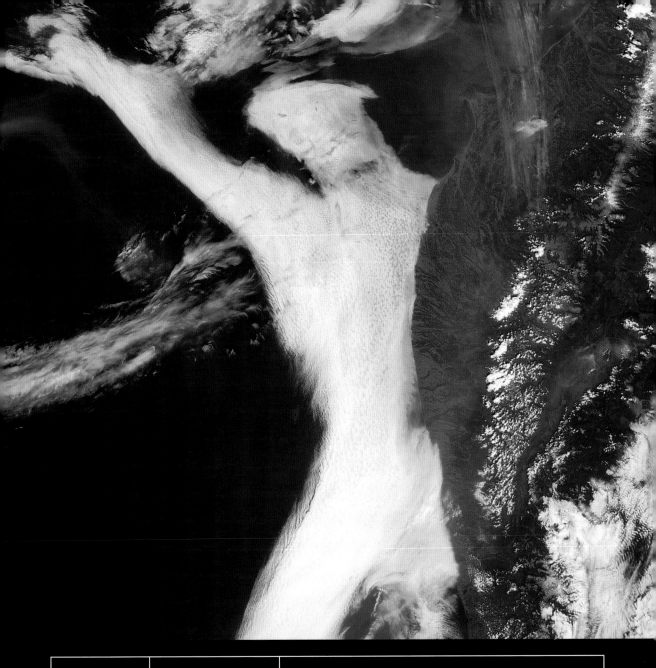

Cloudscape

In 1803 Luke Howard brought order to the seemingly intractable sphere of cloud classification. He divined four basic characters that even today form the kernel of that two-volumed bible of nephology

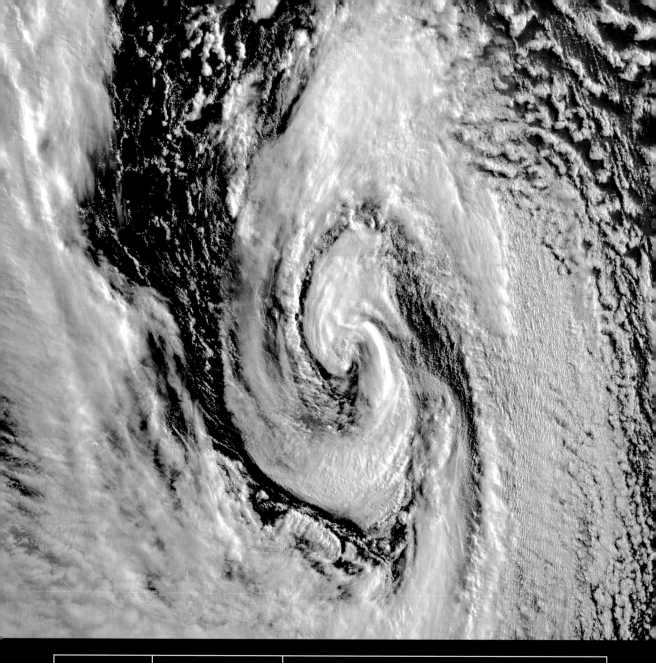

Low-Pressure System

The Sun's warmth falls unevenly on our planet, sculpting an atmospheric landscape where mountains of warm air soar over sunken valleys of cold. But Nature is intolerant of such airy tectonic

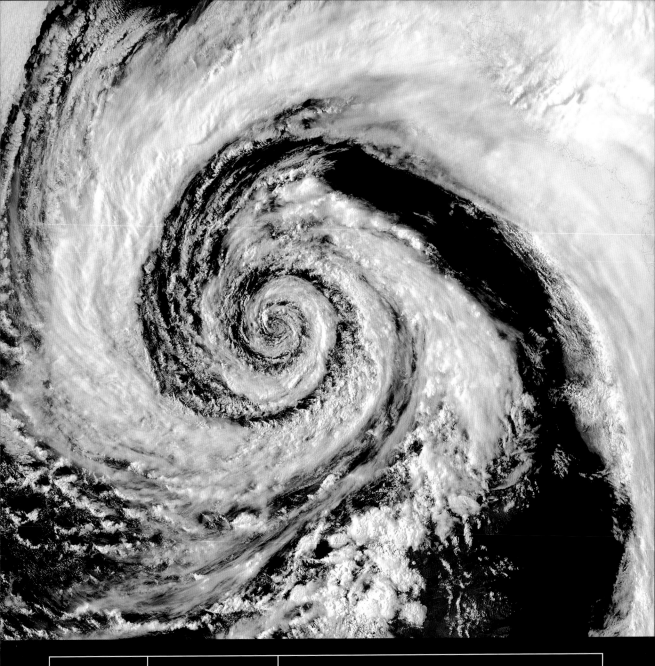

Low-Pressure System

Denmark Strait

Earth's atmosphere weighs over 5,000 trillion tons – 10 million tons rests on every square kilometre of the planet – requiring a mighty engine to stir even the slightest breeze. Powered by the Sun, a mesh of convection cells rise to the task, shunting air around the globe like clockwork. Any cyclonic embellishments are courtesy of the Coriolis effect, an artefact of the planet's rotation.

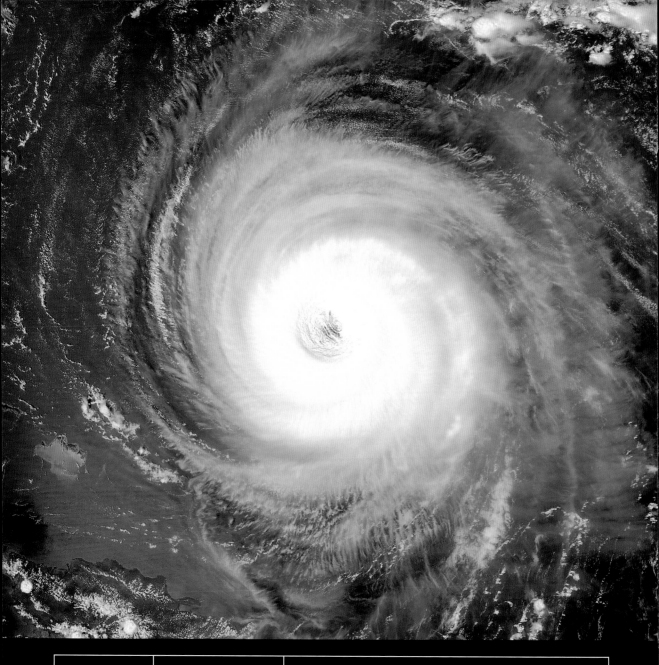

Isabel 2003

Category 5 hurricane
North Atlantic Ocean

Isabel's 260-kph (160-mph) fury belied her humble origins. Spawned in the mid-Atlantic from a cluster of thunderstorms, she fed off warm tropical seas, building a heat engine ultimately capable of generating an hourly energy output equivalent to a 30-megaton nuclear detonation. Seized by trade winds and the Coriolis effect she was loosed on a westward path, towards a terminal collision with North Carolina.

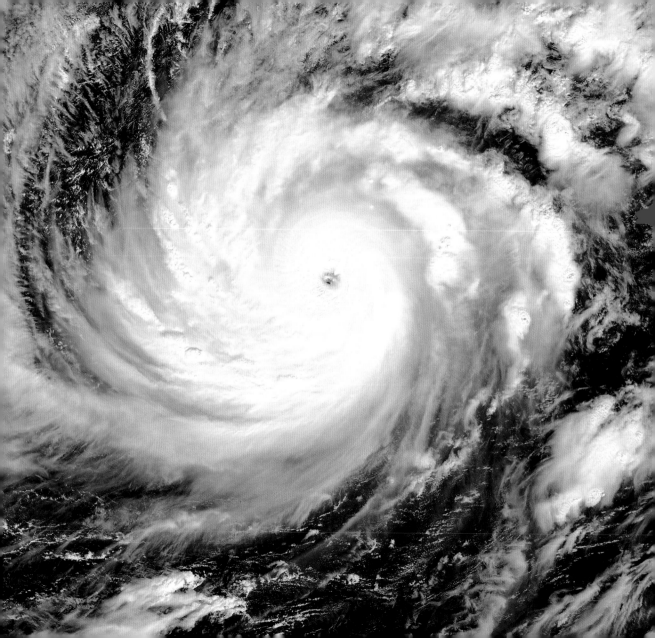

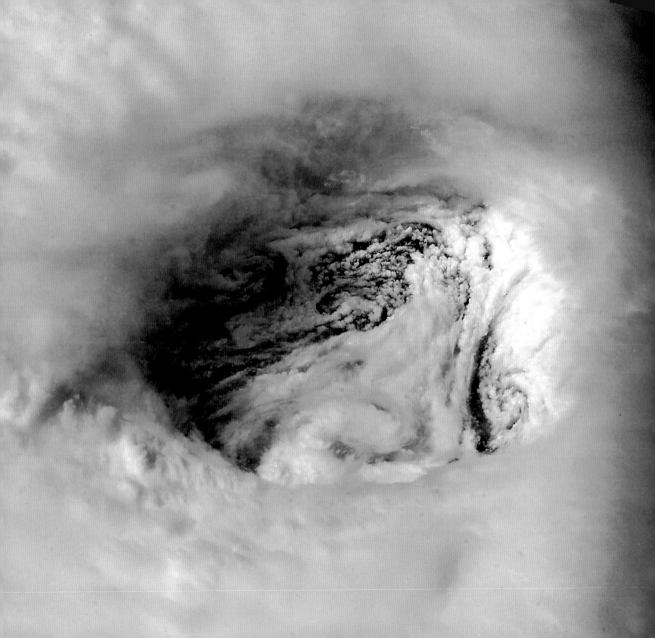

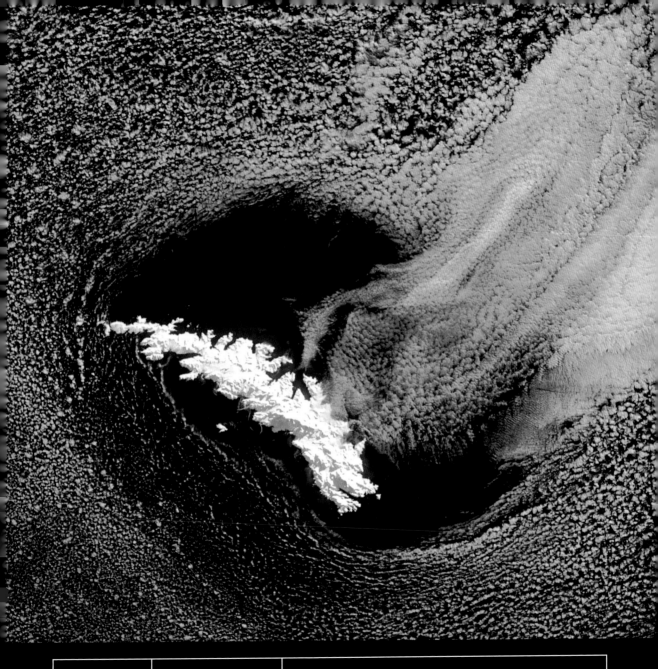

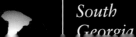

South Georgia

South Georgia's sudden apparition in the South Atlantic 2,735 kilometres (1,700 miles) due east of Argentina disturbs the

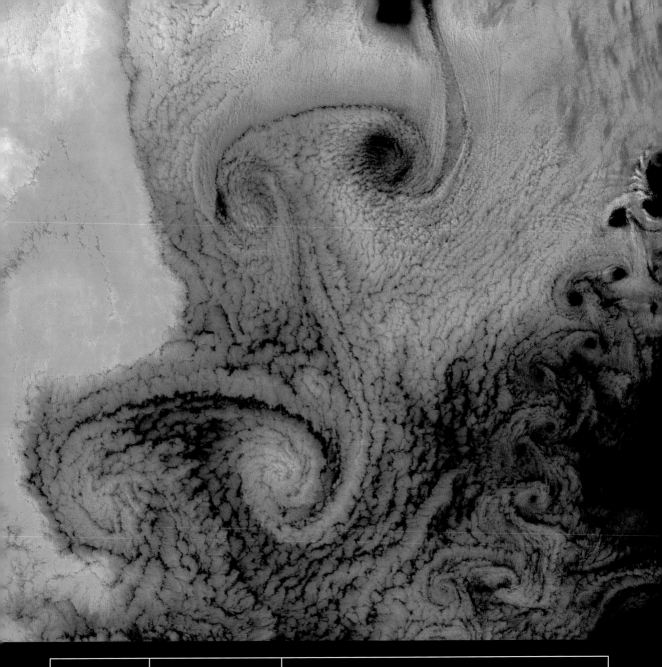

Von Kármán Vortex Streets

The oft-befogged Aleutian Islands break through their cloud cover, generating a swirl of atmospheric turbulence that would look more at home on the face of a gas giant. In fact, these paisley swirls form

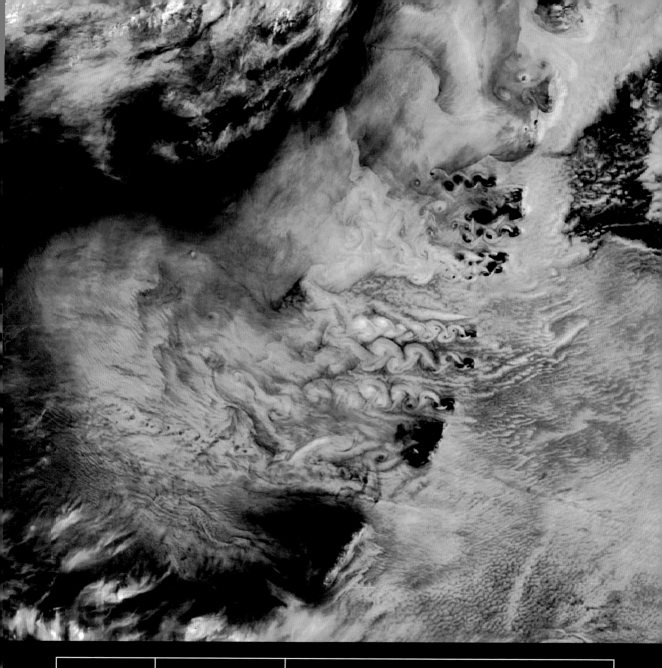

Von Kármán Vortex Streets

Trailing vaporous braids from their stratovolcanic heights, the Kuril Islands stand resolute against a flood of Pacific cloud surging into the Sea of Okhotsk. Extending for hundreds of kilometres, such

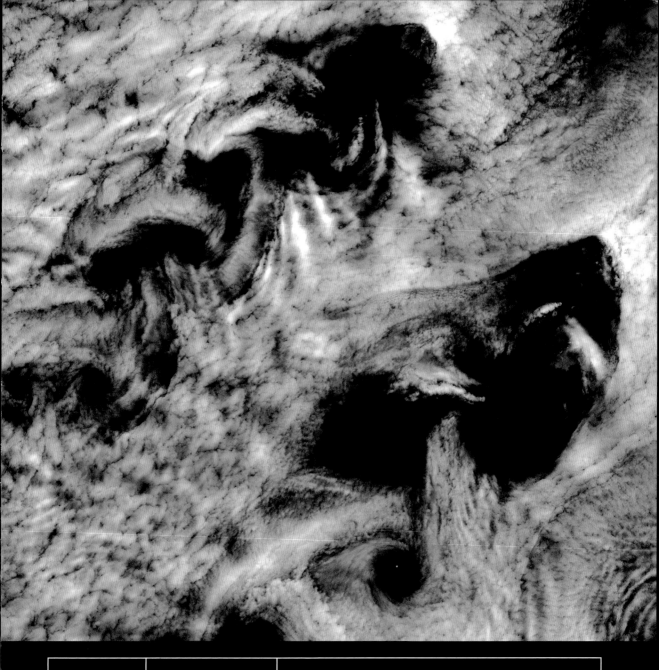

Von Kármán Vortex Streets

Kuril Islands

Air colliding with the Kuril Islands' volcanic bulk (provided, in this case, by Broutona, Chirpoy and Brat Chirpoyev) is warped into a spiralling wake of vortices by a high-pressure bow preceeding the island and a low-pressure shadow lurking to its lee. Once spinning, these atmospheric whirlpools suck in clear air from higher altitudes, spawning the vacant eyes that nest at their centre.

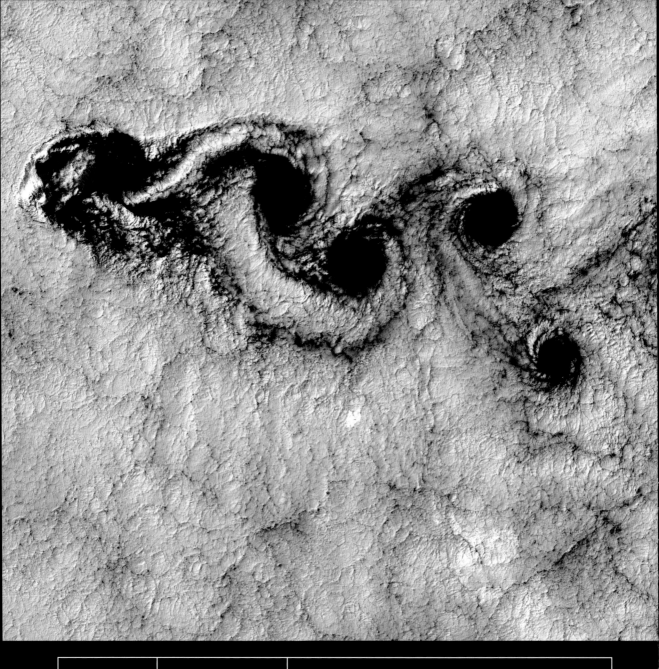

Von Kármán Vortex Streets

Alexander Selkirk Island

Rising 1.6 kilometres (1 mile) above the ocean, Alexander Selkirk Island unfurls a tail of whirling dervishes as wind-driven stratocumuli tangle with its summit. Casting off the mountain in pairs, mirror-image vortices spin downstream, gradually fading as their rotational energy dissipates, ultimately dissolving back into the undifferentiated cloud sea they were conjured from.

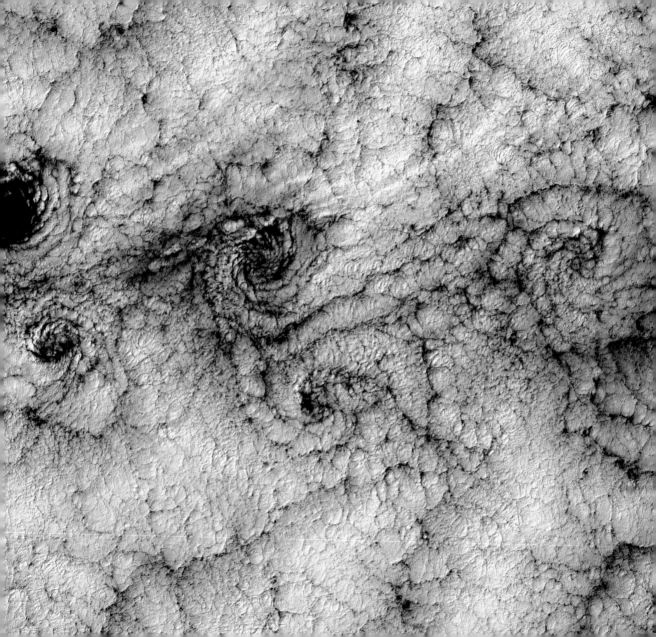

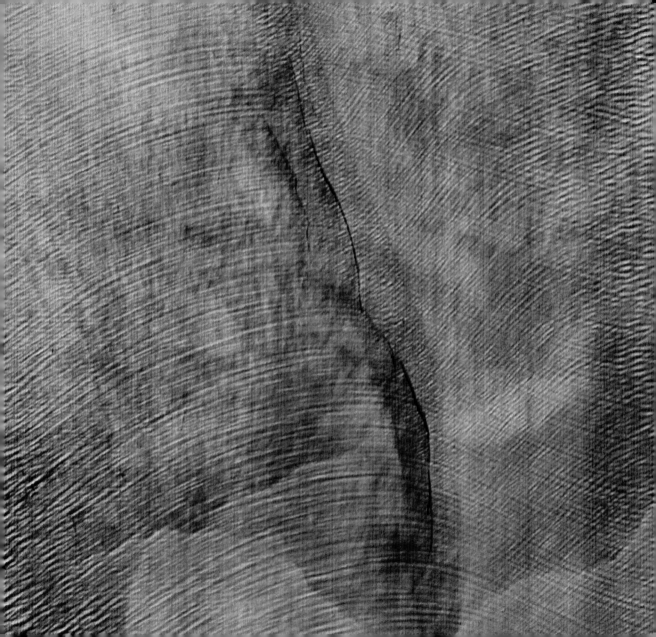

Rub 'al-Khali

Dunes
Saudi Arabia

At the wind's command, wave after wave of dunes sail the arid wastes of Earth's largest sand sea. Adrft in an area the size of France, each peripatetic ridge can span up to 200 kilometres (125 miles) with crests that peak over 300 metres (1,000 feet). Largely unexplored, even the Bedouin shun the Rub 'al-Khali's (Empty Quarter's) waterless, Djinn-infested embrace.

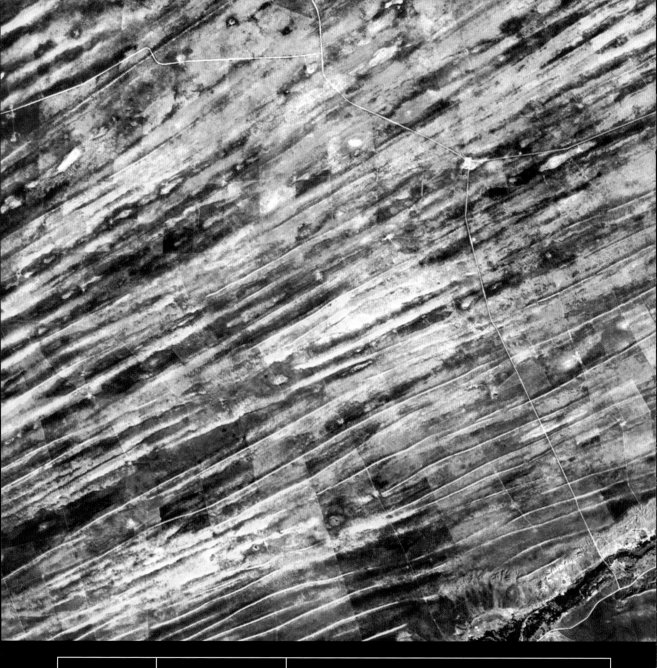

Kalahari Dunes

Namibia

On the edge of the Kalahari Desert in central Namibia, parallel waves of sand dunes encroach once-fertile lands. Healthy vegetation appears red in this image; in the centre, notice the lone red dot. It marks a centre-pivot irrigation system, evidence that at least one optimistic farmer continues to work the fields despite the approaching sand.

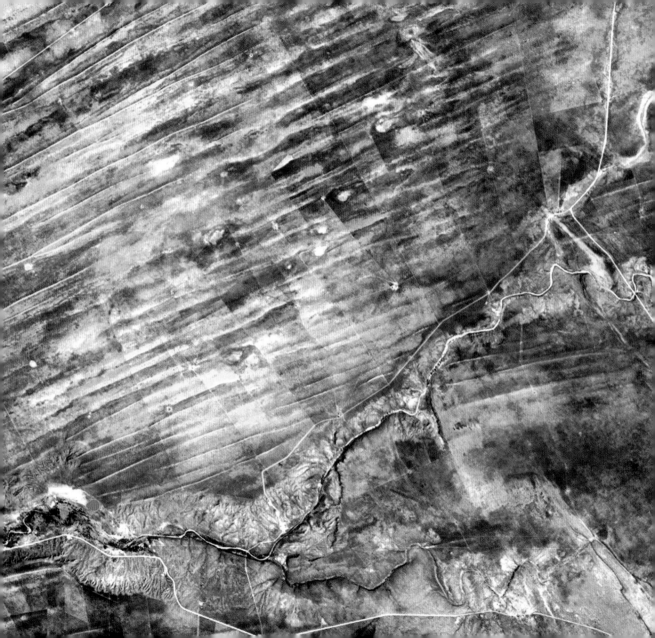

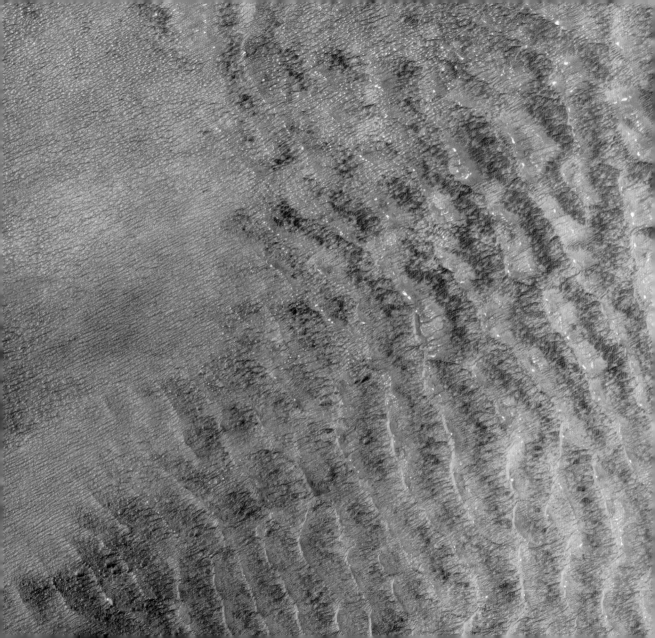

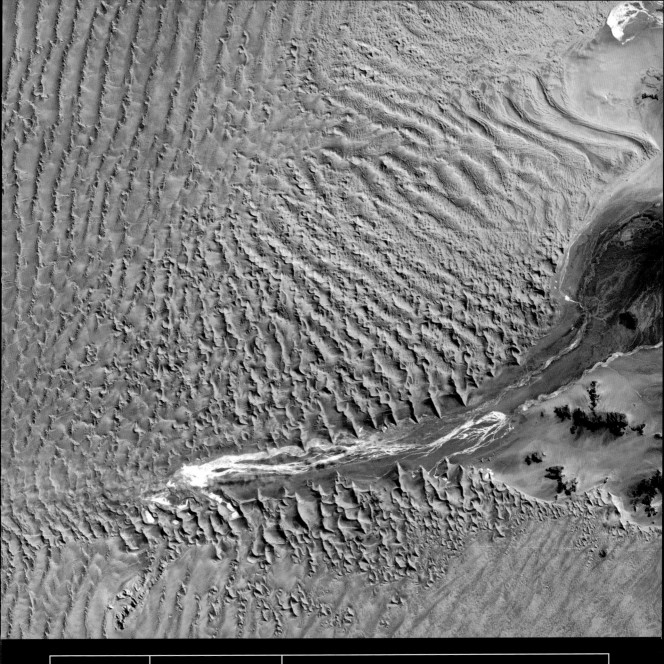

Namib Desert

Namibia

Having endured an 80-million-year drought, the planet's oldest desert has had ample time to evolve its 300-metre (1,000-foot) sand slopes. The grain-by-grain evolution of dunes is not well understood; indeed, sand's very granular nature makes it a process as mathematically mysterious as the turbulent perturbations of our atmosphere are computationally complex.

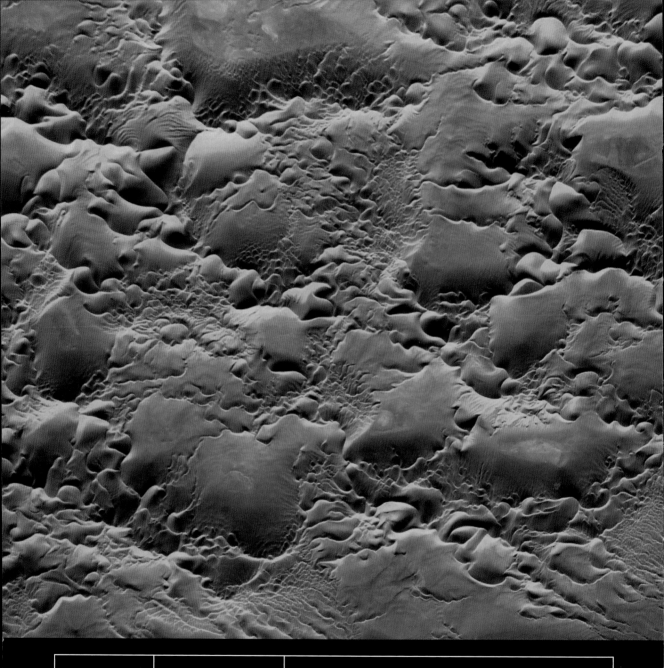

Erg Issaouane

Algeria

Complex wind patterns can sculpt a vibrant society of dunes. Several species cohabit here, but the preeminent citizen is the star dune – a many-limbed creature carved by multidirectional winds. On the flanks and ridges of their larger, more ponderous bretheren, smaller dunes form, flitting in between sandy basins encrusted with the salty residue of evaporated water.

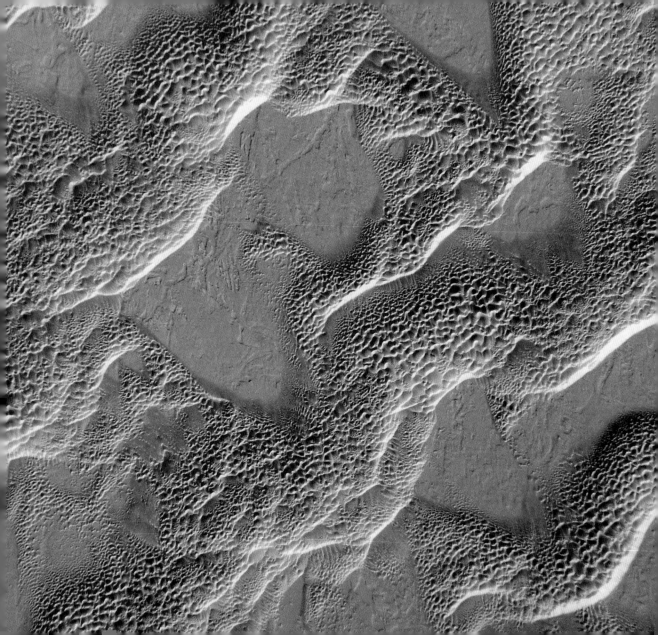

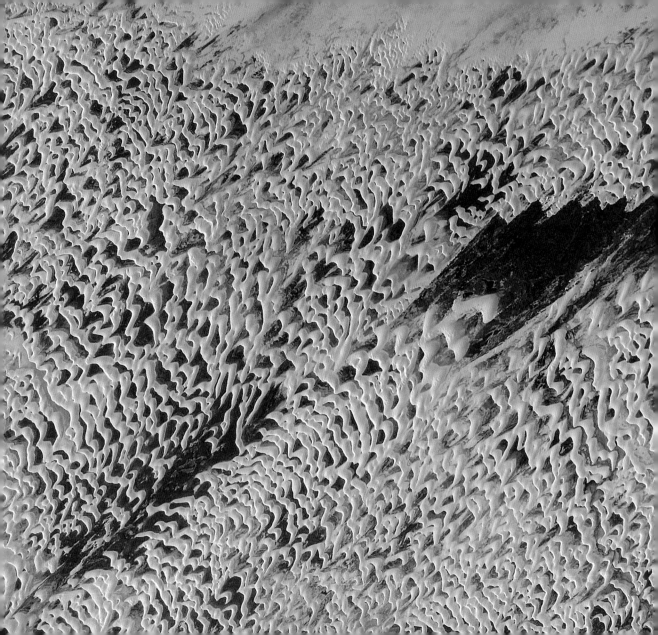

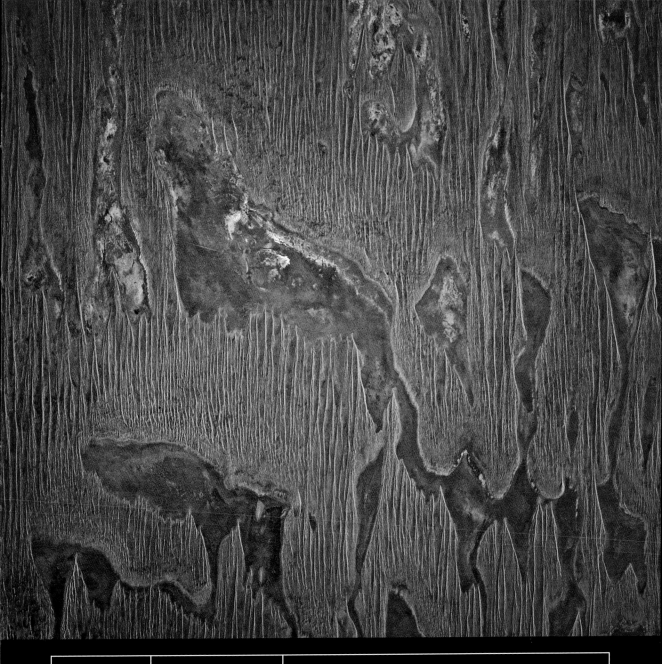

Simpson Desert

South Australia

Australia's outback heartland is corrugated by a seemingly endless succession of longitudinal sand ridges. Creeping northwards at the wind's insistence, their march is interrupted only by the salt-crusted phantoms of evaporated lakes. Rising to heights of more than 30 metres (100 feet), each crest is separated from its neighbour by a 300-metre (1,000-foot) trough.

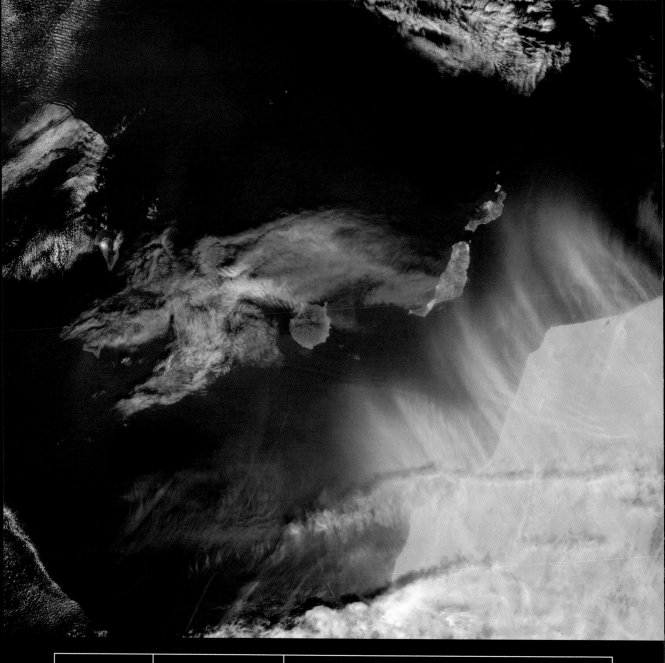

Sandstorm

Morocco / Canary Islands

Not all sands end up neatly stacked in wind-hewn dunes: up to a billion tons are blown into the atmosphere and scattered across the globe every year. Here, dusty Saharan tendrils ride the desert wind, reaching for the Canary Islands, while in the wake of Lanzarote – the northern-most island – waves stir in premonition of the approaching storm.

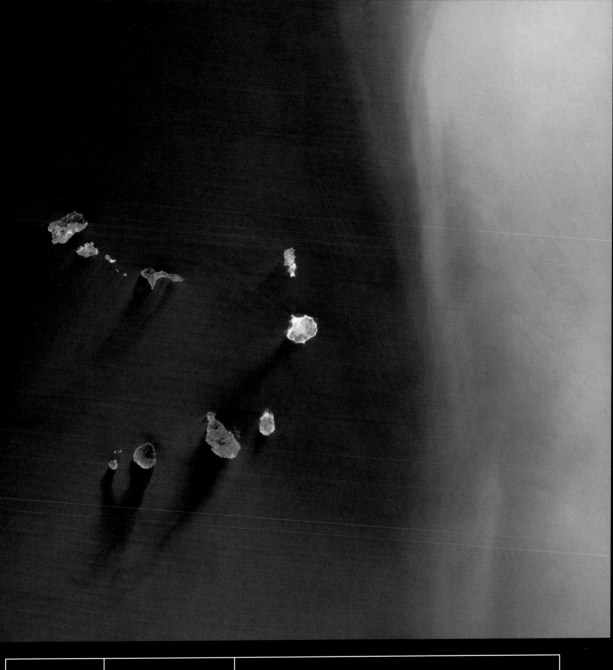

Sandstorm

Cape Verde Islands

Drawn up into an echelon, the Cape Verde Islands prepare to breach the looming storm wall. Riding the trade winds, Saharan sandstorms can cross the entire Atlantic, clouding the skies of Miami and even delivering mineral nutrients to the Amazon. Mars's sandstorms are even more dramatic, often blanketing the entire planet for months.

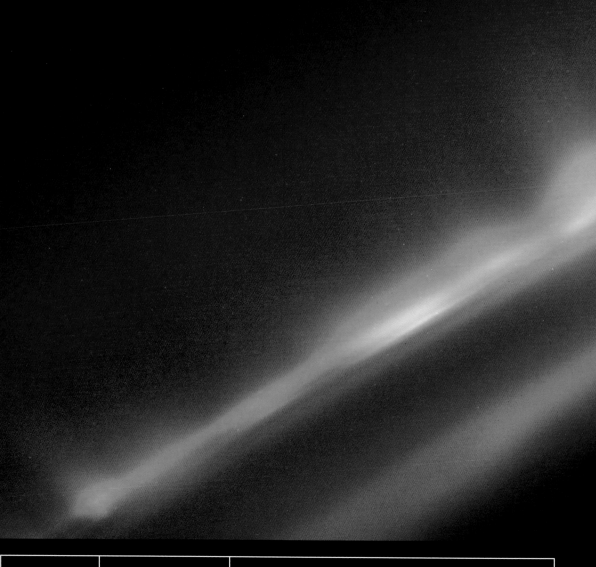

Aurora Borealis

British Columbia, Canada

Earth's magnetic field stands between us and the solar wind, a 3.2 million kph (2 million mph) stream of plasma. As it batters against our geomagnetic shield, some of the wind's particles are captured and corralled above the planet's poles. Here, they pour energy into the atmosphere, which fluoresces with delight at such a bounty, crowning the poles with the northern and southern lights.

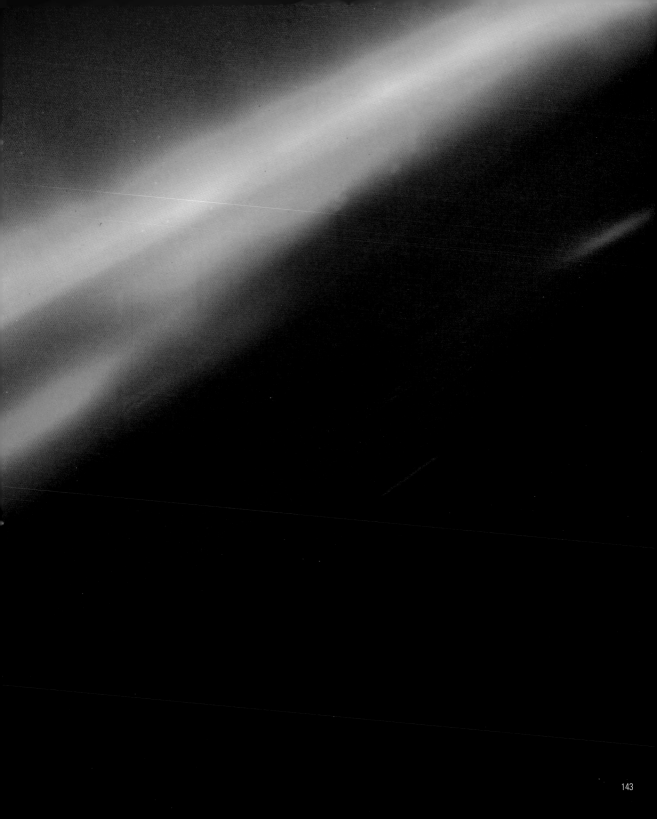

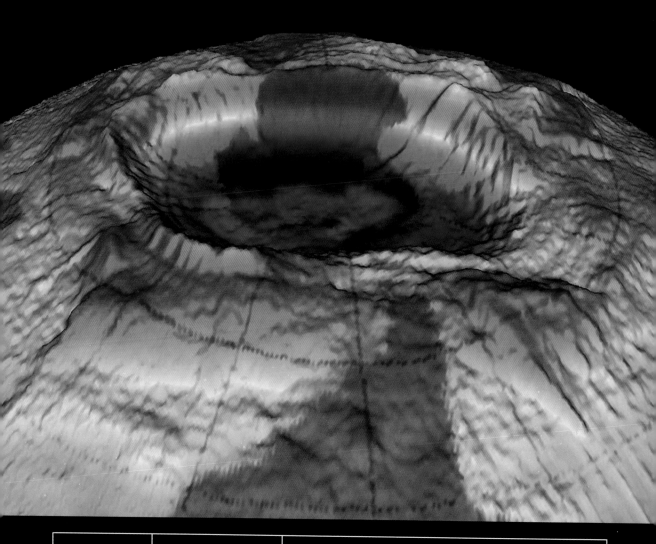

Ozone Hole

Antarctica

Three dimensions provide a worryingly graphic representation of the ozone hole that settles over Antarctica each spring. Comprising three oxygen atoms (O_3) rather than the normal two (O_2), ozone shields us from the most harmful wavelengths of UV radiation despite its atmospheric rarity: if concentrated in the stratosphere Earth's entire supply would measure just 2 millimetres thick.

Gamma Ray Earth

The culmination of a seven-year exposure, the pixelated planet above is the first gamma-ray portrait of Earth. It reveals the atmosphere's high-energy glow as it intercepts an incoming hail of cosmic rays, charged particles and other radiation. Altogther, the planet's 190-kilometre (118-mile) gaseous membrane provides a protective barrier equivalent to 4.5 metres (15 feet) of concrete.

fire

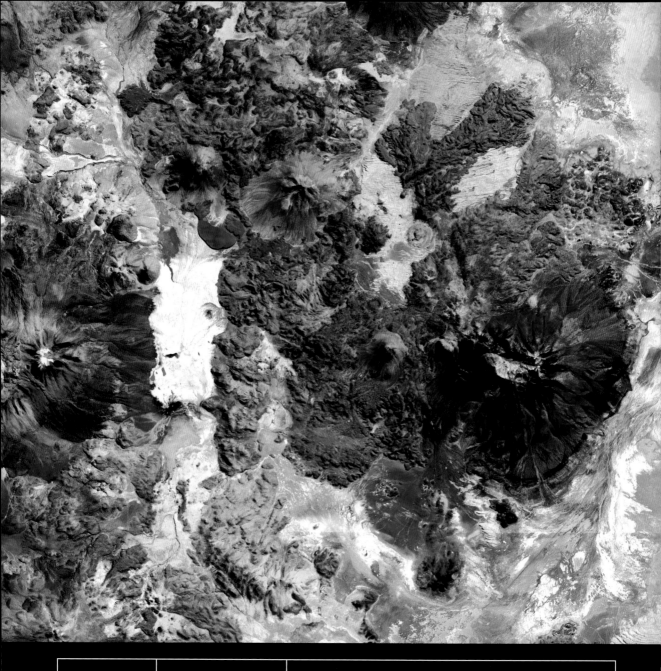

Pampas Luxsar

Bolivia

To infrared eyes the Pampas Luxsar reveal a morass of hardened lava flows enveloping the chasms between Andean peaks. The scrape of ocean plate subducting beneath westward-bound continental crust has spawned an avenue of volcanic spires that not only run through the Andes, but also the entire mountainous backbone of the Americas, from Alaska to Tierra del Fuego.

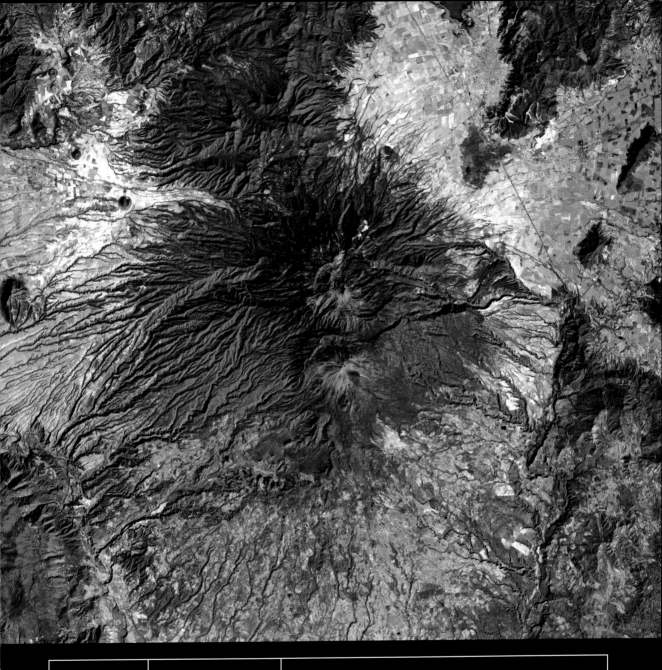

Colima

Stratovolcano
Mexico

Snow-capped Colima Volcano, the most active volcano in Mexico, rises abruptly from the surrounding landscape. Colima is actually a melding of two volcanoes, the older, extinct Nevado de Colima to the north and the younger, altogether more lively Volcan de Colima to the south, which, as I write (August 2005), is enjoying its most powerful eruption in decades.

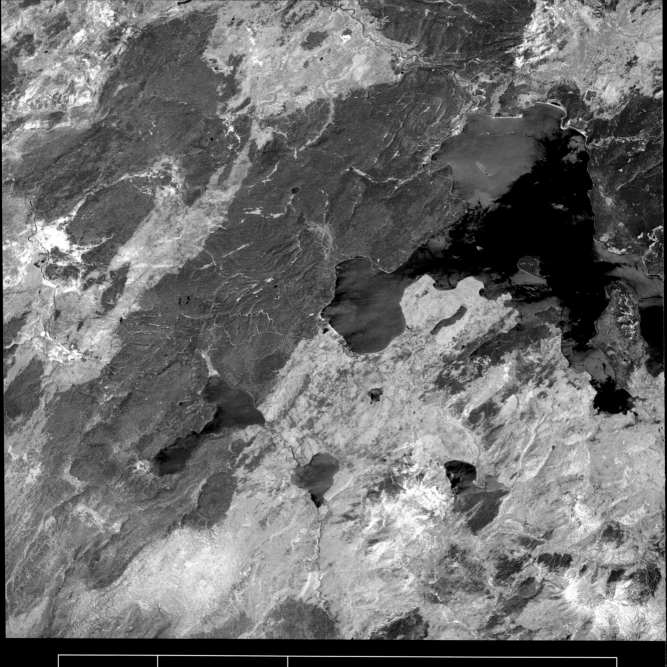

Yellowstone Supervolcano

Wyoming, USA

Beneath the placid hues of Yellowstone National Park sleeps a giant, its fiery exhalations powering geysers and boiling hot springs. It has been 640,000 years since it last stirred, blasting 1,000 cubic kilometres of rock into the atmosphere and leaving a caldera that engulfs nearly the entire park. It's not a question of if this 'supervolcano' will wake again, it's a question of when.

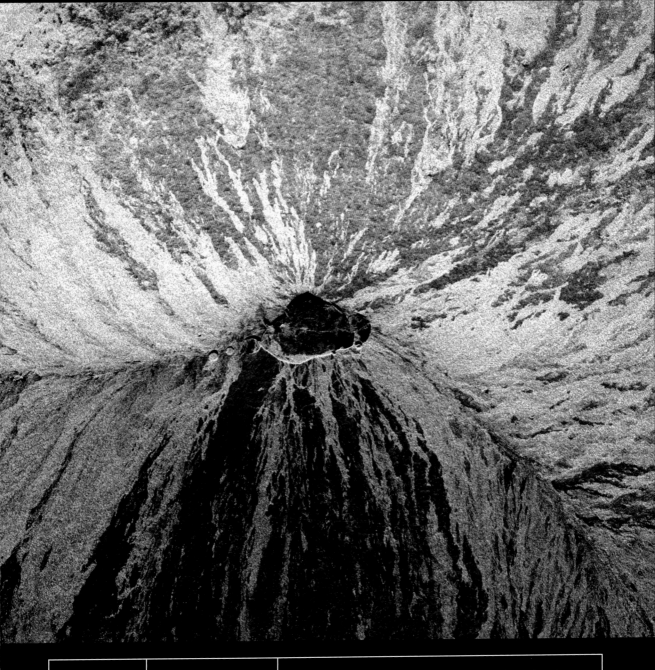

Mauna Loa

Shield volcano
Hawaii, USA

We stare into the maw of Earth's largest active volcano. Over the last million years, Mauna Loa has piled 17 vertical kilometres (10.5 miles) of lava on to the ocean floor. Such is her bulk, only her top 9 kilometres (5.5 miles) protrude, the rest have actually sunk beneath the planet's crust. As a shield volcano, Mauna Loa is of the same volcanic species as that Martian colossus, the Olympus Mons.

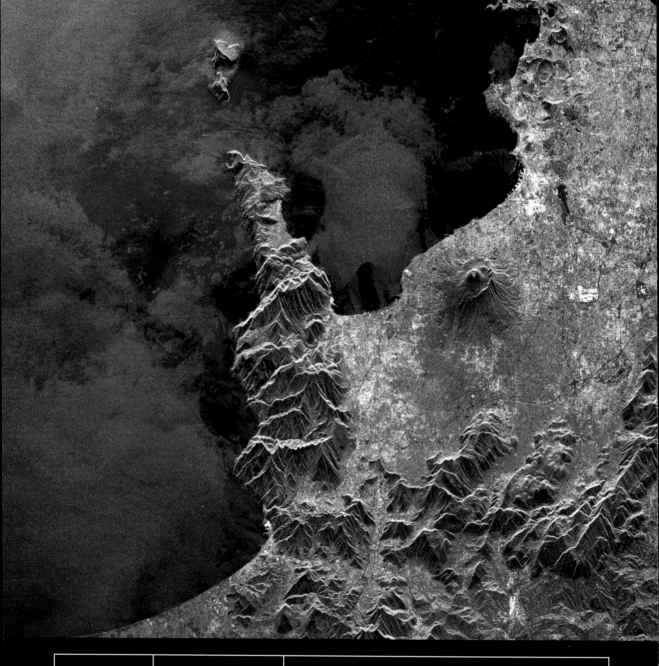

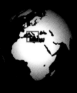

Vesuvius

Stratovolcano

Italy

A viridescent sprawl of orchards and vineyards cloak Vesuvius' ash-enriched killing fields. Since it destroyed Pompeii and Herculaneum in 79 AD, the volcano has erupted over 30 times. In 472 and 1631 these eruptions were violent enough to shower even Constantinople with ash. Quiet since 1944, Vesuvius' past record means it must still be regarded as one of the world's most dangerous volcanoes.

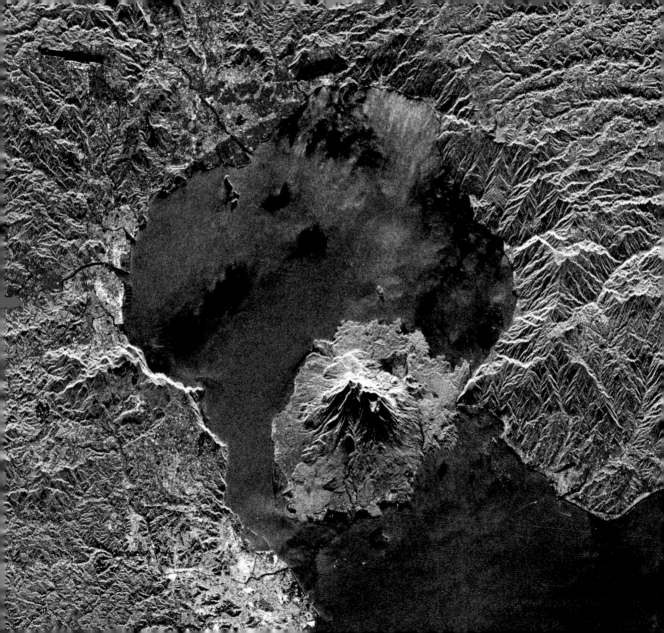

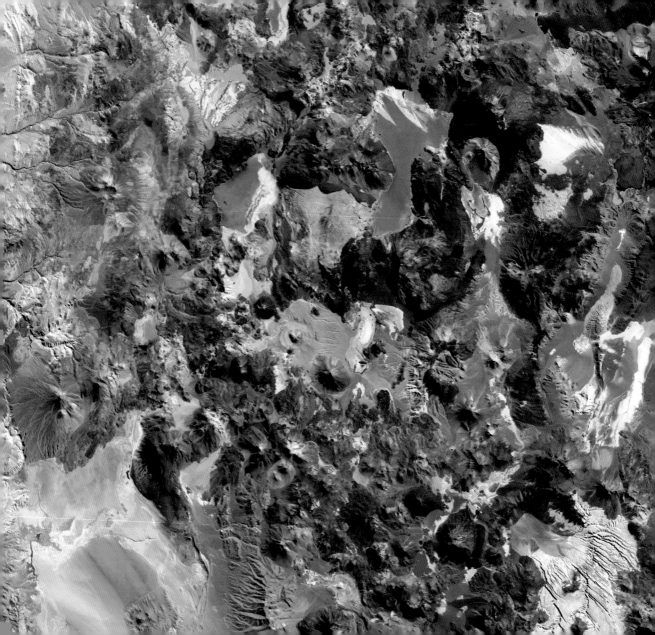

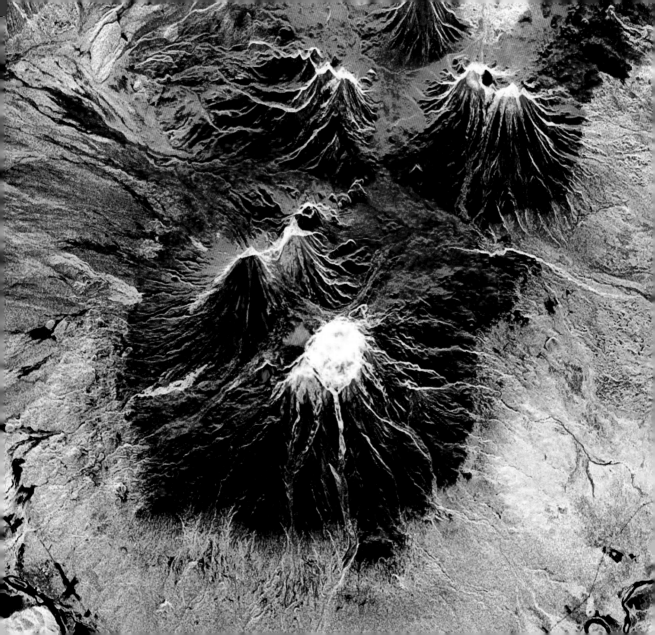

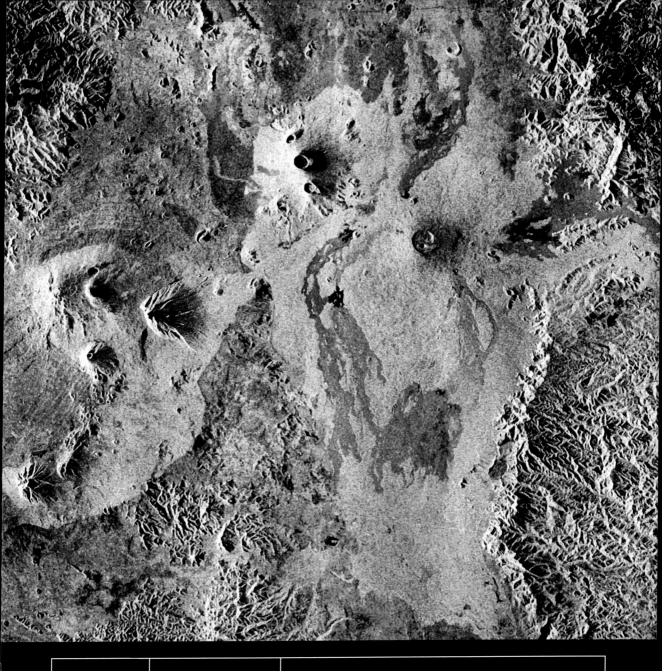

Nyamuragira

Shield volcano
Democratic Rep. of Congo

Radar imaging cuts through the mists and foliage of central Africa's cold mountain jungles, illuminating Mount Nyamuragira's creeping igneous tendrils and a cluster of stratovolcanic siblings. Emerging from a western splinter of the Great Rift Valley, this rash of violently active volcanoes is fuelled by the same rising mantle plumes that are slowly tearing the African continent in two.

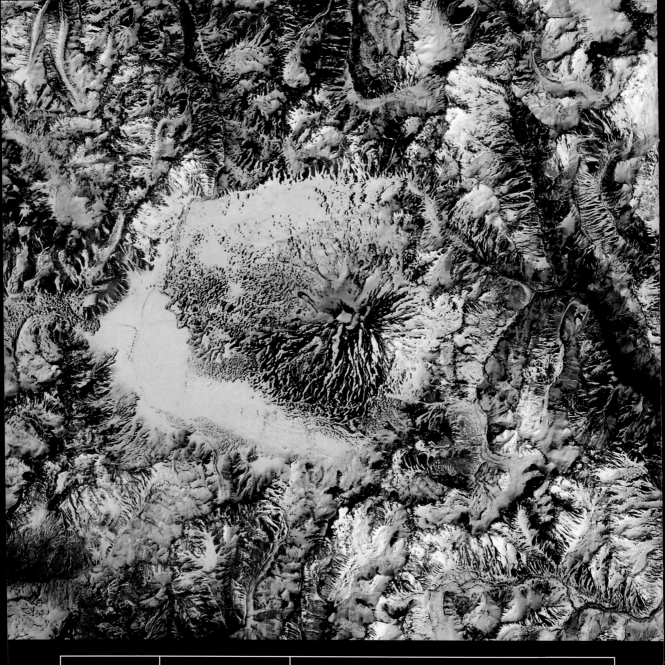

Maipo

Stratovolcano
Chile / Argentina

Guarding the border between Chile and Argentina, Maipo emerges from the 15-by-20-kilometre (9.5-by-12.5-mile) caldera left by its predecessor's explosive demise. Maipo has taken 400,000 years to hoist itself 1,900 metres (6,200 feet) above the crater; by comparison, Paricutin Volcano sprang from a Mexican cornfield in February 1943 and within a year had grown to 336 metres (1,100 feet).

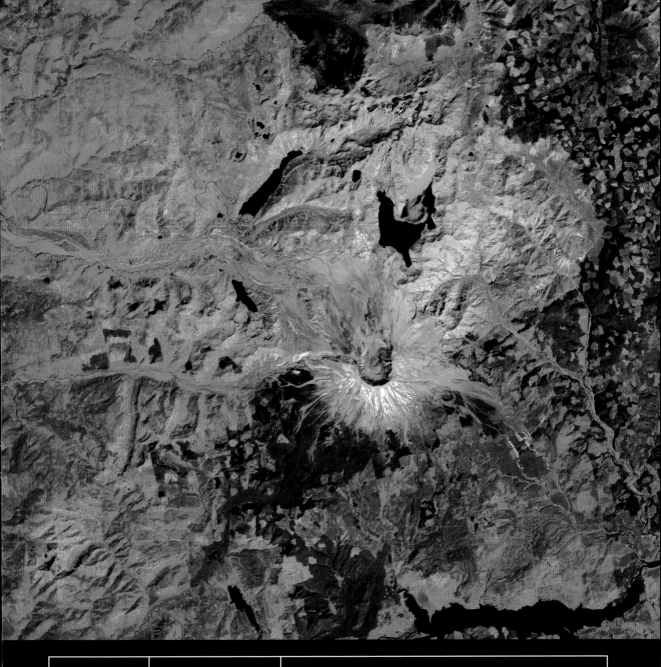

Mt St Helens

Stratovolcano
Washington, USA

On 18 May 1980, Mt St Helens' symmetrical profile was shattered by a 24-megaton lateral blast that destroyed the top 400 metres (1,300 feet) of the mountain, and flattened trees up to 30 kilometres (20 miles) away. Twenty-five years later, the forests are growing back – and so is the volcano. Within its horseshoe crater a new peak is rising: Mt st Helens will soon regain its former stature.

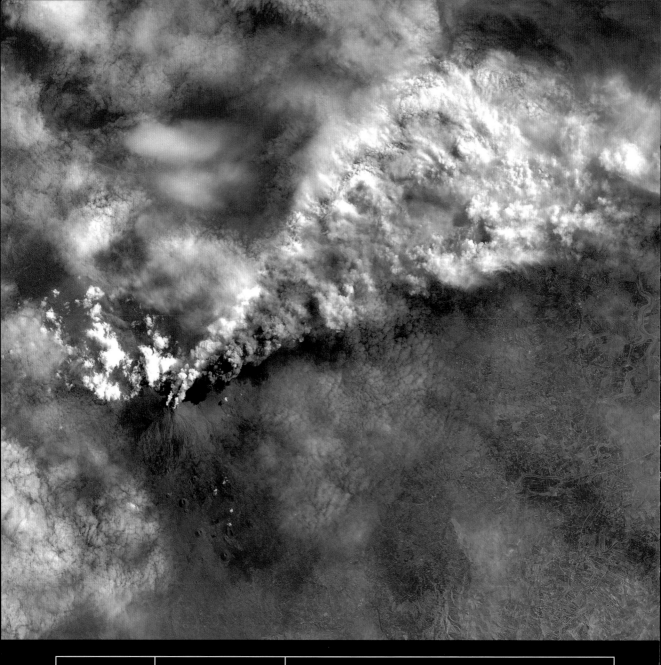

Etna

Shield / stratovolcano
Sicily, Italy

Prison of Typhon, forge of Hephaestus, furnace of the Cyclopes — Etna's mythological bulk is the equal of its physical mass. Despite nearly 200 eruptions over the last 3,500 years, Etna is not generally regarded as a dangerous volcano. Unless, of course, you are a Greek philosopher: Empedocles famously leapt into Etna's fires to prove his immortality. He hasn't been seen since.

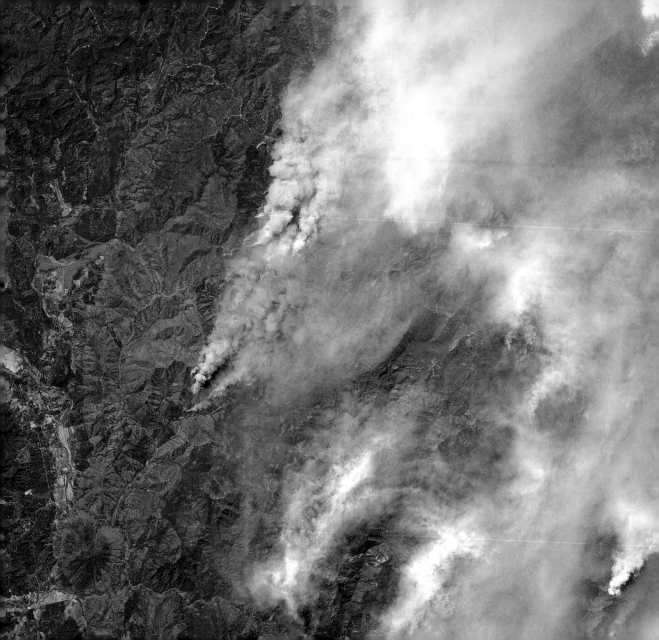

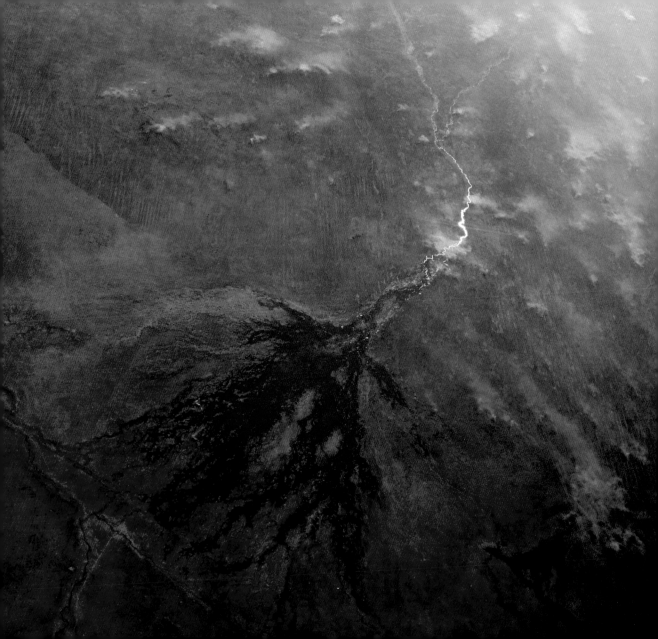

Oil Fields

Texas, USA

Two forests co-exist in this arid landscape. The first – consisting of *Quercus havardii* or the sand shinnery oak – seldom rises more than 1 metre (3 feet) above the ground, yet its roots can penetrate up to 30 metres (90 feet) of soil in the search for water. The second – a pixelated lattice of drill rigs – digs even deeper into the Earth's crust, tapping the underworld itself for fossil energies.

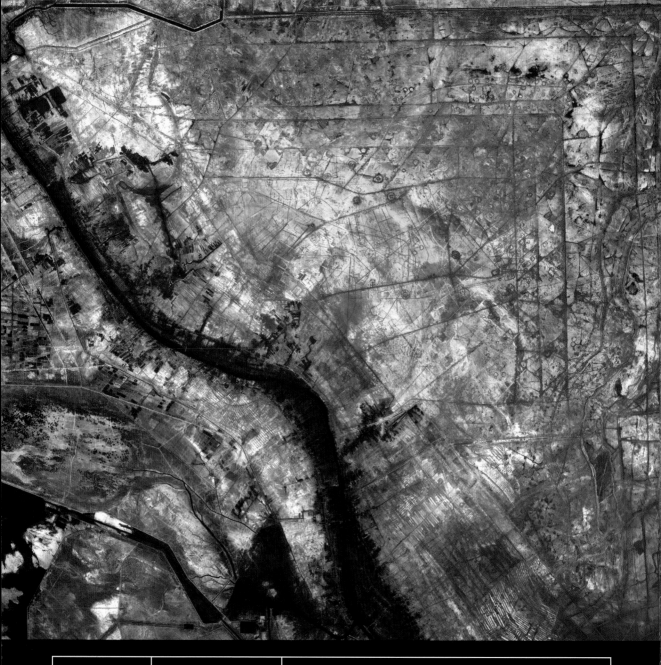

Drained
Wetlands

Iraq

Here lies the Garden of Eden. The wetlands that stood at the confluence of the Tigris and Euphrates were believed to have been the physical inspiration for the biblical myth. A decade ago they were drained, poisoned and entombed behind walls. Who would do such a thing? Know a man by his drainage ditches: the Mother of Battles River, the Loyalty to the Leader Canal and the Saddam River.

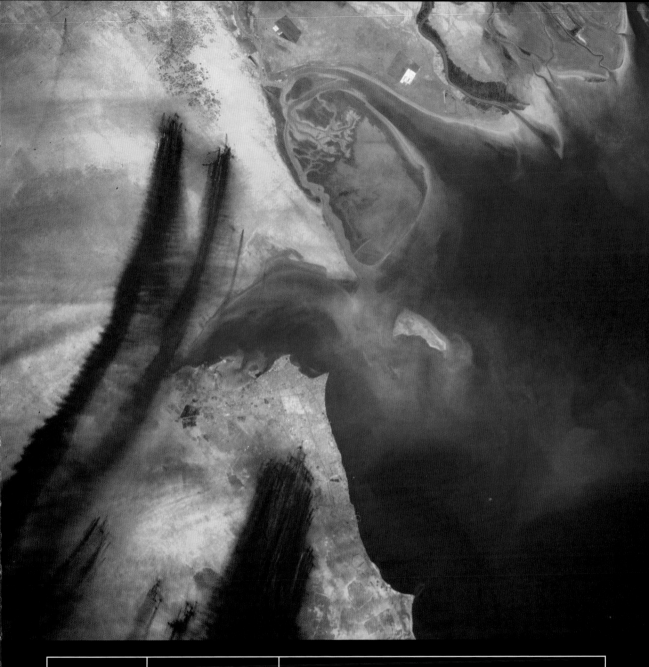

Oil Fires

Kuwait

Retreating from Kuwait in the closing stages of the First Gulf War, Iraqi troops fired over 600 oil wells. Over the next seven months the equivalent of one billion barrels of oil would burn before the fires could be extinguished. Despite a black, oily rain that fell as far afield as Afghanistan, the Iraqi dictator's scorched earth policy didn't have the ecological impact it was orginally feared it might.

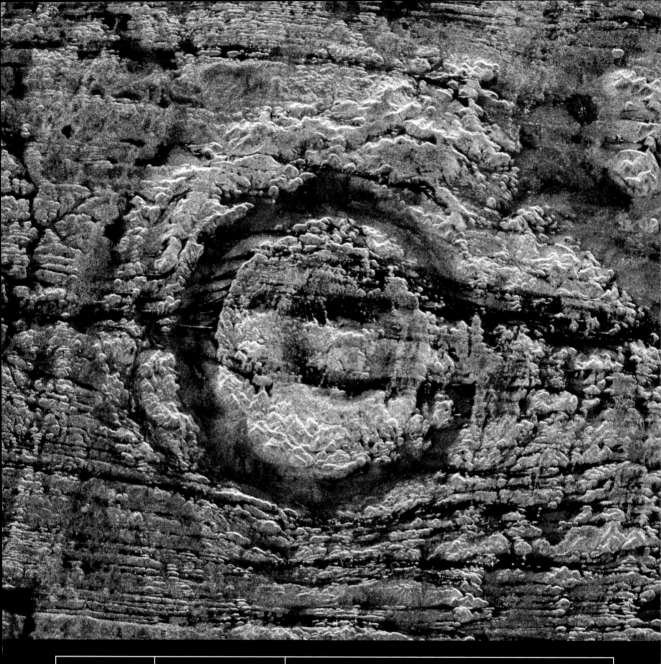

Aorounga

Impact crater

Chad

A hail of ice, rock and metal deluges Earth. In the last billion years she has braved an estimated 130,000 meteorites large enough to leave a crater at least 1 kilometre (0.6 miles) wide. Larger impacts, such as the one that etched these concentric scars across 17 kilometres (10.5 miles) of the Sahara, are less frequent but statistically can be expected every few million years.

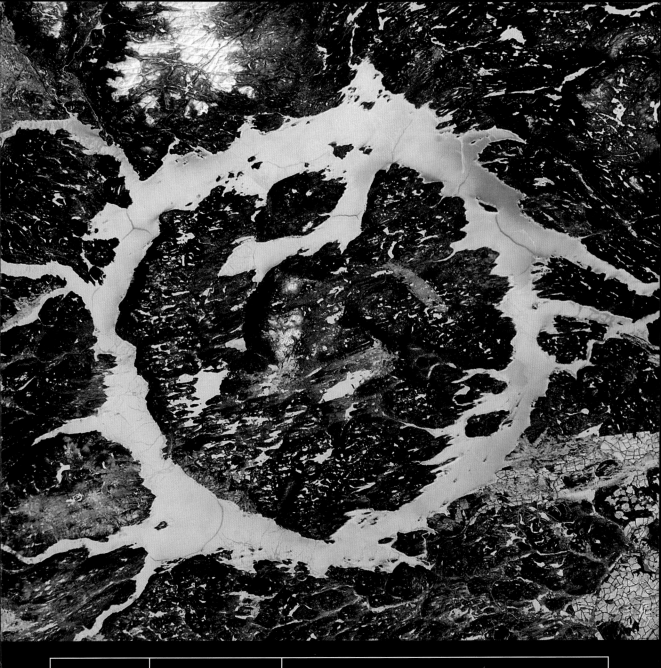

Manicouagan

Impact crater
Quebec, Canada

Denuded of its rim by a succession of ice sheets, the Manicouagan Crater's 72-kilometre (45-mile) girth is the 212-million-year-old legacy of a 40-million-megaton explosion. Such was the heat released, it took several thousand years for the crater's molten rocks to congeal. Some think the impact triggered a global wave of extinctions that swept 60 percent of living species from the planet.

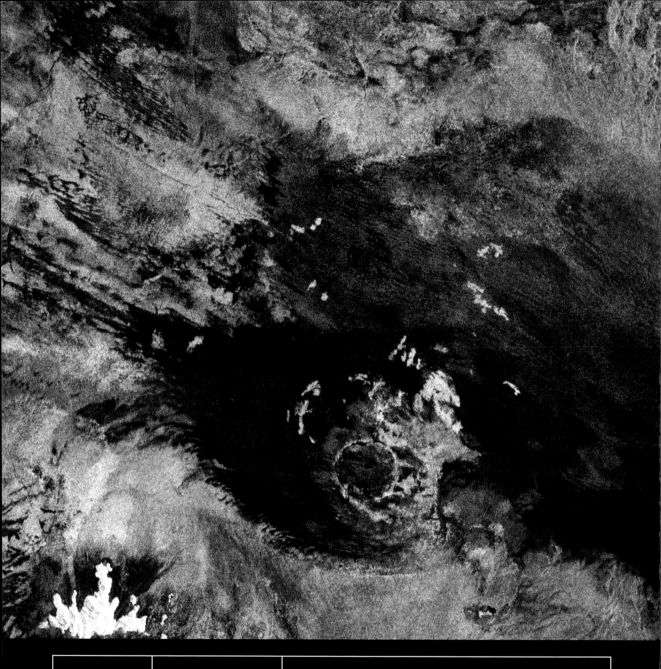

Roter Kamm

Impact crater

Namibia

Five million years old, Roter Kamm is a modest impact crater 2.5 kilometres (1.5 miles) rim to rim, and 130 metres (400 feet) deep. Half-buried beneath wind-blown sands, only the splintered tips of the crater rim reveal themselves to the Mark One Eyeball. But microwave frequencies reveal a blue splash of rock ejected by the original 200-megaton impact surrounding it.

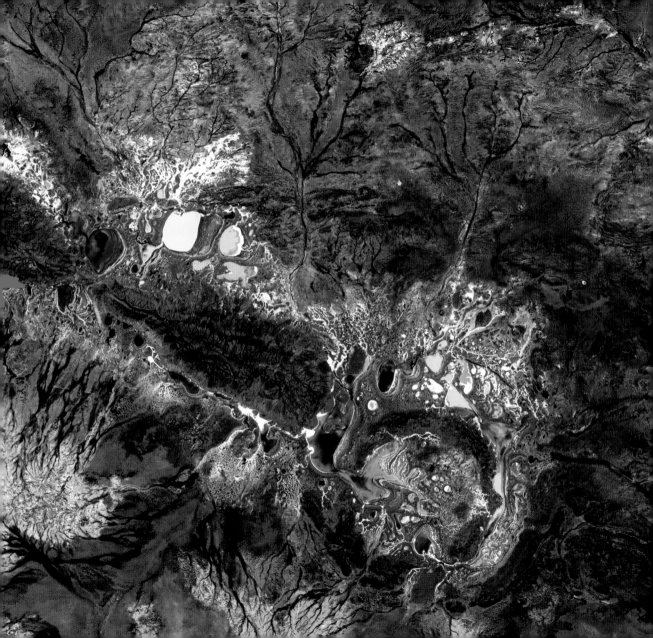

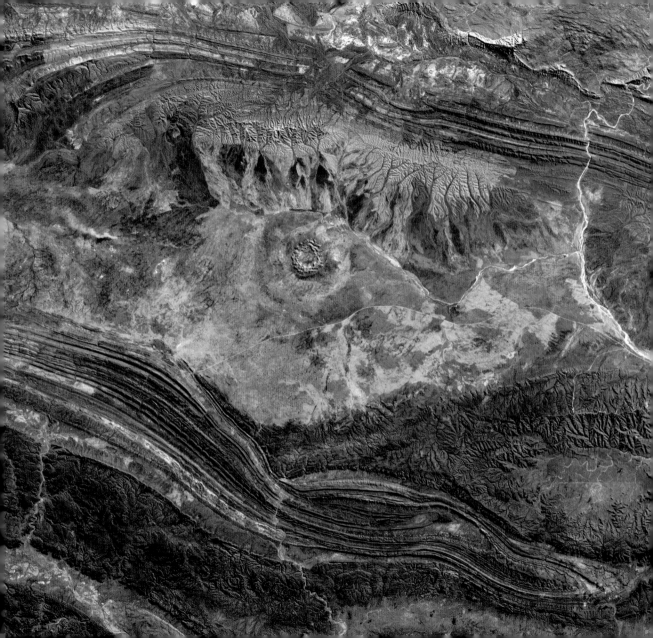

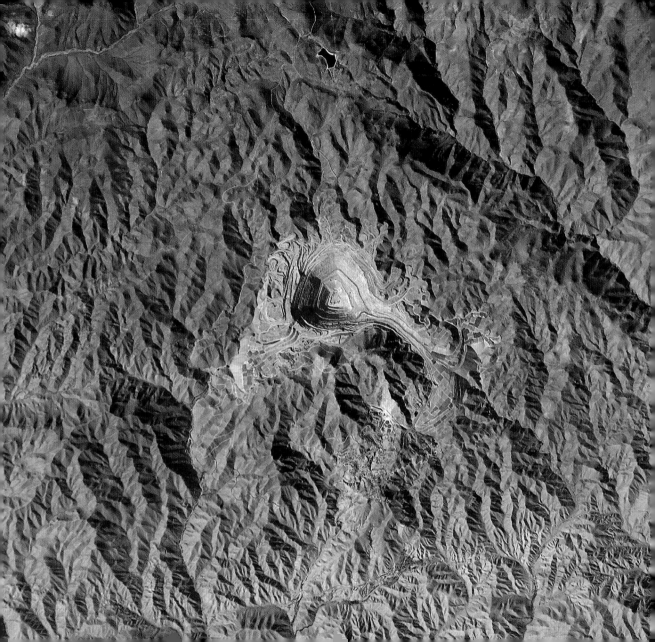

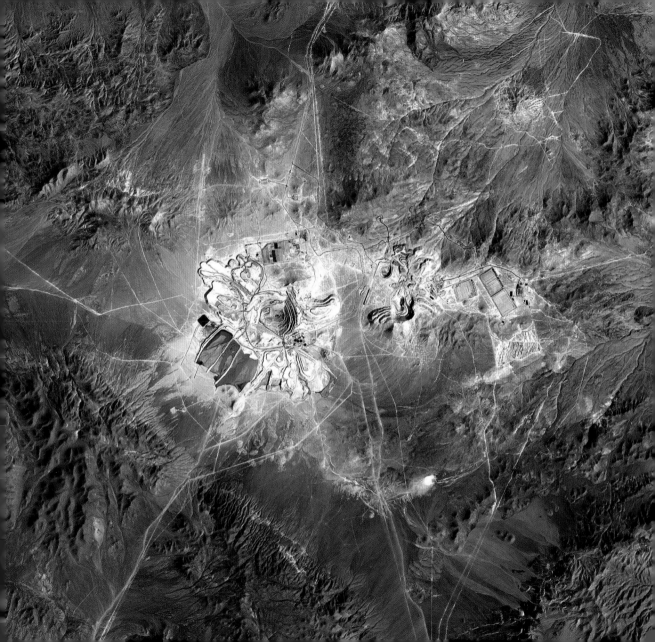

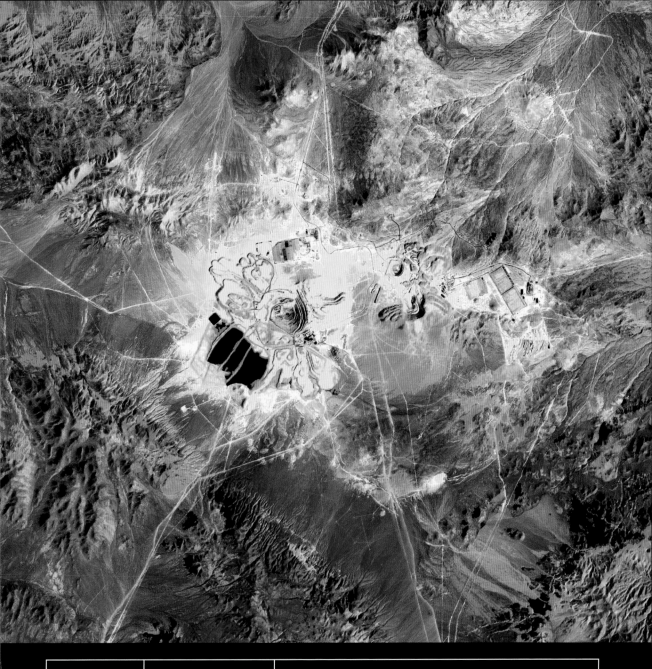

Escondida

Open-cast mine
Chile

Take even a short step beyond the familiar rainbow of visible light and a new world surrounds us. In the near-infrared, sand, soil, vegetation and all species of rock glow with heat, fractional temperature fluctuations lending each a distinct signature. To the prospector such a landscape is rich with information: once hidden seams and pockets of ore are betrayed by their heat spoor.

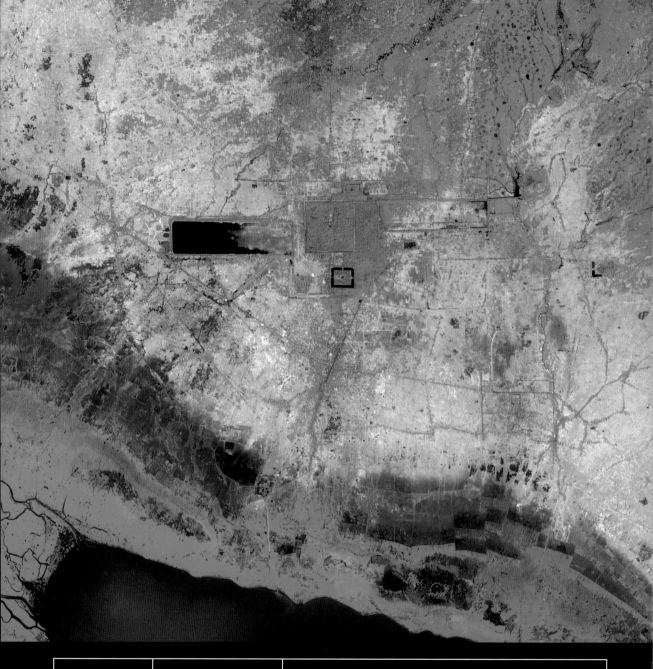

Angkor

Abandoned city
Cambodia

Looking deep into the electromagnetic spectrum, the satellite's all-seeing eye reveals what can't always be seen from the ground. Angkor sat at the heart of the Khmer Empire for 400 years before it was abandoned to the surrounding jungle in the fifteenth century. Now, archaeologists are using infrared and radar data to strip the city of its enshrouding canopy.

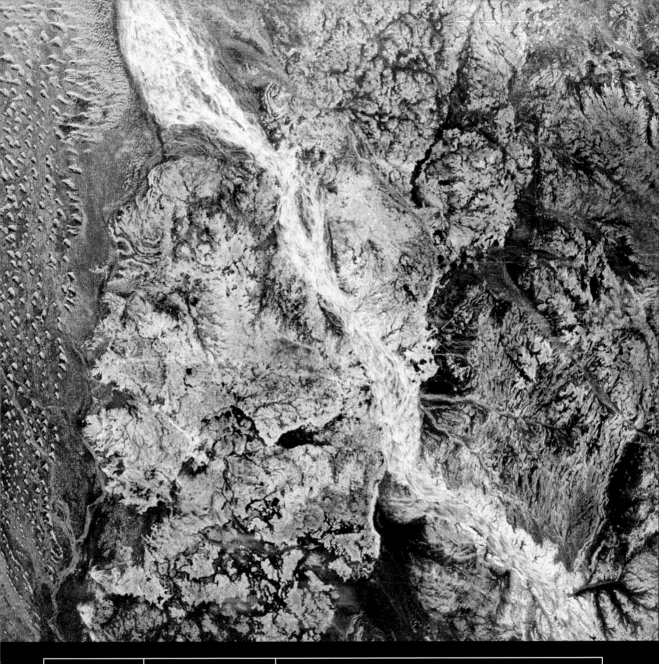

Ubar

Abandoned city
Oman

For 3,000 years the city of Ubar thrived on the edges of the Rub 'al-Khali. But by 300 AD it had vanished from history, swallowed by the desert's infamous sands. It remained hidden until 1992, when orbital radar revealed a web of paths (seen in red) etched across the desert: three millennia of caravans had stamped their mark on the land, and in this case all roads led not to Rome, but to Ubar.

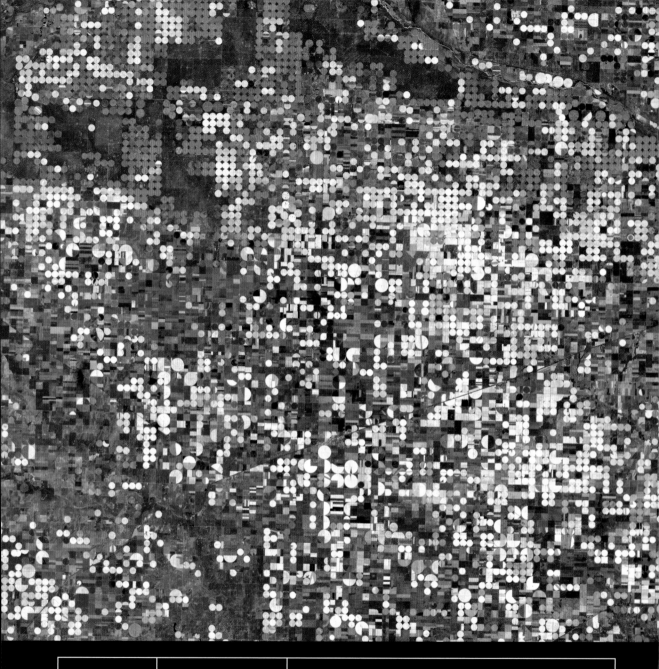

Garden City

Agriculture
Kansas, USA

The agricultural revolution proceeds full-throttle, stencilling Kansas' plains with an unlikely abstract rash. Nearly 90 percent of North America's former prairie is similarly afflicted as centrally irrigated fields mesh together like clockwork gears; frantically spinning to stave off the Malthusian fate that has stalked humanity's burgeoning population for the last 10,000 years.

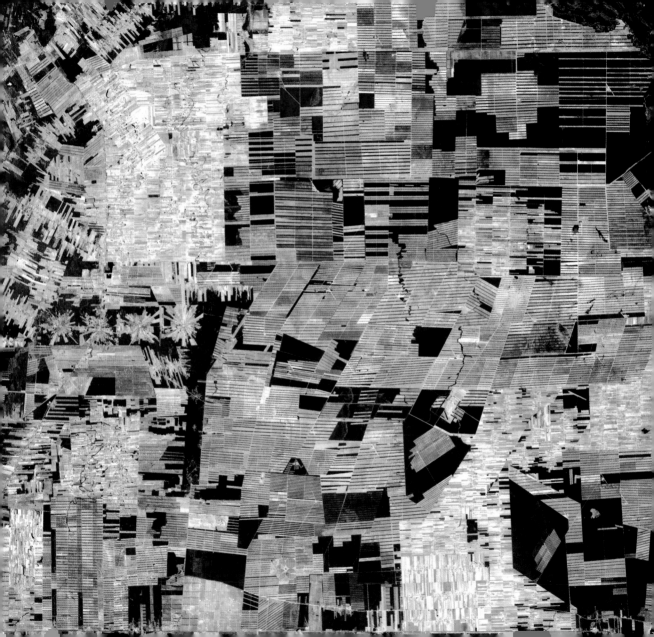

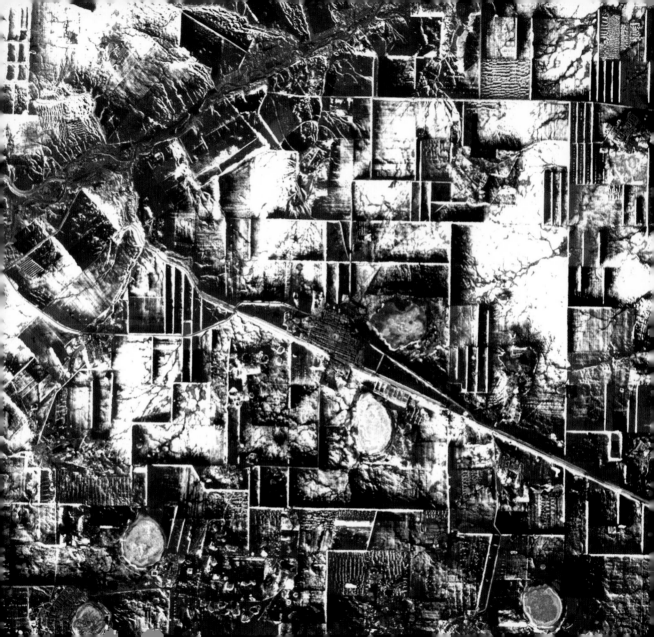

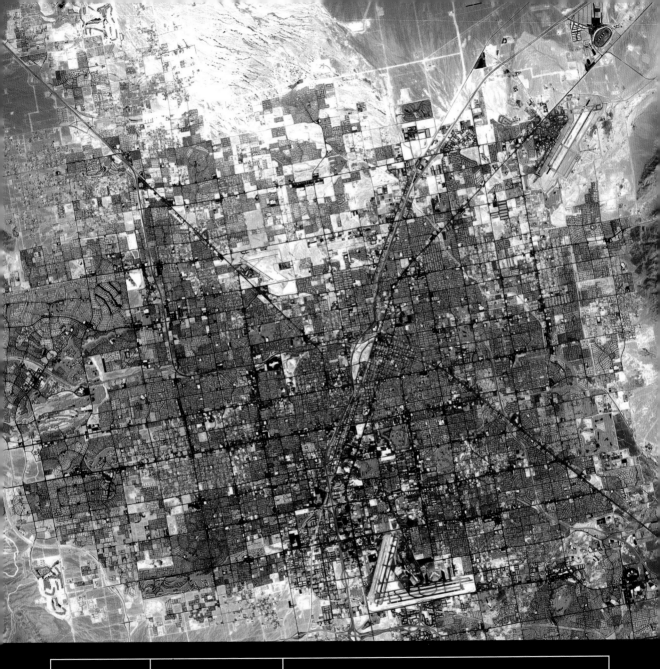

Las Vegas

City

Welcome to Fabulous Las Vegas. In a city dedicated to excess, there is no greater symbol of conspicuous consumption than its grass lawns and golf courses, which in the near-infrared, as seen here, quite outshine the Strip's neon lights. The fastest growing metropolitan area in the United States, this refrigerated oasis is spreading over

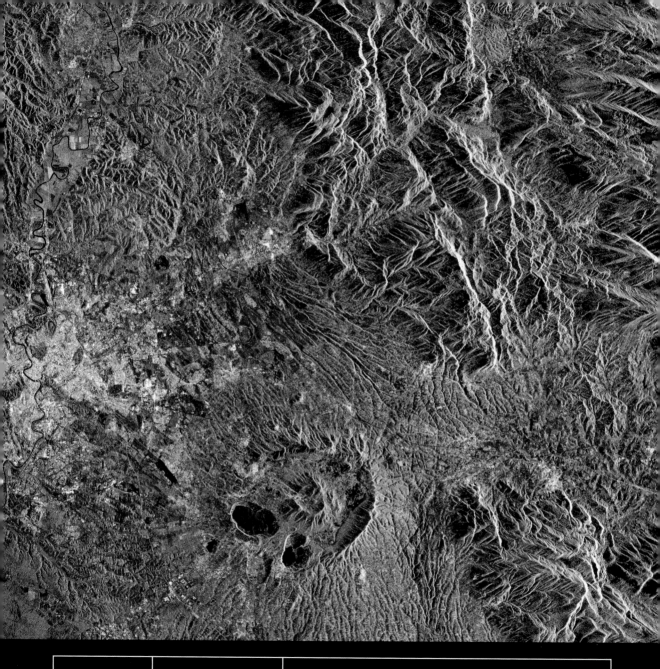

Rome

City

Only slightly younger than the volcanic landscape that surrounds it, the Eternal City has stood for nearly three millennia. At its height, it was the largest city in the world, ruling one-fifth of the planet's total population. But great cities are like hurricanes – without a prodigious fuel supply, they must collapse. When the incubating waters of its

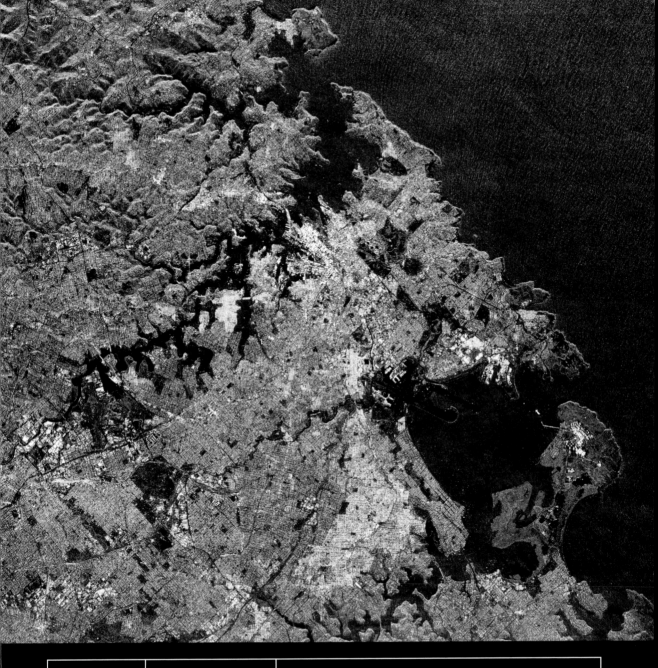

Sydney

City
NSW, Australia

Under radar illumination, Sydney shines: gold and turquoise mark urban sprawl; skyscrapers burn white. Nearly half the planet's human population is now citybound. In a decade, that figure will be closer to 60 percent. Swathed in concrete, the metropolises that house such multitudes dominate their environments absolutely, even to the extent of manufacturing their own weather.

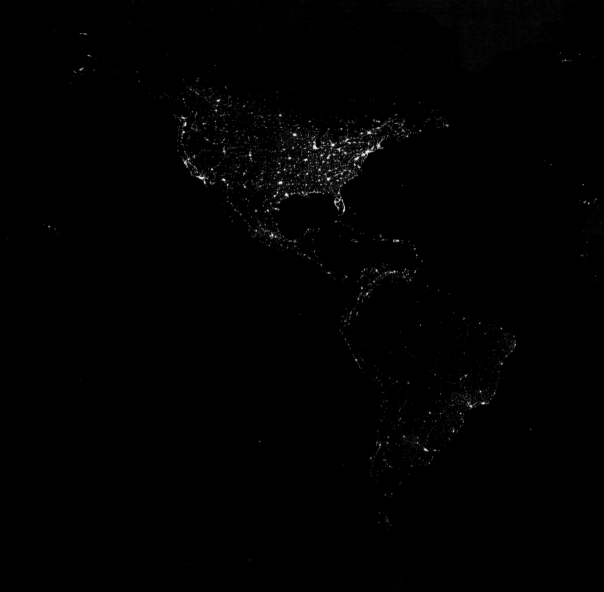

City Lights

The night betrays us, revealing our tenure on planet Earth to the cosmos. As humanity blooms, so do our cities. In the darkness, Earth shimmers as they swarm across the globe, following coasts, rivers, railroads, highways and political borders. As a race, we are abandoning our ancestors' habitats for a new environment of our own making.

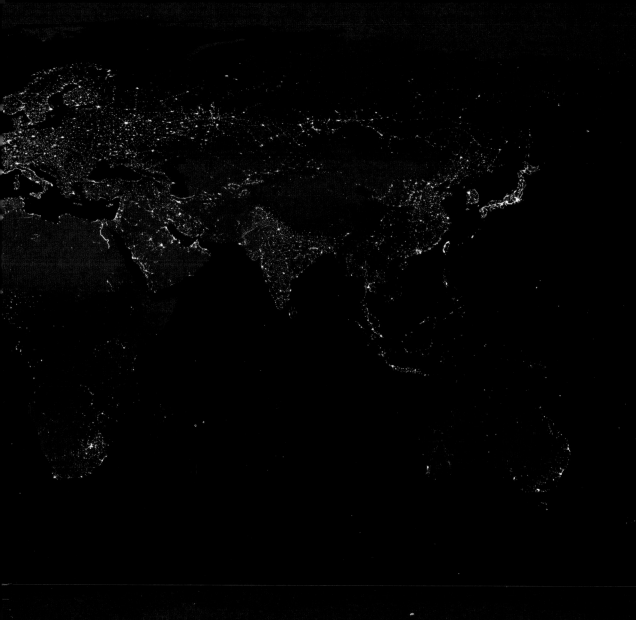

glossary

Abyssal
Relating to the deep ocean floor.

Aquifer
A subterranean layer of porous rock that can hold water.

Asteroid
A small (up to 1,000 kilometres or 600 miles in diameter) rocky body orbiting the Sun. The vast majority are found in the asteroid belt between Jupiter and Mars, but a significant number do have Earth-crossing orbits and the potential for a future Earth impact.

Astrobleme
An asteroid impact crater; literally a 'star wound'.

Atmosphere
The envelope of gases surrounding Earth: a mix of nitrogen (78 percent), oxygen (21 percent) and trace amounts of water vapour, argon, carbon dioxide, neon, helium, methane, krypton and hydrogen. It is divided into five zones:
Troposphere: from the Earth's surface to 7 kilometres (4.5 miles) at the poles, 17 kilometres (10.5 miles) at the equator. Comprising 80 percent of the total atmospheric mass, this layer is where most weather phenomena occur.
Stratosphere: between 17 kilometres (10.5 miles) and 50 kilometres (30 miles). Hosts the ozone layer.
Mesosphere: between 50 kilometres (30 miles) and 80 kilometres (50 miles).
Thermosphere: between 80 kilometres (50 miles) and 500 kilometres (300 miles).
Exosphere: over 500 kilometres (300 miles). The uppermost layer of the atmosphere. There is no precise boundary between the atmosphere and the rigours of outer space, rather a gradual fade to vacuum that is more or less complete by 10,000 kilometres (6,000 miles) above the planet.

Atoll
A ring-shaped coral reef that once fringed a half-submerged volcano. Once extinct, the volcano sinks back into the ocean floor, forcing the coral reef to build ever higher to remain near the sea surface. Eventually the volcano disappears entirely, leaving only a coral island as its memorial.

Aurora
An optical phenomenon characterized by fluorescent displays of light in the night sky, caused by the interaction of charged particles from the solar wind with the upper atmosphere. Earth's magnetic field centres the display over the poles, where they are known as the Northern and Southern Lights, or the Aurora Borealis and Aurora Australis, respectively.

Biosphere
The planetary zone that supports life, an intersection of the lithosphere, hydrosphere and atmosphere.

Caldera
A large circular volcanic crater caused by post-eruption collapse into an emptied magma chamber.

Chaos
The state of a system that is deterministic (runs according to a set of rules) but appears to exhibit random behaviour due to an extreme sensitivity to its initial parameters. The practical consequence of this is the long-term behaviour of a chaotic system – such as the weather – cannot be predicted with anything less than a perfect measurement of the position and velocity of every single atom in, on and around the planet. The butterfly effect is often presented as an example of chaos: the tiny eddies produced when a butterfly flaps its wings could propagate through a chaotic system and cause a hurricane on the other side of the globe. Note that this definition of 'chaos' is very much at odds with its common usage: for scientists chaos is not disorderly, just unpredictable.

Cloud
A visible mass of water droplets or ice crystals suspended in the atmosphere. Cloud forms when air rises and cools, leading to the condensation of the water vapour it is carrying. Clouds are classified according to their altitude and shape. The major types of clouds include: cirrus, cirrocumulus, cirrostratus, altocumulus, altostratus, nimbostratus, strato-cumulus, stratus, cumulus and cumulonimbus.

Convection
The transfer of heat through the movement of fluids (specifically air, water and hot ductile rocks in Earth's case) driven by internal temperature and density differentials. When heated, fluids expand, becoming less dense and more buoyant and so rise, while colder fluids, being denser, sink.

Convection cell
An organized unit of convection. A rising body of fluid gradually cools as it loses heat to its surroundings. At some point it becomes denser than the fluid below it, which is still rising. Since it cannot descend through the rising fluid, it moves to one side. At some distance its downward force overcomes the rising force underneath it and the fluid begins to descend. As it descends, it warms again and the cycle repeats itself.
The whole planet churns with a clockwork-like mesh of convection cells. The heat of radioactive decay powers convection in the outer core, which drives cells in the mantle, which propel the lithospheric motions of plate tectonics. Above ground, the Sun heats the oceans and the atmosphere, stirring interlocking convection cells that are responsible for Earth's weather and climate.

Core
The centre of the Earth, comprising the outer core and the inner core. The outer core lies at a depth of 2,900 kilometres (1,800 miles) and consists of a turbulent white-hot liquid (3,500 to 4,000 °C or 6,300 to 7,200 °F) composed mostly of iron, nickel and sulphur. Its churning convection cells are believed to generate Earth's magnetic field. At a depth of 6,400 kilometres (4,000 miles) lies the inner core, a solid sphere of iron and some nickel. At 4,700 °C (8,500 °F) it is hotter than the surface of the Sun. Recent evidence suggests that this heat is produced by an 8-kilometre (5-mile) ball of uranium at the very heart of the inner core. The pressure here is 3 million times that of the atmosphere at the surface: if you pierced the planet to its core it would probably explode like a pricked balloon. It is this pressure that keeps the inner core solid.

Coriolis effect
An artefact of the planet's rotation that causes moving objects to be deflected to the right in the northern hemisphere and to the left in the southern hemisphere. The effect is responsible for the direction of flow in meteorological phenomena such as cyclones and hurricanes.

Cretaceous
A period of geological time, stretching between 142 million and 65 million years ago.

Crust
The rigid outermost layer of the solid Earth. Two types of crust are recognized: continental crust and oceanic crust. Continental crust is 20 to 70 kilometres (12.5 to 44 miles) thick, consists of granite and supports the continents and their margins. Oceanic crust is typically thinner, only 5 to 10 kilometres (3 to 6 miles) thick, made of denser basalt and underlies the planet's deep oceans.

Cumulonimbus cloud
A vertical cloud that can tower 15 kilometres (9 miles) high, often characterized by an anvil-shaped summit. Dense with water – over 275,000 tons in large specimens – similarly heavy weather is associated with cumulonimbus, including: high winds, hail, lightning, tornadoes, hurricanes and, of course, heavy rain.

Cumulus cloud
The prototypical flat-bottomed, low-altitude, fluffy cloud. Cumulus clouds form on rising columns of warm air, their bases marking the level at which water vapour condenses.

Delta
A low, nearly flat accumulation of sediment deposited at the mouth of a river or stream. Sometimes a river will form an inland delta, dividing into multiple branches before rejoining and continuing to the sea; such features often occur on former lake beds.

Dune
A hill-shaped deposit of sand gathered and sculpted by the wind. There are several species of dune, distinguished by their anatomy: the crescent-shaped barchan, or crescentic, dune; the straight-ridged seif, or linear, dune; and the many-armed star dune. Each dune type can occur in three forms: simple, compound and complex. Simple dunes conform to their standard anatomy; compound dunes are large dunes on which smaller dunes of the same species are superimposed; and complex dunes are combinations of two or more dune types – for example, a barchan dune with a star dune superimposed on its crest. Simple dunes represent a wind regime that has not changed in intensity or direction since the formation of the dune, compound dunes represent a change in intensity and complex dunes suggest that both intensity and direction have changed.

Earth
Third planet from the Sun and the solar system's largest terrestrial planet. Formed 4.57 billion years ago, it measures 12,756 kilometres (7,926 miles) across the equator and masses 5.98 trillion trillion tons. Iron, oxygen, silicon and magnesium, nickel, calcium and aluminium make up over 99 percent of the planet. (See atmosphere, crust, mantle, core.)

Electromagnetic radiation
The most familiar type of electromagnetic radiation is light, but visible light is a brief archipelago in an ocean of wavelengths. The full electromagnetic spectrum runs from extremely energetic gamma rays to low-power radio waves via X-rays, ultraviolet, visible and infrared light and microwaves.

El Niño
An eastward surge of warm water across the surface of the equatorial Pacific that disrupts normal ocean circulation patterns. Occurring at irregular intervals of 2–7 years and usually lasting 1–2 years, El Niño has been linked to wetter, colder winters in the United States; drier, hotter summers in South America and Europe; and drought in Africa.

Erg
A large windswept, sand-covered area of desert: a sand sea.

Erosion
The removal of rock or soil from a surface by wind, water and ice. Earth owes its diverse and ever-changing landscape to the interaction between plate tectonics and erosion.

Fault
A fracture in the Earth's crust, usually caused by the differential motion of tectonic plates. Depending on the direction of displacement, a fault is described as normal (down), thrust (up) or strike-slip (sideways).

Fluorescence
An optical phenomenon whereby a molecule absorbs an invisible high-energy ultraviolet photon and re-emits it as a visible, lower-energy photon.

Gamma ray
The most energetic form of electromagnetic radiation.

Glacier
A perennial river of ice that flows in response to gravity, formed from a multi-year accumulation of snowfall in mountainous or arctic terrains. Glacier ice is the largest reservoir of fresh water on Earth.

Gondwana
An ancient supercontinental landmass, the ancestor of Africa, South America, India, Arabia, Australia, Antarctica, Madagascar and New Zealand. Originally assembled some 650 million years ago, it began to break up 160 million years ago.

Gravity
A physical force that appears to exert a mutual attraction between all masses, proportional to the mass of the objects and distance between them.

Hurricane
see Tropical cyclone

Hydrosphere
The sum total of water encompassing the Earth, comprising all the bodies of water, ice, and water vapour in the atmosphere. Although it covers 71 percent of the planet's surface, the hydrosphere accounts for just 0.023 percent of its total mass.

Ice age
Recurring epochs in Earth's history characterized by the presence of ice sheets. There have been four major ice ages in the planet's past and as ice sheets can currently be found in Antarctica and Greenland, we are, technically speaking, enjoying a warm interlude in a cold snap than began 40 million years ago. Such interludes are known as interglacials and alternate with colder glacial periods at a 40,000-year frequency. Colloquially, and in this book, the term 'ice age' refers to the last glacial period, which ended approximately 10,000 years ago.

Ice-cap
A dome-shaped glacier covering a mountain or mountain range but covering an area less than 50,000 square kilometres (19,300 square miles).

Ice sheet
A glacier covering an area in excess of 50,000 square kilometres (19,300 square miles). An ice sheet is not confined by the underlying topography and is capable of swallowing an entire continent. During the last ice age, ice sheets covered large parts of North America and northern Europe, but they are now confined to polar regions (e.g. Greenland and Antarctica).

Ice tongue
A long, narrow spit of ice that projects from the coastline where a glacier flows rapidly into the sea or a lake.

Igneous rock
Rock of volcanic origin, formed by the crystallization of magma either beneath (intrusive igneous rock) or at (extrusive igneous rock) the Earth's surface. The most common examples include granite and basalt.

Infrared
A section of the electromagnetic spectrum invisible to human eyes, but sensed as heat or thermal radiation.

Jet stream
Rivers of high-speed air in the atmosphere at an altitude of 12 to 20 kilometres (7.5 to 12 miles). Jet streams form at the boundaries of global air masses where there is a significant difference in atmospheric temperature: the two main streams are at polar latitudes, one in each hemisphere, with two minor subtropical streams closer to the equator. The jet streams may be several hundred kilometres across and 3 kilometres (2 miles) deep, with core windspeeds as high as 400 kph (250 mph).

Katabatic
A cold wind that blows down a topographic gradient such as a mountain or glacier.

Latent heat
The heat energy required to change a liquid into gas (such as water into water vapour). This energy is released when the vapour condenses, and drives the vertical punch of cumulonimbus clouds and the heat engine of a tropical cyclone.

Laurentia
A 3-billion-year-old continental plate. Currently forms the heart of North America, as well as the Barents Shelf and Greenland.

Lava
Magma that has reached the Earth's surface via a volcano.

Light
Electromagnetic radiation the human eye can detect. However, the term can also be applied to all electromagnetic radiation.

Lithosphere
The outermost rocky shell of the planet, comprising the crust and a solid portion of the upper mantle. The planet's tectonic plates are denizens of the lithosphere.

Low-pressure system
A horizontal area where the atmospheric pressure is lower than it is in adjacent areas. Nature abhors even the suggestion of a vacuum, so air will always move from areas of high pressure to areas of low pressure to equalize the pressure. This inflow of air towards the low will be deflected by the Coriolis effect and wound into a spiral that rotates in a counterclockwise direction in the northern hemisphere, and in a clockwise direction in the southern hemisphere. Such low-pressure cells are called cyclones.

Mackerel
A pelagic denizen of the hydrosphere.

Magma
Molten rock generated deep within the earth, erupts as lava.

Magnetic field
An area influenced by a magnetic force – a phenomenon produced by moving electrons in an electric current. The Earth's magnetic field is believed to be generated by the liquid churning of the planet's metallic outer core.

Mantle
A layer of silicate rock that lies between Earth's crust and outer core. Approximately 2,900 kilometres (1,800 miles) deep, it makes up 84 percent of the planet's volume and divides into two sections: the upper and lower mantles. The top layer of the upper mantle is solid and attached to the crust, forming the lithosphere and the planet's tectonic plates. Beneath the lithosphere is the semi-plastic asthenosphere, the slow churn of its convection cells is the immediate engine of plate tectonics. At a depth of between 200 and 400 kilometres (125 miles and 250 miles) we transfer to the lower mantle which extends to the outer core. Temperatures here range between 1,000°C (1,800 °F) at its upper boundary and over 3,500°C (6,300 °F) at the lower. Although these temperatures far exceed the melting points of the mantle's rocks, the enormous pressure at these depths keeps them solid.

Mantle plume
A vertical column of magma that intrudes into the crust. If it breeches oceanic crust it is known as a 'hotspot', spawning island chains such as the Kuril Islands or Hawaii as ocean plate moves over it. Under continental crust it can promote the formation of rifts, such as the Great African Rift.

Megaton
A unit of energy equivalent to the detonation of one million tons of TNT.

Mesa
A flat-topped hill that rises sharply above the surrounding landscape. The top of this hill is usually capped by a rock formation that is comparatively resistant to erosion.

Metamorphic rock
Any rock formed from the recrystallization of igneous, sedimentary or other metamorphic rocks through compression, shearing stress, temperature rise or chemical alteration. Examples include marble (heated limestone) and slate (compression of mudstone and siltstone).

Microwave radiation
A form of electromagnetic radiation with a wavelength of between 0.1 and 100 centimetres.

Mid-Atlantic Ridge
A chain of submarine mountains in the Atlantic Ocean where oceanic crust is created from rising magma plumes.

Ozone
A relatively unstable allotrope of oxygen comprising three atoms of oxygen, rather than the more stable diatomic version. On average, ozone constitutes less than one part per million (ppm) of the gases in the atmosphere – even within the stratospheric ozone layer concentrations are only 10 ppm – yet it absorbs nearly all of the Sun's biologically hazardous ultraviolet radiation before it reaches the Earth's surface.

Ozone hole
An annual area of intense stratospheric ozone depletion over the Antarctic continent that typically occurs between late August and early October. The hole has increased conspicuously since the late 1970s and early 1980s, a direct result of the release of man-made chlorofluorocarbons (CFCs).

Pangaea
An ancestral global supercontinent. Formed from the union of Gondwana, Laurentia, Baltica and Siberia 300 million years ago, it started breaking up as the Atlantic opened 180 million years ago.

Permafrost
Perennially frozen soil, occurring in high latitude or high altitude environments.

Plasma
The 'fourth state of matter', an electrically conductive mixture of electrons and ions.

Plate
See tectonic plate.

Plate tectonics
A theory suggesting that the Earth's crust is composed of rigid plates that move over a less rigid interior, driven by rising heat from the planet's core. The theory is central to our current understanding of Earth's geology as it can explain the occurrence and formation of mountains, folds, faults, volcanoes, earthquakes, ocean trenches and mid-oceanic ridges, all in relation to the movement and interaction of plates.

Precambrian
The most ancient division of geologic time, opening with the formation of the planet 4.57 billion years ago and closing at the beginning of the Cambrian period, 540 million years ago.

Radar
An active sensing system that transmits microwaves and 'listens' for their echo.

Rain shadow
An area of reduced precipitation commonly found on the leeward side of a mountain, caused by the air shedding its moisture as it rises over the mountain.

Rift valley
A depression or trough formed as a section of Earth's crust sinks between parallel faults (Africa's Great Rift Valley has sunk, in places, up to 10 kilometres or 6 miles). Formed where the forces of plate tectonics are beginning to split a continent.

Rock cycle
A self-perpetuating process through which one type of rock (igneous, sedimentary or metamorphic) is converted into another. Volcanic activity creates igneous rocks at the planet's surface. Erosion of surface rocks produces sediments, which are transformed through burial into sedimentary rocks. Deep burial, or exposure to other stresses, induces metamorphic changes. Uplift and erosion return buried rocks to the surface, or subduction returns them to the mantle – and the cycle begins again. The twin engines of this crustal turnover are plate tectonics and erosion.

Sedimentary rock
Rock resulting from the consolidation of accumulated sediments, including sandstone, siltstone and limestone.

Stratocumulus cloud
Low-altitude grey cloud of patches and sheets, formed when rising air is trapped beneath a higher layer of warmer air.

Strata
Layers of sedimentary rock; the singular is stratum.

Subduction
The process by which one tectonic plate is forced beneath another and into the mantle where it is destroyed. Implicated in construction of mountain ranges and volcanoes.

Supercontinent
A landmass welded together from several continental cores, such as Eurasia. Approximately every 250 million years plate tectonics brings all the continents together to form one global supercontinent.

Tectonic
Pertaining to the forces that shape the Earth's crust (see Plate tectonics).

Tectonic plate
An extensive section of the lithosphere that moves as a discrete unit on the surface of Earth's asthenosphere (see Plate tectonics).

Topography
The surface relief of an area.

Trench
A deep depression found at the edge of the ocean floor, formed by one tectonic plate subducting under another.

Tropical cyclone
Tropical cyclones, hurricanes and typhoons are all tempests of the same ilk: extreme low-pressure systems characterized by windspeeds exceeding 117 kph (73 mph). They masquerade under different names according to their hunting grounds: hurricanes stalk the western hemisphere; typhoons the eastern; and tropical cyclones the Indian Ocean. They are further ranked on the Saffir-Simpson Hurricane Scale according to their maximum sustained winds: a category 1 storm has the lowest maximum winds, a category 5 has the highest (greater than 250 kph or 156 mph).

Structurally, tropical cyclones are characterized by a large, rotating wheel of clouds and thunderstorms punctuated by a central area of relative calm and extreme low pressure at the centre. Maximum windspeeds can gust over 300 kph (200 mph), powered by the release of heat from the condensation of water vapour at high altitudes. Because of this, a tropical cyclone can be thought of as a giant vertical heat engine.

Tropical cyclones are only spawned over warm oceans (heated to 25.5 °C or 78 °F to a depth of at least 60 metres or about 200 feet), at a minimum of 10 degrees from the equator so the Coriolis effect can kick-start their rotation. Once their thunderous heat engines are up and running, they are self-sustaining, until deprived of their fuel source by either moving on to land or into colder waters.

Typhoon
See Tropical cyclone.

Ultraviolet (UV) radiation
Electromagnetic radiation with a shorter wavelength than violet light.

Volcano
An elevated area of land where magma from the Earth's interior forces its way through the crust. There are two main species of volcano: shield volcanoes and stratovolcanoes. Shield volcanoes have wide shallow-sloped flanks and are formed by low-viscosity lava flows. Earth's largest volcano, Mauna Loa in Hawaii, is a shield volcano, as is the largest known mountain in the solar system, Olympus Mons on Mars. Stratovolcanoes are tall, conical mountains composed of both lava flows and ejected rock, which form the strata which give rise to the name. The classic example is Mount Fiji in Japan. Supervolcano is a popular term applied to a volcano that has produced an exceedingly large, catastrophic explosive eruption (ejecting thousands of cubic kilometres of debris) and left a correspondingly giant caldera, commonly applied to the volcanoes hidden beneath Yellowstone National Park in he USA and Lake Toba in Sumatra. Volcanoes are usually situated behind subduction zones, or over mantle plumes.

Wadi
A dry riverbed, inundated only after heavy rainfall.

Picture credits

The publishers would like to thank the following individuals and institutions for permission to reproduce the images on the pages listed below. Every effort has been made to trace the copyright holders. Quercus apologise for any unintentional omissions and, if informed of such cases, will correct any future edition.

p.1–5 all images Nicolas Cheetham; p.6 NASA; p.9 Image Analysis Laboratory/NASA Johnson Space Center/image: ISS009-E-22187; p.10 NASA/Roger Ressmeyer/Science Faction/image: STS065-71-46; p.13 Image Analysis Laboratory/NASA Johnson Space Center/image: STS091-711-28; p.15 Nicolas Cheetham; p.16 NASA/Goddard Space Flight Center; p.18 Image Analysis Laboratory/NASA Johnson Space Center/image: ISS004-E-8852; p.19 Image Analysis Laboratory/NASA Johnson Space Center/image: ISS010-E-8454; p.20 NASA/GSFC/METI/ERSDAC/JAROS and U.S./Japan ASTER Science Team; p.21 NASA/JPL; p.22 NASA Landsat Project Science Office and USGS National Center for EROS; p.23 NASA Landsat Project Science Office and USGS National Center for EROS; p.24 NASA/GSFC/METI/ERSDAC/JAROS and U.S./Japan ASTER Science Team; p.25 NASA/GSFC/METI/ERSDAC/JAROS and U.S./Japan ASTER Science Team; p.26 NASA Landsat Project Science Office and USGS National Center for EROS; p.27 NASA Landsat Project Science Office and USGS National Center for EROS; p.28 NASA Landsat Project Science Office and USGS National Center for EROS; p.29 NASA/GSFC/METI/ERSDAC/JAROS and U.S./Japan ASTER Science Team; p.30 NASA Landsat Project Science Office and USGS National Center for EROS; p.31 NASA Landsat Project Science Office and USGS National Center for EROS; p.32 NASA Landsat Project Science Office and USGS National Center for EROS; p.34 NASA/GSFC/METI/ERSDAC/JAROS and U.S./Japan ASTER Science Team; p.35 NASA Landsat Project Science Office and USGS National Center for EROS; p.36 NASA/GSFC/METI/ERSDAC/JAROS and U.S./Japan ASTER Science Team; p.37 NASA Landsat Project Science Office and USGS National Center for EROS; p.38 NASA/Roger Ressmeyer/Science Faction/image: STS040-152-180; p.40 ESA; p.41 NASA Landsat Project Science Office and USGS National Center for EROS; p.42 NASA/GSFC/METI/ERSDAC/JAROS and U.S./Japan ASTER Science Team; p.44 ESA; p.45 NASA Landsat Project Science Office and USGS National Center for EROS; p.46 NASA Landsat Project Science Office and USGS National Center for EROS; p.47 NASA/JPL; p.48 ESA; p.50 NASA/JPL; p.51 NASA/JPL; p.52 ESA; p.53 ESA; p.54 NASA/GSFC/METI/ERSDAC/JAROS and U.S./Japan ASTER Science Team; p.55 NASA/JPL/NIMA; p.56 ESA/GP/JPL; p.57 GFZ Potsdam/JPL/NASA; p.59 Nicolas Cheetham; p.60 NASA/GSFC/METI/ERSDAC/JAROS and U.S./Japan ASTER Science Team; p.62 Jacques Descloitres, MODIS Land Rapid Response Team, NASA/GSFC; p.64 ESA; p.65 ESA; p.66 NASA Landsat Project Science Office and USGS National Center for EROS; p.67 NASA Landsat Project Science Office and USGS National Center for EROS; p.68 NASA/GSFC/METI/ERSDAC/JAROS and U.S./Japan ASTER Science Team; p.69 NASA/GSFC/METI/ERSDAC/JAROS and U.S./Japan ASTER Science Team; p.70 ESA; p.72 ESA; p.73 Image Analysis Laboratory/NASA Johnson Space Center/image: STS032-96-32; p.74 NASA Landsat Project Science Office and USGS National Center for EROS; p.76 NASA Landsat Project Science Office and USGS National Center for EROS; p.77 ESA; p.78 NASA/GSFC/METI/ERSDAC/JAROS and U.S./Japan ASTER Science Team; p.79 NASA Landsat Project Science Office and USGS National Center for EROS; p.80 NASA/GSFC/METI/ERSDAC/JAROS and U.S./Japan ASTER Science Team; p.81 Image Analysis Laboratory/NASA Johnson Space Center/image: STS099-706-90; p.82 Image Analysis Laboratory/NASA Johnson Space Center/image: NM23-739-93; p.83 Image Analysis Laboratory/NASA Johnson Space Center/image: STS061-075-022; p.84 Jacques Descloitres, MODIS Land Rapid Response Team at NASA/GSFC; p.85 Jacques Descloitres, MODIS Land Rapid Response Team, NASA/GSFC; p.86 NASA/GSFC/METI/ERSDAC/JAROS and U.S./Japan ASTER Science Team; p.87 NASA Landsat Project Science Office and USGS National Center for EROS; p.88 Image Analysis Laboratory/NASA Johnson Space Center/image: STS078-747-81; p.89 Image Analysis Laboratory/NASA Johnson Space Center/image: STS51A-45-44; p.90 NASA/GSFC/METI/ERSDAC/JAROS and U.S./Japan ASTER Science Team; p.91 NASA Landsat Project Science Office and USGS National Center for EROS; p.92 ESA; p.93 ESA; p.94 Jeffrey Kargel, USGS/NASA JPL/AGU; p.96 NASA Landsat Project Science Office and USGS National Center for EROS; p.97 NASA Landsat Project Science Office and USGS National Center for EROS; p.98 NASA Landsat Project Science Office and USGS National Center for EROS; p.99 NASA Landsat Project Science Office and USGS National Center for EROS; p.100 Robert Simmon, based on data provided by the NASA GSFC Oceans and Ice Branch and the Landsat 7 Science Team; p.101 NASA/GSFC/METI/ERSDAC/JAROS and the U.S./Japan ASTER Science Team; p.102 NASA/JPL; p.103 ESA; p.104 NASA/JPL; p.105 Bob Evans, Peter Minnet at the University of Miami, NASA; p.107 Nicolas Cheetham; p.108 Image Analysis Laboratory/NASA Johnson Space Center/image: STS101-707-60; p.110 F. Hasler et al., (NASA/GSFC) and The GOES Project; p.111 R.B. Husar, Washington University – the land layer from the SeaWiFS Project, fire maps from the European Space Agency, sea surface temperature from the Naval Oceanographic Office's Visualization Laboratory; and cloud layer from SSEC, U. of Wisconsin; p.112 Jeff Schmaltz, MODIS Rapid Response Team, NASA/GSFC; p.113 Jacques Descloitres, MODIS Rapid Response Team, NASA/GSFC; p.114 Image Analysis Laboratory/NASA Johnson Space Center/image: STS41B-41-2347; p.115 Image Analysis Laboratory/NASA Johnson Space Center/image: ISS006-E-11101; p.116 Jacques Descloitres, MODIS Land Rapid Response Team at NASA GSFC; p.117 Jeff Schmaltz, MODIS Rapid Response Team, NASA/GSFC; p.118 Jacques Descloitres, MODIS Rapid Response Team, NASA GSFC; p.119 Jacques Descloitres, MODIS Rapid Response Team, NASA/GSFC; p.120 Jacques Descloitres, MODIS Rapid Response Team, NASA/GSFC; p.121 Jeff Schmaltz, MODIS Rapid Response Team, NASA/GSFC; p.122 Image Analysis Laboratory/NASA Johnson Space Center/image: ISS009-E-20645; p.123 Jacques Descloitres, MODIS Land Rapid Response Team at NASA GSFC; p.124 NASA Landsat Project Science Office and USGS National Center for EROS; p.125 NASA Landsat Project Science Office and USGS National Center for EROS; p.126 ESA (Image processed by Brockmann Consult); p.127 NASA Landsat Project Science Office and USGS National Center for EROS; p.128 NASA Landsat Project Science Office and USGS National Center for EROS; p.130 NASA/GSFC/METI/ERSDAC/JAROS and U.S./Japan ASTER Science Team; p.131 Image Analysis Laboratory/NASA Johnson Space Center/image: STS101-707-60; p.132 NASA Landsat Project Science Office and USGS National Center for EROS; p.134 NASA/GSFC/METI/ERSDAC/JAROS and U.S./Japan ASTER Science Team; p.135 NASA Landsat Project Science Office and USGS National Center for EROS; p.136 Image Analysis Laboratory/NASA Johnson Space Center/image: ISS010-E-13539; p.137 Image Analysis Laboratory/NASA Johnson Space Center/image: ISS005-E-16469; p.138 Image Analysis Laboratory/NASA Johnson Space Center/image: ISS007-E-15177; p.139 Image Analysis Laboratory/NASA Johnson Space Center/image: STS044-81-55; p.140 Jacques Descloitres, MODIS Rapid Response Team, NASA/GSFC; p.141 Jacques Descloitres, MODIS Land Rapid Response Team, NASA/GSFC; p.142 Image Analysis Laboratory/NASA Johnson Space Center/image: ISS006-E-41626; p.144 Fritz Hasler and Hal Pierce/NASA/Goddard Space Flight Centre; p.145 Dirk Petry (GLAST Science Support Center), EUD, EGRET, NASA; p.147 Nicolas Cheetham; p.148 NASA/GSFC/METI/ERSDAC/JAROS and U.S./Japan ASTER Science Team; p.149 NASA/GSFC/METI/ERSDAC/JAROS and U.S./Japan ASTER Science Team; p.150 NASA/GSFC/METI/ERSDAC/JAROS and U.S./Japan ASTER Science Team; p.151 NASA/JPL; p.152 ESA; p.153 NASA/JPL; p.154 NASA Landsat Project Science Office and USGS National Center for EROS; p.155 NASA Landsat Project Science Office and USGS National Center for EROS; p.156 NASA/JPL; p.157 NASA/JPL; p.158 Image Analysis Laboratory/NASA Johnson Space Center/image: ISS009-E-22625; p.159 NASA/GSFC/METI/ERSDAC/JAROS and U.S./Japan ASTER Science Team; p.160 NASA/GSFC/METI/ERSDAC/JAROS and U.S./Japan ASTER Science Team; p.161 NASA/GSFC/METI/ERSDAC/JAROS and U.S./Japan ASTER Science Team; p.162 Image Analysis Laboratory/NASA Johnson Space Center/image: ISS005-E-21295; p.163 NASA Landsat Project Science Office and USGS National Center for EROS; p.164 Image Analysis Laboratory/NASA Johnson Space Center/image: STS043-151-32; p.165 Image Analysis Laboratory/NASA Johnson Space Center/image: STS060-83-31; p.166 NASA Landsat Project Science Office and USGS National Center for EROS; p.167 Image Analysis Laboratory/NASA Johnson Space Center/image: STS037-152-91; p.168 NASA/JPL; p.169 Image Analysis Laboratory/NASA Johnson Space Center/image: ISS006-E-47703; p.170 NASA/JPL; p.171 NASA Landsat Project Science Office and USGS National Center for EROS; p.172 NASA Landsat Project Science Office and USGS National Center for EROS; p.173 Image Analysis Laboratory/NASA Johnson Space Center/image: ISS007-E-15222; p.174 NASA/GSFC/METI/ERSDAC/JAROS and U.S./Japan ASTER Science Team; p.175 NASA/GSFC/METI/ERSDAC/JAROS and U.S./Japan ASTER Science Team; p.176 Jesse Allen, Earth Observatory, using data provided courtesy of NASA/GSFC/METI/ERSDAC/JAROS, and the U.S./Japan ASTER Science Team; p.177 NASA/JPL; p.178 NASA Landsat Project Science Office and USGS National Center for EROS; p.179 NASA Landsat Project Science Office and USGS National Center for EROS; p.180 NASA Landsat Project Science Office and USGS National Center for EROS; p.181 NASA/GSFC/METI/ERSDAC/JAROS and U.S./Japan ASTER Science Team; p.182 ESA; p.183 NASA/JPL; p.184 Marc Imhoff of NASA GSFC

Index

For Flavia

Quercus Publishing
21 Bloomsbury Square
London
WC1A 2NS

First published in 2006
This edition published in 2008
Copyright © Quercus 2006, 2008

A catalogue record for this book is available from the British Library.

Cloth case edition:
ISBN-13: 978 1 84724 639 4

Paperback edition:
ISBN-13: 978 1 906719 04 3

Written and designed by Nicolas Cheetham

Printed in China